STATE OF DECEPTION
THE POWER OF NAZI PROPAGANDA

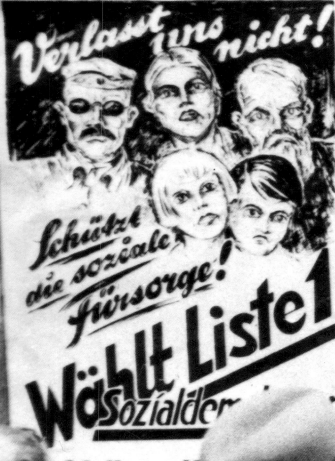

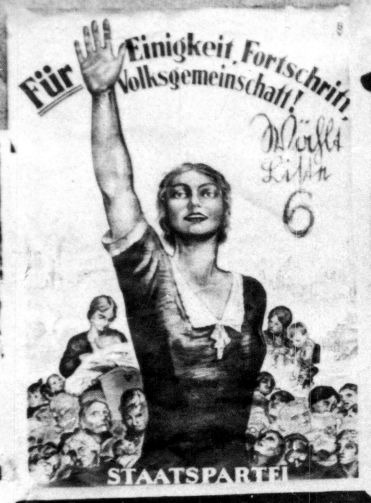

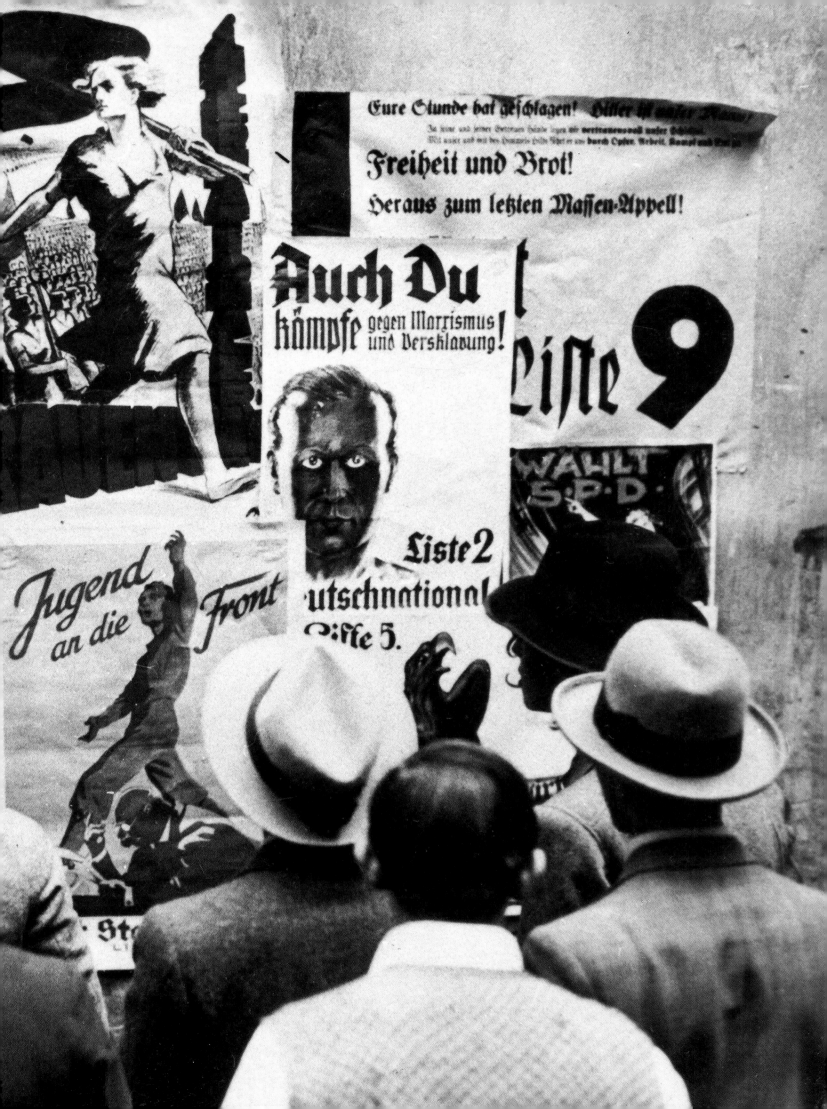

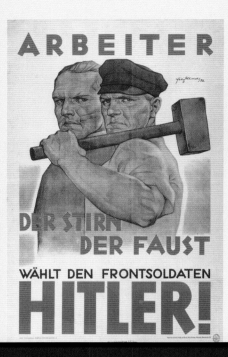

ARBEITER

DER STIRN DER FAUST

WÄHLT DEN FRONTSOLDATEN

HITLER!

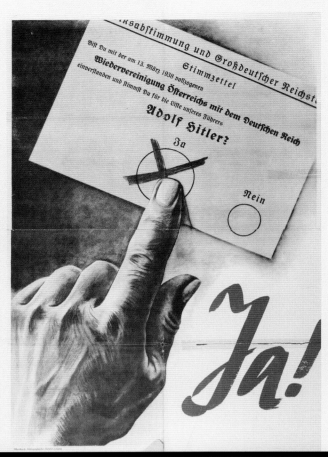

Volksabstimmung und Großdeutscher Reichstag

Stimmzettel

Bist Du mit der am 13. März 1938 vollzogenen Wiedervereinigung Österreichs mit dem Deutschen Reich einverstanden und stimmst Du für die Liste unseres Führers Adolf Hitler?

Ja

Nein

Ja!

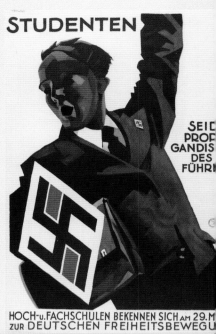

STUDENTEN

SEID PROP GANDIS DES FÜHR

HOCH-u. FACHSCHULEN BEKENNEN SICH AM 29. M zur DEUTSCHEN FREIHEITSBEWEGU

STATE OF

LISTE 1

National-Sozialisten

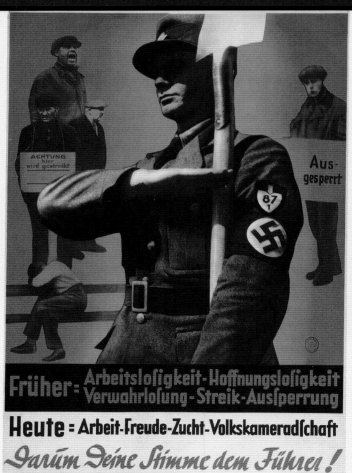

ACHTUNG hier wird gestreikt

Aus-gesperrt

87 1

Früher = Arbeitslosigkeit · Hoffnungslosigkeit Verwahrlosung · Streik · Aussperrung

Heute = Arbeit · Freude · Zucht · Volkskameradschaft

Darum Deine Stimme dem Führer!

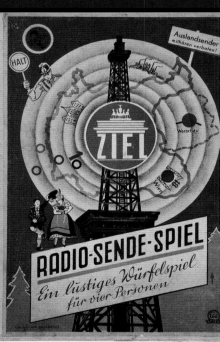

HALT

Auslandsender mithören verboten!

ZIEL

Warschau

RADIO-SENDE-SPIEL

Ein lustiges Würfelspiel für vier Personen

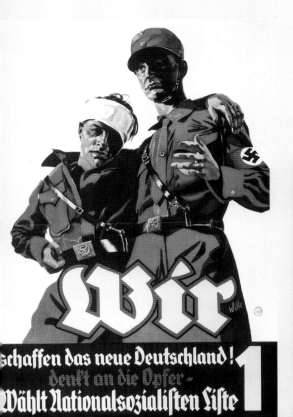

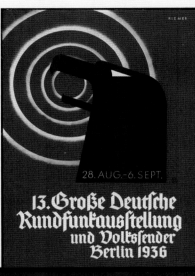

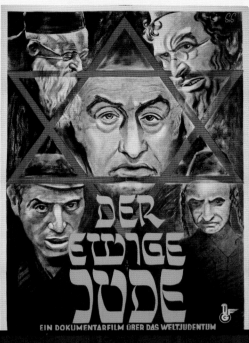

DECEPTION

THE POWER OF NAZI PROPAGANDA

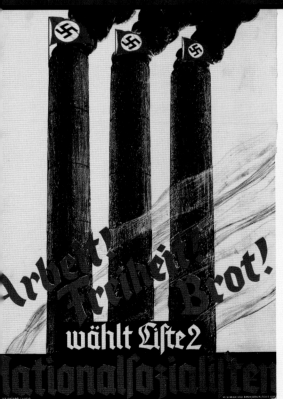

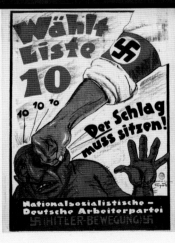

UNITED STATES
HOLOCAUST
MEMORIAL
MUSEUM

WASHINGTON, D.C.

This book is published in conjunction with the exhibition *State of Deception: The Power of Nazi Propaganda* at the United States Holocaust Memorial Museum, Washington, D.C., January 2009–October 2011.

The Museum's educational initiative on propaganda, including this publication, has been underwritten by The Marcus Foundation, Atlanta, Georgia.

Project Director: Susan Bachrach
Editor: Edward Phillips
Publishing Director: Lea Caruso
Art Director: Amy Donovan
Senior Editor: Bruce Tapper
Production Manager: Dwight Bennett

Photographic Coordination: Neal Guthrie
Research and Project Assistance: Clare Cronin, Ramee Gentry, Paul Rose
Object Photography: Max Reid

Book Design: Laura Lindgren
Typeset in Atma, Noble, and Bernhardt Gothic
Printed through Asia Pacific Offset, Inc.
Printed in China

ISBN 978-0-8904-714-3

COVER: From a poster for the film *S.A. Mann Brand*, 1933. Kunstbibliothek Berlin/BPK, Berlin/Art Resource, New York

PAGES ii–iii: Parliamentary election posters, Berlin, September 1930. BPK

OPPOSITE: Nazi Party member hawking *Der Angriff* (The Attack), the party paper edited by Goebbels. Berlin, June 1932. *BAK, Bild 146-2006-0068, Fotograf: Weinrother*

UNITED STATES HOLOCAUST MEMORIAL MUSEUM
Fred S. Zeidman, Chairman
Joel M. Geiderman, Vice Chairman
Sara J. Bloomfield, Director

100 Raoul Wallenberg Place, SW
Washington, DC 20024-2126

Distributed by W. W. Norton & Company, Inc.
500 Fifth Avenue, New York, NY 10110

CONTENTS

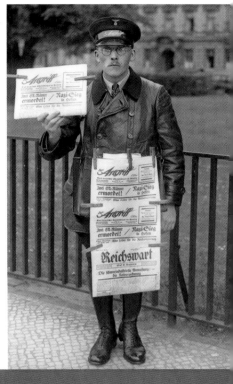

ACKNOWLEDGMENTS

For many of us, the words "Nazi propaganda" may immediately evoke mindless youth marching in lockstep to the Führer or thousands of Nazi Party members raising their arms and shouting "Heil, Hitler!" in unison at Nuremberg rallies. The movie *Triumph of the Will* created by German filmmaker Leni Riefenstahl ensured that such iconic images would endure long after the collapse of the regime she served. Along with Riefenstahl's films, numerous other techniques were skillfully used, for example to promote the cult of the Führer, one of the most successful elements of "positive" Nazi propaganda, retaining widespread appeal until the very end of the Third Reich.

Yet presenting all Germans in the Nazi era as unthinking automatons seduced by the rallies and messages of the Ministry of Propaganda and Public Enlightenment and the Nazi Party propaganda apparatus—both headed by Joseph Goebbels—would be not only inaccurate but also a version of history from which we could all too easily distance ourselves. Holocaust history is far more complicated and nuanced. The goal of the United States Holocaust Memorial Museum is to present this history with all its nuances and complexity and to encourage the public to reflect on its implications for their own lives. The Museum's exhibition, *State of Deception: The Power of Nazi Propaganda*, aims to do precisely that.

State of Deception shows that the Nazi propaganda machine was a highly sophisticated organization deploying tactics carefully crafted to reach diverse segments of the population and extending the party's appeal to the broad German public. This capacity for using propaganda, developed during the party's remarkable rise to power in the late 1920s and distinguishing it from its political rivals, would serve Hitler and the Nazis well once they took power.

After 1933 Nazi propaganda became an increasingly dangerous weapon with the regime's suppression of democratic freedoms and control of the police and other coercive powers. Most means of mass communication as well as educational and cultural institutions fell quickly under Nazi control, and the expression of opposing political viewpoints became punishable crimes.

The rapid dismantling of democratic institutions in Germany reminds us of the need for vigilance in safeguarding our freedoms and remembering our responsibilities, particularly those pertaining to speech. In "the marketplace of ideas" that defenders of First Amendment rights in the United States view as the best protection against hate speech in any form, cultivating an informed citizenry capable of critical thinking is a key public challenge.

In the Third Reich, "negative" propaganda that targeted Jews and others—examples of which abound in *State of Deception*—went increasingly unchecked and took its toll, even on the ordinary Germans who were not Nazi fanatics and who may even have been repulsed by crude Nazi imagery such as that of the hateful film *The Eternal Jew*, notorious for its depiction of Jews as vermin-spreading rats. The majority of Germans at least passively accepted discrimination against Jews. The feeling that the Jews were a "different race" became generalized and helped set the stage for the "Final Solution."

The aims and consequences of Nazi propaganda have left an important legacy that influences the way people think about contemporary genocide, antisemitism, and hate propaganda. The postwar trials of Nazi propagandists, notably the prosecution and conviction at Nuremberg of Julius Streicher, editor of the virulently antisemitic journal *Der Stürmer*, provided the basis for later discussions about hate propaganda and have been used as legal precedents in more recent court cases, including the "Media Trial" of three propagandists charged with "incitement to genocide" following the massacres in the Central African country of Rwanda in the 1990s. Government officials and diplomats in a number of countries have proposed charging Iranian president Mahmoud Ahmadinejad with "incitement to genocide" for his call that Israel be "wiped off the map."

The Nazis were skilled haters and propagandists; but they were hardly the first or the last. So why are we presenting this exhibition now? More than six decades after the postwar promise of "never again," we find ourselves in an era of antisemitism, genocide, and extremism—even denial of the facts of the Holocaust itself. Equally important, the haters and propagandists have new tools in this age of the Internet, and at the same time consumers of information seem less equipped to handle the massive amount of unmediated information confronting them daily. So perhaps a deeper examination of the complexities of our past can help us navigate familiar and unfamiliar waters in the future.

On behalf of the United States Holocaust Memorial Museum, I want to express heartfelt appreciation to the many people who have helped bring *State of Deception: The Power of Nazi Propaganda* to fruition. The development of exhibitions requires the efforts and enthusiasm of dedicated staff and volunteers, the willing support of lenders, the generosity of benefactors, the expertise of scholars and other advisers, and the encouragement of our board, the United States Holocaust Memorial Council and its Chairman Fred S. Zeidman and Vice Chairman Joel M. Geiderman. Everyone who contributed to the project shares the Museum's commitment to enlighten the public about Holocaust history and its lessons for today—and tomorrow.

<div style="margin-left:40%">

Sara J. Bloomfield
Director
United States Holocaust Memorial Museum

</div>

CREDITS

SuperStock, Inc., Jacksonville, FL
Temple University Library, Special
 Collections, Philadelphia, PA
U.S. Army Center of Military History,
 Washington, DC
United States Holocaust Memorial Museum,
 Washington, DC (USHMM)
The Wolfsonian–Florida International
 University, Miami Beach, FL

Individuals
Randall Bytwerk, Marvin Goldstein,
 Arthur Walker

HISTORICAL ADVISERS
Peter Black, Steven Carr, David Culbert,
Paul Fussell, Jeffrey Herf, Shanto Iyengar,
Michael Kazin, Marianne Lamonaca,
Susan D. Moeller, Peter Paret,
Shawn J. Parry-Giles, Geoffrey R. Stone,
David Welch, Jay Winter

EXHIBITION RESEARCH AND DEVELOPMENT
Curator
Steven Luckert

Development and Coordination
Nancy Gillette, Gregory Naranjo

Research and Coordination
Clare Cronin, Ramee Gentry, Neal Guthrie,
Kathleen Mulvaney, Paul Rose

Registrars
Charles Bills, Heather Kajic

Editor
Edward Phillips

Project Oversight
Stephen Goodell, Sarah Ogilvie,
 Edward Phillips

Historical Film Adviser
Raye Farr

Film Assistance
Bruce Levy, Leslie Swift, Lindsay Zarwell

Photograph Assistance
Judith Cohen, Nancy Hartman,
Hannah Morris, Caroline Waddell,
Kimberly Wydeen

Artifact Photography
Max Reid, Arnold Kramer

Special Assistance
Bridget Conley-Zilkic, John Corrigan,
Timothy Kaiser, Kenneth Kulp,
Wendy Lower, Kevin Mahoney, Polly Pettit,
Teresa A. Pollin, Kyra Schuster,
Alina Skibinska, Vincent Slatt,
Susan Goldstein Snyder, Anatol Steck

Translator
Fritz Gluckstein

EXHIBITION DESIGN AND PRODUCTION
Design
LaymanDesign, Glenview, IL,
Archegraph, Crete, IL

Fabrication
Display Dynamics Inc., Clayton, OH
MCA Construction, Inc., Alexandria, VA

Production Manager
Richard Ernst

Lighting
David Bobeck

Conservation and Installation
Eileen Blankenbaker, Adam Bradshaw,
Duane Brant, Shaw Fici, Cynthia Hughes,
Jane Klinger, Anne Marigza,
Rand Michael Robinson, David Stolte,
Archival Art Services, Inc., Washington, DC

VIDEO AND INTERACTIVE PROGRAMS
Production
Cortina Productions, McLean, VA

Media Integration and Installation
Electrosonic Systems, Inc., Minnetonka, MN

FILM SOURCES
Bulgaria
Bulgarska Nacionalna Filmoteka, Sofia

Croatia
Memorijalni muzej Jasenovac

Estonia
Eesti Filmiarhiiv, Estonia–Eesti Filmiarhiiv,
 Tallinn

France
Établissement Cinématographique et Photo-
 graphique des Armées, Ivry-sur-Seine

Germany
Bundesarchiv, Berlin
Chronos-Media GmbH, Potsdam
Hauptstaatsarchiv, Stuttgart

Jüdisches Museum Berlin
Transit Film GmbH, Munich
YildizFilm, Munich

Hungary
Gyorgy Antos, Budapest

Poland
WFDiF Documentary and Feature Film
 Studio, Warsaw

Ukraine
Central State Film, Photo and Sound
 Archive, Kiev

United Kingdom
British Movietone News, Middlesex
Imperial War Museum, London

United States
Archive Films by Getty Images, New York, NY
Harry N. Bromberg Collection, Kansas City,
 MO
Sam Bryan, Julian Bryan Collection, New
 York, NY
Fox News, Inc., New York, NY
Thomas P. Headen Collection, White Plains,
 MD
Library of Congress, Washington, DC
National Archives and Records
 Administration, College Park, MD
National Center for Jewish Film, Brandeis
 University, Waltham, MA
Reuters News Agency, New York, NY
University of South Carolina, Newsfilm
 Library, Columbia, SC
George Wheeler Collection

ORAL HISTORIES
Robert Behr, Peter Feigl, Gerda Hass,
Carola Steinhart, Guy Stern

*The United States Holocaust Memorial Museum
exhibitions program is supported in part by the
late Lester Robbins and Sheila Johnson Robbins
Traveling and Temporary Exhibitions Fund,
established 1990.*

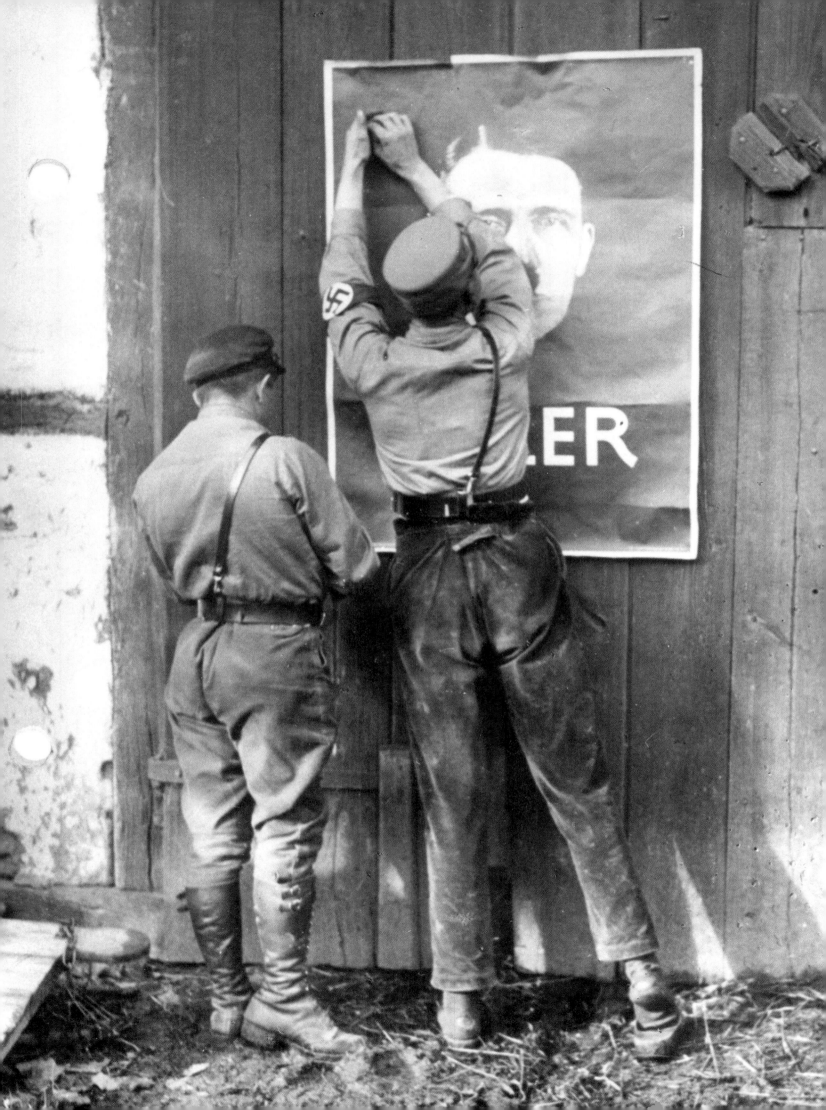

INTRODUCTION

Propaganda," Adolf Hitler declared in 1924 in his book *Mein Kampf* (My Struggle), "is a truly terrible weapon in the hands of an expert." During the subsequent two decades, Nazi leaders showed the world bold, new ways to use this tool. With a variety of sophisticated techniques, the Nazi Party sought to sway millions of Germans and other Europeans with appealing ideas of a utopian world along with frightful images of enemies deemed to be threats to those dreams. Ultimately, Nazi Germany drove the world into war, pursuing a vision that cost the lives of some fifty–five million people, including six million Jewish men, women, and children. While the effectiveness of Nazi propaganda to change minds continues to be debated, Allied officials who prosecuted war crimes after the war and Nazi leaders themselves believed that propaganda played a crucial role in the implementation of Nazi policies. Many scholars support this view as well.

WHAT IS PROPAGANDA?

Today the word *propaganda* sounds ominous, conjuring up images of falsehood and dishonesty, manipulation and brainwashing, and dictatorship and servility. It stands as the antithesis of objectivity, rationality, and truthfulness. It is commonly associated not only with Nazi Germany but also with brutal regimes in Fascist Italy and the Soviet Union, in which the state controlled or greatly restricted public access to information and dictated what could or could not be disseminated to the public through the press, film, radio, and the arts. Even in democratic societies, where law guarantees freedom of expression and the press, popular fears about mass manipulation by governmental and private public relations agencies, the media, and "spin doctors" are widespread. The renowned British essayist and novelist George Orwell once gave expression to these views: "All propaganda is lies, even when one is telling the truth."[1]

Defining the term *propaganda* has long been a challenge, and its meaning has changed over the course of time. The original Latin word referred to the biological reproduction of flora and fauna. But when the Catholic Church attempted to stem the rising tide of Protestantism during the Counter–Reformation in the sixteenth and seventeenth centuries, the Papacy coined the phrase *propaganda fide*, indicating the propagation of the faith. Gradually, the use of the word expanded from the religious to the political realm.[2] One of the leading scholars of Nazi propaganda, Aristotle A. Kallis, recently characterized propaganda as a form of mass communication and persuasion

Nazi SA-men hanging a campaign poster for Adolf Hitler's bid to be elected president of Germany, 1932. *BAK, Bild 146-1978-096-03*

developed in modern societies: "a systematic process of information management geared to promoting a particular goal and to guaranteeing a popular response as desired by the propagandist."[3]

The term *propaganda* as used in this book refers to the dissemination of information, whether truthful, partially truthful, or blatantly false, that aims to shape public opinion and behavior. Propaganda simplifies complicated issues or ideology for mass consumption, is always biased, and is geared to achieving a particular end. In contrast to the ideal of an educator, who aims to foster independent judgment and thinking, the practitioner of propaganda does not aim to encourage deliberation by presenting a variety of viewpoints and leaving it up to the audience to determine which perspective is correct. The propagandist transmits only information geared to strengthen his or her case and consciously omits contrary information. Propaganda generally uses symbols, whether in written, musical, cinematic, or other visual forms, and aims to channel complex human emotions toward a desired goal. It is often employed by governmental and private organizations to promote their causes and institutions and denigrate their opponents and is linked to both advertising and public relations. Propaganda functions as just one weapon in the arsenal of mass persuasion.

Propaganda, of course, is not always successful. Its effectiveness depends upon a variety of factors, including the receptivity of an audience to its message and a favorable social context. Propaganda, regardless of the skills of its users, cannot win wars or transform thoughtful human beings into mindless automatons. For instance, the Nazis could not turn back the tide of Allied victory after the middle of 1943 regardless of the power of their messages, and as German losses mounted, the Nazi propaganda machine's hopeful claims faced an increasingly skeptical audience. Propaganda delayed defeat, but it could not bring Germany victory.

WORLD WAR I AND THE PUBLIC DISCOVERY OF PROPAGANDA

Propaganda did not get widespread international public recognition as a tool of mass mobilization until World War I (1914–18). This watershed event also gave the term its negative connotations. All the major powers—the Central Powers (Austria-Hungary, Bulgaria, the German Empire, the Ottoman Empire) and their enemies, the Allies (Britain, France, Russia, Italy, the United States)—created propaganda agencies, sometimes bearing innocuous names such as the Committee on Public Information or the Ministry of Information. Their purpose was to rally the home front and the soldiery in support of the war, maintain or boost morale, weaken the enemy's will to fight, and win over public opinion in neutral countries. These newly founded institutions recruited or employed respected journalists, intellectuals and scholars, media moguls, advertising specialists, artists, filmmakers, and others to sell their governments' messages to the populace. In an era of "Total War," all the participating regimes, whether monarchies or democracies, realized that the successful prosecution of the war depended upon the masses of the home front at least tacitly supporting the aims of their governments and tolerating the characterization of the enemy as vile and barbaric. Propaganda was particularly crucial to ensure the continuous recruitment of new volunteers or conscripts for the armed forces.

Program from the Committee on Public Information, a U.S. government agency created to influence support for American involvement in World War I, 1917. The "4 Minute" refers to the length of the promoter's appeal during war bond drives. *LC, PPD*

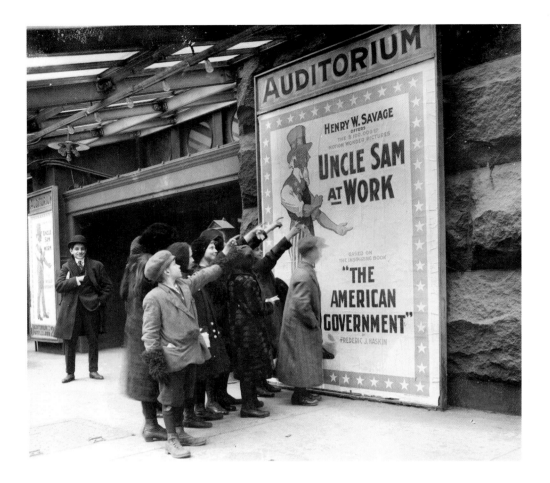

Youths in Chicago reading an advertisement for the film *Uncle Sam at Work*, February 20, 1915. *Chicago History Museum, N-0064184*

Poster of "Germania," by artist Friedrich August von Kaulbach, 1914. *DHM*

Discerning truth from half-truth and fabrication became difficult in an atmosphere characterized by government censorship and outright manipulation of the press. Psychoanalyst Sigmund Freud described this quandary in 1915, less than a year after the outbreak of hostilities: "Swept as we are into the vortex of this war-time, our information one-sided, ourselves too near to focus the mighty transformations which have already taken place or are beginning to take place, and without a glimmering of the inchoate future, we are incapable of apprehending the significance of the thronging impressions, and know not what value to attach to the judgments we form. . . . Science herself has lost her passionless impartiality; in their deep embitterment her servants seek for weapons from her with which to contribute towards the defeat of the enemy. The anthropologist is driven to declare the opponent inferior and degenerate; the psychiatrist to publish his diagnosis of the enemy's disease of mind or spirit."[4]

In the aftermath of World War I, which claimed the lives of more than ten million people, the sense of disillusionment and mass manipulation that Freud had felt emerged quickly in Europe and the United States. Journalists, intellectuals, politicians, and the public all came to recognize, and sometimes overestimate, the power of propaganda to shape or manipulate popular opinion and behavior. The issue of propaganda became a "problem" that generated heated debate on both sides of the Atlantic, and the study of propaganda produced several thousand works by 1935.[5]

The perceived power of propaganda during World War I generated fears among some commentators. American newspaperman Will Irwin worried that he and his contemporaries were living in "an age of lies."[6] Other critics saw in propaganda the

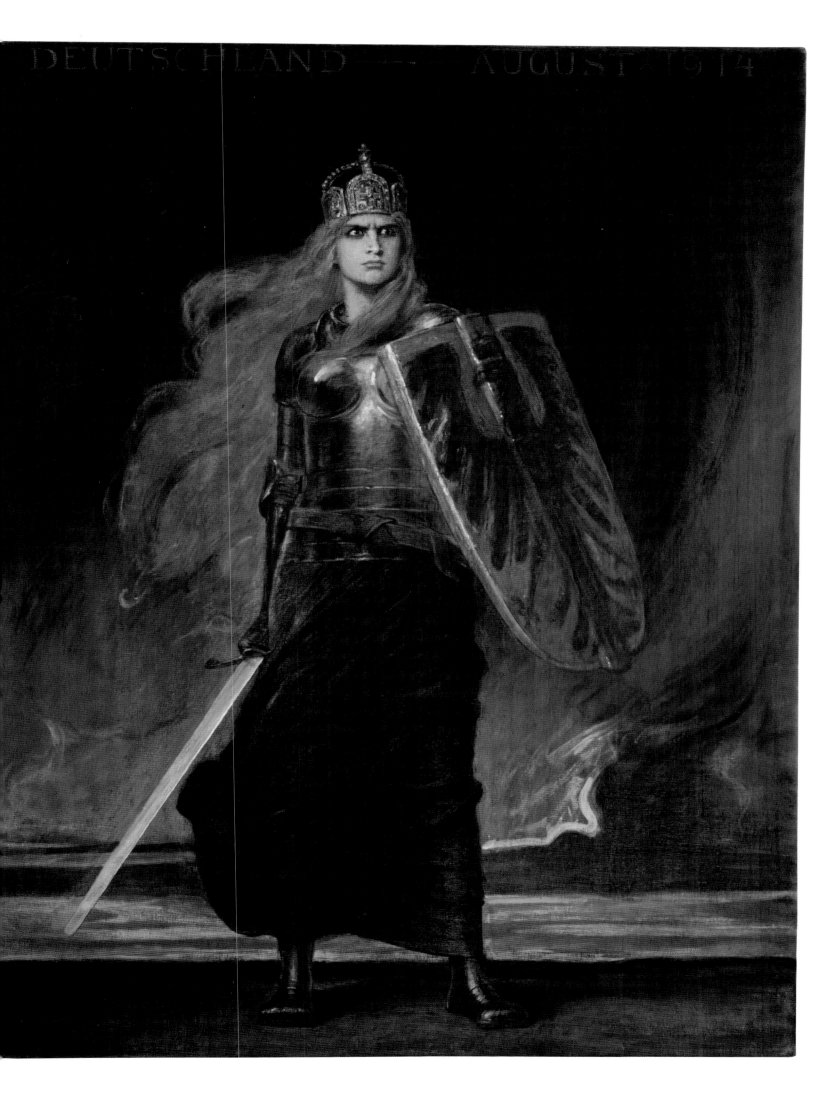

DEUTSCHLAND ——— AUGUST · 1914

ominous signs of the end of democracy. Because its "aim is to 'put something over' on people, with or without their knowledge or consent," propaganda would have far graver consequences and jeopardize democracy.[7] Still others perceived any effort to restrict propaganda as a curtailment of democratic freedoms of the speech and the press. "The cure for propaganda is more propaganda," liberal American journalist Bruce Bliven declared. In his view, readers should examine both sides of the issue, subscribe to multiple and opposing newspapers, and demand that schools and other public forums present all aspects of controversial questions. "The harmful and dangerous thing," he wrote, "is the suppression of all opinions save one, the exclusive control of these agencies by people who advocate a particular group of ideas."[8] It was not the presence of propaganda in society that was the key problem for Bliven and others but the absence of competing propaganda or opinions.

Still others, such as Edward L. Bernays—Freud's nephew, a former propagandist for the U.S. Committee on Public Information, and one of the fathers of public relations— held out the positive and progressive benefits of propaganda. He wrote in 1928: "The innovator, the leader, the special pleader for new ideas has through necessity developed a new technique—the psychology of public persuasion. Through the application of this new psychology he is able to bring about changes in public opinion that will make for the acceptance of new doctrines, beliefs, and habits."[9] While recognizing that public persuasion could be used for tyrannical purposes, its potential benefits, he argued, far outweighed its negative aspects. "Propaganda," he stated in 1935, "is the voice of the people in the democracy of today, because it gives everyone an opportunity to present his point of view." Bernays frowned upon demands to restrict this form of mass persuasion: "Freedom of propaganda is as important to our democracy as our other civil liberties—freedom of religion, press, speech, radio, and assembly. Propaganda provides an open forum for the people in which opposing ideas are presented for the judgment of the public. . . . Sound minority ideas would seldom have a public hearing without propaganda. New political, economic, industrial ideas would have slow growth or quick death without propaganda. . . . Women's suffrage, the effective battles against tuberculosis, and diabetes, were hastened by propaganda. So were the X-ray, the radio and the automobile."[10]

Popular fascination with propaganda, and concerns about it, expanded throughout the 1920s and 1930s. The memoirs of leading wartime propagandists and revelations about the Allied fabrication of "atrocity stories" about German wartime activities engendered suspicions of propaganda and fears of manipulation in the Western world.[11] Popular exposés and studies of World War I proclaimed that British propaganda and greedy industrialists and financiers, the so-called merchants of death, had pushed the United States into the conflict, leading to the unnecessary loss of American lives.[12] Critics also discussed the erosion of free speech and other civil liberties in wartime that prevented dissenting viewpoints from being heard.[13]

In the United States especially, there was a growing sense of skepticism and cynicism about public information in general. Propaganda was everywhere, and everything was propaganda.[14] The rapid spread of modern communications technology, such as radio and motion pictures, conveyed both promise and danger—the dream that the world's nations would grow closer competed with the foreboding that these media could be used to spread propaganda to unsuspecting audiences.[15] The same way

Poster, by artist Ellsworth Young, depicting the propagandistic use of alleged atrocities committed by German soldiers in Belgium, 1917. *LC, PPD*

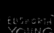

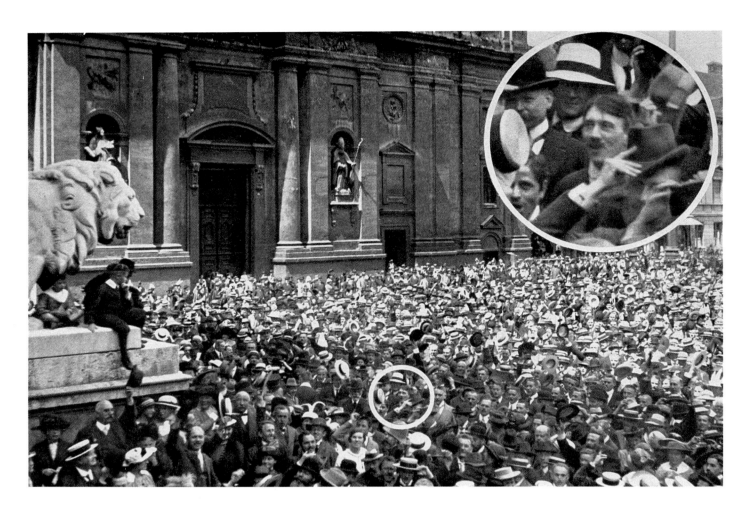

Adolf Hitler at a rally in Munich to celebrate the declaration of war, August 2, 1914. *USHMM, gift of Debra Gierach*

OPPOSITE: Poster advertising the 13th Great German Radio Exhibition, Berlin, 1936. *LC, PPD*

that Americans had feared aerial bombardment during World War I, some Europeans and Americans worried that radio transmissions from "enemy" broadcasting stations could pass through the ether and penetrate homes and offices thousands of miles away, sowing dissension and mayhem. The mass panic and hysteria created in 1938 by Orson Welles's dramatic broadcast of *The War of the Worlds* drew international attention to the immense power and influence of radio, particularly because it occurred during a time of heightened tensions in Europe over Hitler's territorial demands against Czechoslovakia.[16] Coupled with these technological advances were the expanding roles in society and the economy of advertising, social psychology, and public opinion research. The capitalist drive to mass-market and to create demand for consumer goods began in the nineteenth century but rapidly expanded in the twentieth. Not surprisingly, a number of former World War I propagandists, including Bernays, went on to enter the fields of advertising and public relations, transforming them through cleverly crafted campaigns and strategies.[17]

World War I also dramatically influenced the field of mass psychology. The pioneering work of conservative French scholar Gustave Le Bon in 1885 on the psychology of crowd behavior paved the way for the analyses of Freud and later figures.[18] But the war and its ensuing political turmoil heightened fear of the masses and concerns about propaganda and underscored the perceived need to control crowd behavior. Influenced by Social Darwinism, sociologists Wilfred Trotter and I. W. Howerth saw in the actions of the belligerent nations the "herd instinct" at work—

RIEMER

28. AUG. – 6. SEPT.

13. Große Deutsche
Rundfunkausstellung
und Volksender
Berlin 1936

people, like animals, would unite against a common threat, be highly susceptible to suggestion, and be controlled by their leaders. "Because of the stupidity, passion, and consequent danger of crowds," Howerth wrote, "every nation should endeavor through education to fortify its citizens against the contagion of the crowd spirit, and those in authority should do everything possible to prevent the formation of crowds."[19]

Another related development that shaped modern propaganda was the growing interest of governments, politicians, advertisers, journalists, and others in scientifically assessing public opinion. Certainly, the notion of finding out what the populace was thinking was not a twentieth-century phenomenon. Spying and gathering public opinion through surveillance had been around for centuries and did not disappear when new methods appeared. In dictatorships and authoritarian regimes, surveillance was the technique of choice for both governments and their underground opponents. In the 1930s, Americans George Gallup and Elmo Roper pioneered a new form of public-opinion-gathering polls, which dramatically affected electioneering and politics in democratic societies. By giving a voice to the public, polls have guided political parties in their selection of candidates and their campaign strategies and have influenced political leaders' development of policies and votes on proposed legislation.

NAZI PROPAGANDA

Although World War I and the public discussion that followed it first transformed propaganda into a pejorative term, the Nazi use of mass persuasion techniques—to gain popular support and political power, establish a one-party dictatorship, plunge the globe into war, and help create the climate for the persecution and mass murder of Europe's Jews and other victims—further cemented the notion of propaganda as an insidious form of communication. Today, Adolf Hitler and the Nazi regime continue to represent the evil power and perils of propaganda. Since the 1930s, Nazi propaganda has been the subject of many books, articles, films, and exhibitions.[20] German filmmaker Leni Riefenstahl and Hitler's personal photographer Heinrich Hoffmann were the subjects of shows highlighting their contributions to the creation of Nazi myths.[21]

This book begins with an examination of the Nazis' sophisticated use of propaganda during the Weimar Republic (1918–1933), when the fledgling Nazi Party succeeded in winning millions of adherents in a few short years and in competition with dozens of political parties. The second chapter looks at the Nazis' use of propaganda, in combination with terror, to consolidate power during the early years of the new regime (1933–1939). The next chapter focuses on the war years (1939–1945) and the Nazi use of propaganda to build and maintain popular support for or acquiescence to the war and to facilitate mass murder. This chapter shows the lengths to which the Nazis went to craft propaganda messages that succeeded in encouraging millions of Germans and other Europeans to ignore many of the horrific crimes committed by the regime and its allies. Nazi propaganda was meant not only to inculcate hatred in masses of the population and incite true believers and "ordinary men" to carry out brutal atrocities and genocide, but also to foster a climate of indifference toward the sufferings of neighbors, former friends, and other peoples. The last chapter addresses the issue of Nazi propaganda in the post–World War II era, when the victorious Allies pledged to

eradicate militarism and Nazism from German soil. In the service of reeducation and denazification, they confiscated or destroyed countless Nazi works, criminalized Nazi propaganda, and tried propagandists for the first time in history. The trials of Nazi propagandists at Nuremberg established legal precedents for prosecuting individuals for the international crime of publicly inciting genocide. Today, the specter of Nazi propaganda continues to inform the ways in which the public and the legal community address the issue of hate speech. Most recently, the United Nations International Criminal Tribunal for Rwanda, which tried and sentenced propagandists linked to the 1994 genocide in that Central African country, cited as precedents the crimes of Nazi propagandists.

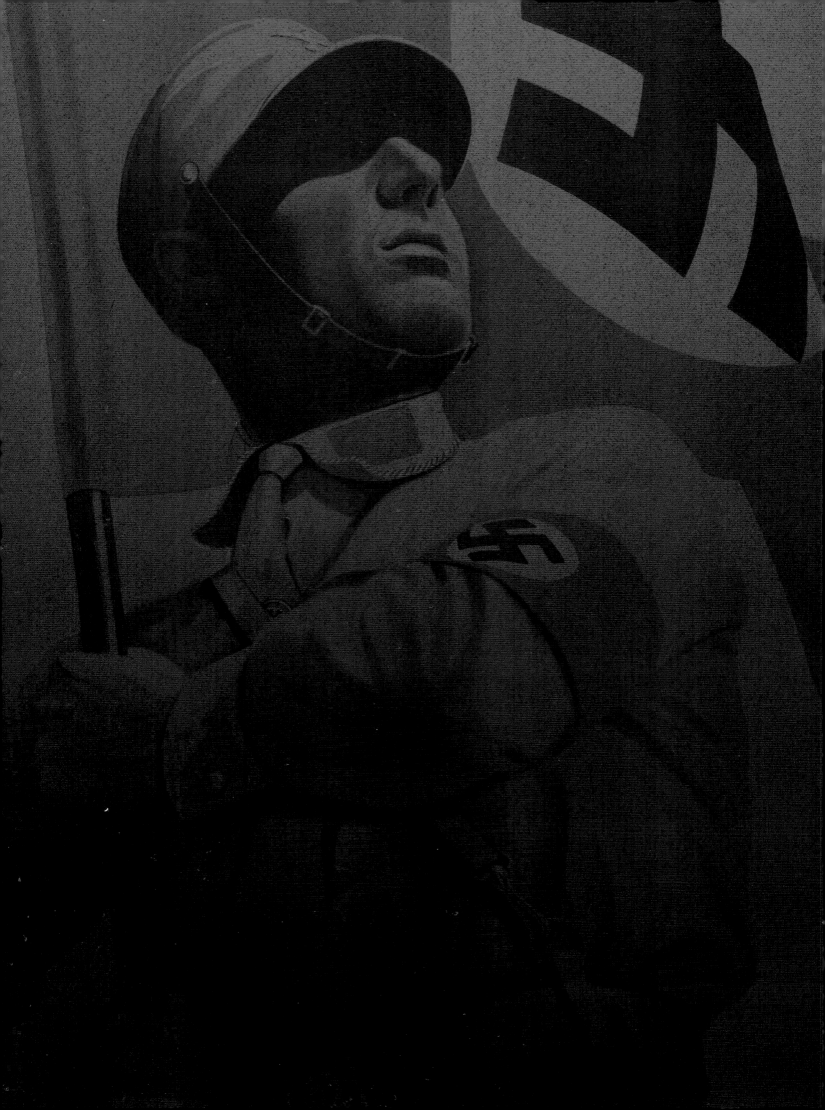

PROPAGANDA FOR VOTES AND POWER

The development of a sophisticated propaganda organization, techniques, and messaging helped the Nazi Party—a small regional organization at its birth in 1919 and one of many small, right-wing, antidemocratic groups—to become by the middle of 1932 the most popular political party in Germany. The beginning of the Great Depression in 1929 and ensuing political instability provided a rich seedbed for radical ideas and solutions. Support for the Nazi Party grew at a meteoric rate between the national elections of September 1928 and July 1932, permitting it to supplant the Social Democratic Party as the largest party in the Reichstag (parliament). Exploiting popular discontent with the older political parties for their failure to provide solutions to the nation's economic and social problems, the Nazi Party under the leadership of Adolf Hitler was able far more effectively than its rivals to craft attractive messages that had broad appeal across diverse segments of the German population. The party also used innovative ways of directly reaching far larger numbers of the public in its campaigns and developed grassroots networks that allowed it to continually incorporate audience feedback about its propaganda.

THE MAKING OF A PROPAGANDIST

The Nazi appreciation of the value of propaganda began in September 1919, when a disgruntled war veteran, Adolf Hitler, entered the new party's ranks. Far more than anyone else, Hitler dictated the early course of the Nazi Party and laid the foundation for its propaganda apparatus. Neither university educated nor a journalist by profession, Hitler developed his ideas about propaganda from personal experience, including his days as a schoolboy in Linz, Austria, when he was first enthralled by ancient German myths and German theater, especially the operas of Richard Wagner. The intense emotional power of myth in those operas, coupled with dramatic music, staging, and lighting, appealed to Hitler, and he later incorporated many of these theatrical elements into the political events, rallies, and meetings that he staged at Nuremberg and elsewhere. Wagner's music reinforced for Hitler the notion that long–forgotten epochs in history could be made useful for the present.[1]

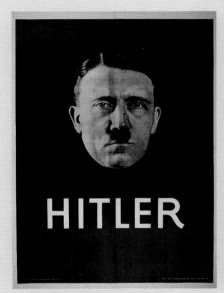

Election poster with photo by Heinrich Hoffmann, 1932. *USHMM*

OPPOSITE: From a poster advertising the film *S.A. Mann Brand* (SA-Man Brand), directed by Franz Seltz, 1933. *Kunstbibliothek Berlin/BPK, Berlin/Art Resource, New York*

First exposed to mass political movements during the years he lived as a struggling artist in Vienna, from 1907 to 1913, Hitler drew inspiration from two popular antisemitic politicians, Karl Lueger, Vienna's Christian Social mayor, and Georg Ritter von Schönerer, leader of the Austrian Pan-German Party that advocated the union under German rule of all German-speaking peoples in Central Europe. The Nazi Party would later adopt tools of political indoctrination and mobilization that these two Austrian politicians used to attain support. These tools included the cult of the leader—von Schönerer's portrait adorned shop windows, and followers referred to him as Führer (leader) and used the "Heil" (hail) greeting—and the distribution of party newspapers to taverns.[2] Lueger effectively employed mass meetings, marked by militaristic and quasi-religious trappings, and his Christian Social Party extended its reach by creating affiliated groups for women, teachers, and youth. He denounced the press as a tool of Jewish influence, and his city government distributed antisemitic children's books to schools. The two Austrian politicians' use of violence and fear to intimidate political opponents and Jews also provided a model for the future Nazi leader.[3]

The other prototype for a successful popular movement came from the Left. Hitler observed the tactics of the powerful Social Democratic parties, which enjoyed mass support in Austria-Hungary and in Germany. In his book *Mein Kampf*, written in 1924, Hitler begrudgingly admired the Socialists' "astounding" skills in mobilizing large segments of the population—the mass festivals, meetings, demonstrations, and parades designed to raise worker pride, impress bystanders, and intimidate foes. He also noted the use of violence to terrorize political rivals.[4] Hitler came to believe that "to destroy Marxism," the Nazi Party would have to create a propaganda machine and its own terror organization, the SA (Sturmabteilung), or storm troopers; in other words, he would use the very weapons of the Marxist parties in the political struggle against them.[5]

Above all, World War I (1914–18) shaped Adolf Hitler's views on propaganda. In *Mein Kampf*, Hitler praised the skill of the enemy propagandists. He felt that U.S. and British propagandists had succeeded, whereas Germany's had not, by following a few essential guidelines: content was emotional and simple, presenting a case in black and white; it concentrated on repeatedly making a few points, albeit in different forms; and it focused on one enemy. Hitler also admired the Allies' skillful demonizing of the Germans as fearsome invaders who threatened to destroy civilization: "By representing the Germans to their own people as bloodthirsty barbarians and Huns, they prepared the individual soldier for the terrors of war . . . [and] increased his rage and hatred against the vile enemy."[6] Hitler believed that, in contrast, German and Austrian propaganda tried to make the enemy look ridiculous rather than terrifying and that this strategy had harmful consequences for the frontline soldiers. "Actual contact with an enemy soldier was bound to arouse an entirely different conviction, and . . . the German soldier . . . felt himself swindled by his propaganda service. His desire to fight, or even to stand firm, was not strengthened, but the opposite occurred. His courage flagged."[7]

Certainly, to the Western mind, the term *Hun* conjured up images of the "barbarian hordes" that emerged out of Central Asia to threaten Christianity and civilization during the late Roman Empire. The image of the Hun starkly evoked the imperative

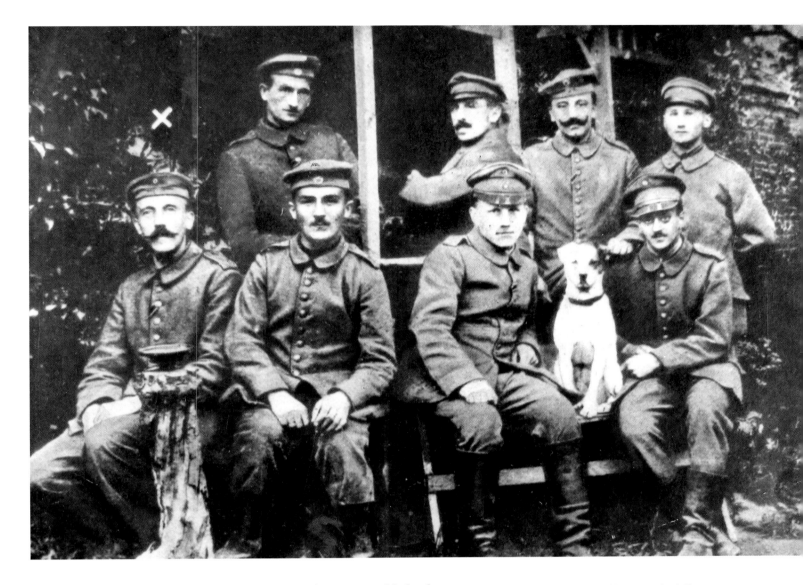

Adolf Hitler (*front row, far left*) served on the Western Front and was twice decorated for service, injured, and temporarily blinded in a mustard-gas attack. He used his veteran status in later election campaigns. *NARA*

to defend the nation from invasion, barbarism, and tyranny and helped maintain popular support in the protracted conflict by implying that the war was morally justifiable. Lending credence to the depictions of the Germans as Huns were the atrocity stories widely disseminated in the press, by official statements, and through rumors as well as by vivid posters, cartoons, and films. Numerous genuine crimes were committed against civilian populations in Belgium by German troops, by Russians against ethnic Germans and Jews, and by Ottoman soldiers against Armenians. But claims of German brutalities—many of them unsubstantiated—probably did more to help demonize the enemy and portray the war as a morally righteous crusade than anything else in the Allies' propaganda arsenal. Within weeks of the August 4, 1914, invasion of Belgium, reports of German atrocities against the populace began appearing in the Allied and neutral press. More responsible newspapers, including the *New York Times*, questioned the veracity of these stories, but their reports did not seem to matter. Tales about Germans cutting off the hands of a Belgian girl or the thumbs and fingers of Belgian Red Cross nurses took hold in the popular mind.[8] Film, theater, and the press helped keep the stories alive.[9] Atrocity stories no doubt made it easier for soldiers to rationalize the death of opponents as belated justice to those who

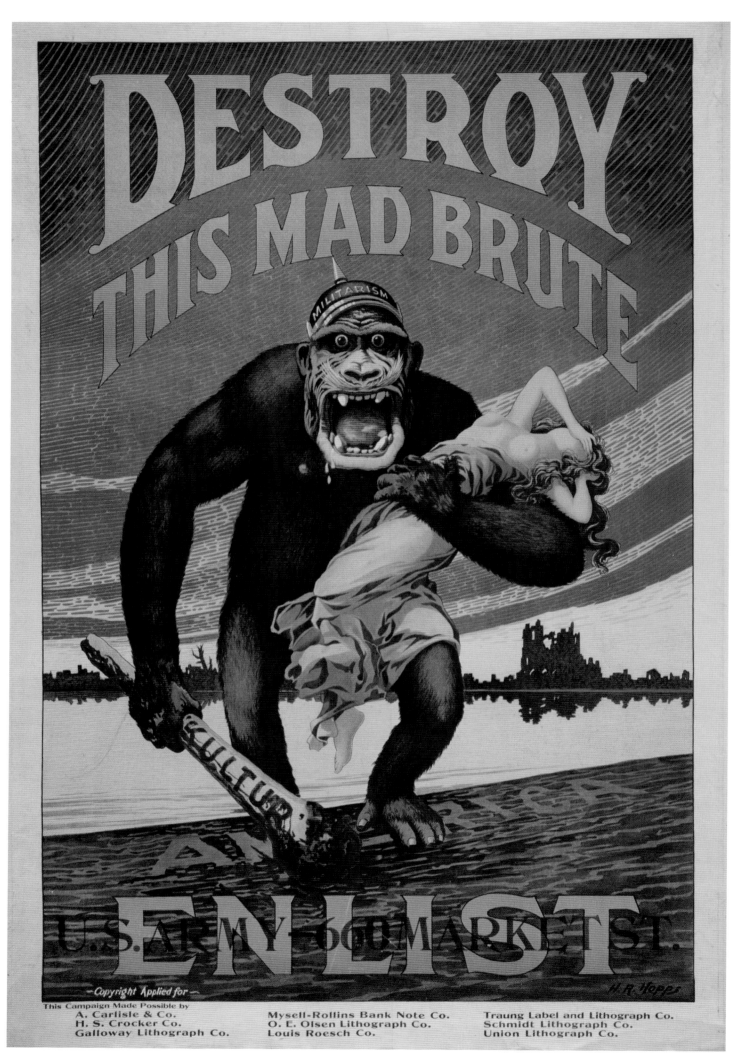

Enlistment poster, by artist H. R. Hopps, 1917. *Harry Ransom Humanities Research Center, The University of Texas at Austin*

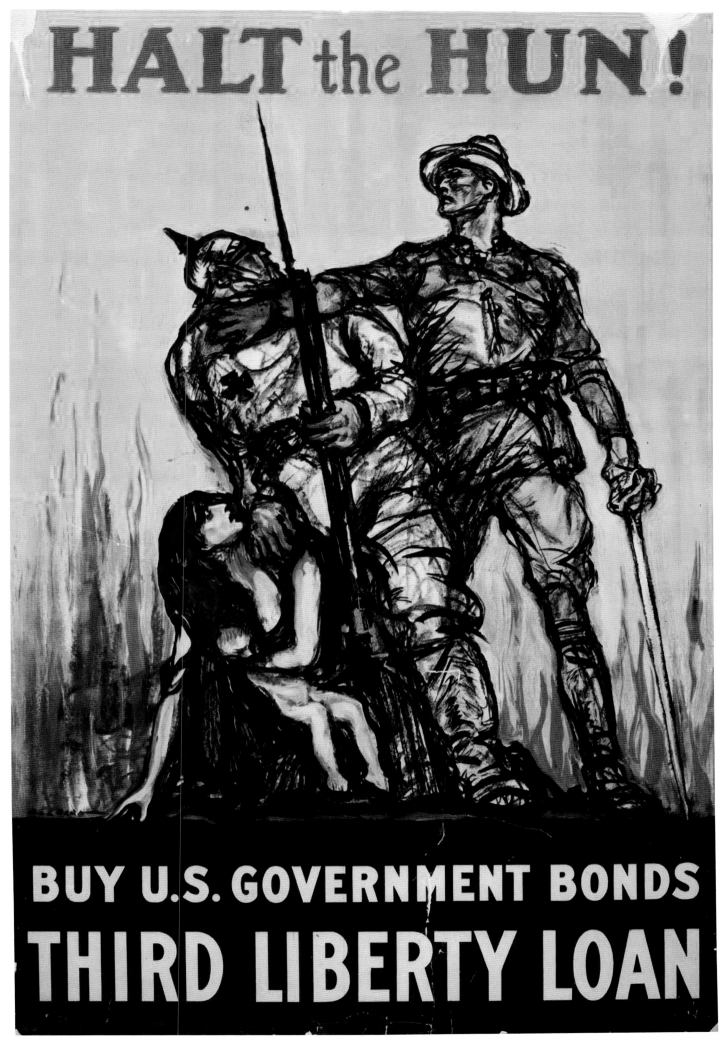

Poster for U.S. war bond drive, by artist Henry Raleigh, 1918. The image of the German as Hun was common in Allied propaganda during World War I. *LC, PPD*

WORLD WAR I AND THE BIRTH OF MODERN PROPAGANDA

World War I helped give birth to modern propaganda. If the term *propaganda* rarely appeared before 1914 in encyclopedias and dictionaries, by 1918 newly published works devoted long entries to the concept.[10] Army officers, politicians, and intellectuals came to see propaganda as an essential component of modern military warfare. World War I ushered in killing on a massive scale with the use of new weaponry, such as tanks, submarines, aircraft, machine guns, artillery and railway guns, and poison gas. The protracted nature of the war, requiring the mobilization of between sixty million and seventy million soldiers from five continents and unprecedented military losses (2 million German, 1.1 million Austro-Hungarian, 1.4 million French, and nearly 900,000 British soldiers killed) meant that propagandists had to continually appeal to the populace to recruit more men for the armed forces and to convince their nations that the war needed to be fought until victory.

Though government-sponsored propaganda was not directly responsible for the outbreak of war in August 1914, the nationalist rhetoric and publications of the prewar era helped create an explosive environment in Europe. When war broke out, official propaganda—the war of words— quickly became an important factor in keeping the conflict going and soon gained support from the private propaganda efforts of political parties, patriotic societies, and others. Mass media became a "weapon of warfare."[11] By 1914, new media technology could speedily transmit news across the Atlantic via undersea cables or wireless radio and create newsreels and silent motion pictures for mass distribution. American press associations, such as the Associated Press, the United Press, and the International News Service joined Great Britain's Reuters, France's Havas, and Germany's Wolff Telegraphic Agency in covering worldwide events.[12] Understanding the importance of global communications, governments invested heavily in the new technology, especially radio, and understood its potential military significance—for example, its usefulness in locating U-boats and other ships.[13]

Each of the belligerent governments created an official propaganda agency to sell its messages to its own population, to the enemy, and to neutral countries. In Germany, the military was placed in charge of government propaganda, whereas in other countries, this function was handled largely by civilians. The British government enlisted celebrated writers such as Arthur Conan Doyle, Rudyard Kipling, Joseph Conrad, H. G. Wells, and J. M. Barrie to promote the Allied cause to the world.[14] President Woodrow Wilson chose former muckraking journalist George Creel to head the propaganda agency in the United States, the Committee on Public Information.[15] In addition, nonofficial, largely uncontrolled propaganda created by individual writers, artists, and illustrators of newspapers, posters, and books played a vital role in mobilizing public opinion behind the war effort, as did messages conveyed by schoolteachers to their pupils and by religious leaders to their congregations.[16] In combination with simple appeals, such as the British poster captioned "Daddy, what did *you* do in the Great War?" governments used another dimension of propaganda—censorship and subterfuge—to hide the truth from the populace, including the extent of casualties.[17]

British recruitment poster, 1915. *LC, PPD*

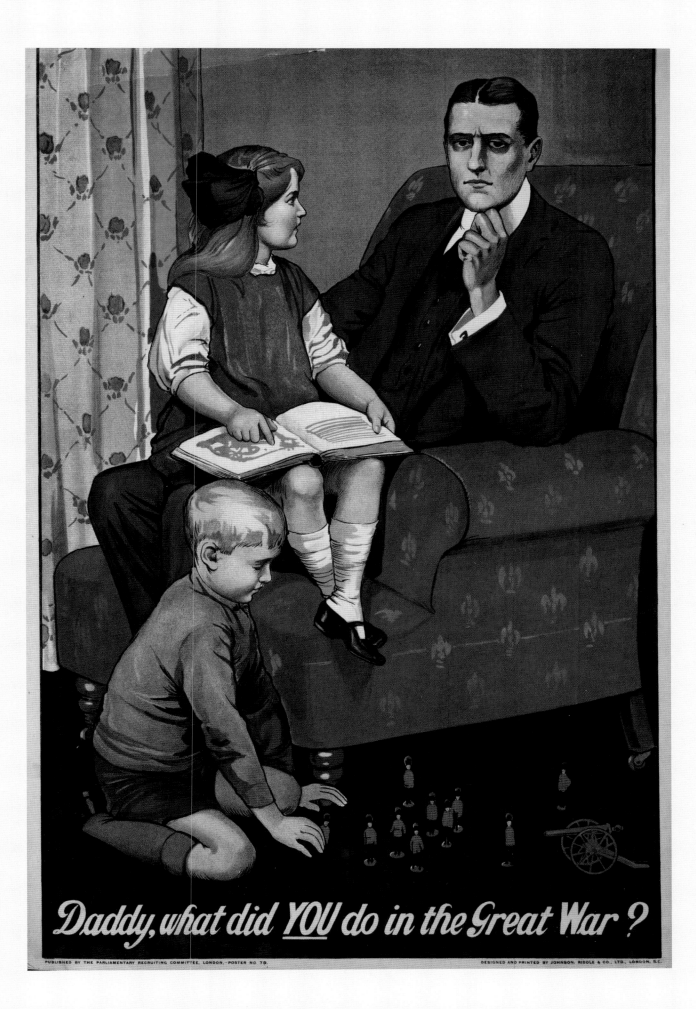

Daddy, what did _YOU_ do in the Great War?

PUBLISHED BY THE PARLIAMENTARY RECRUITING COMMITTEE, LONDON.—POSTER NO. 79. DESIGNED AND PRINTED BY JOHNSON, RIDDLE & CO., LTD., LONDON, S.E.

TELL THAT TO THE MARINES!
AT 24 EAST 23rd STREET

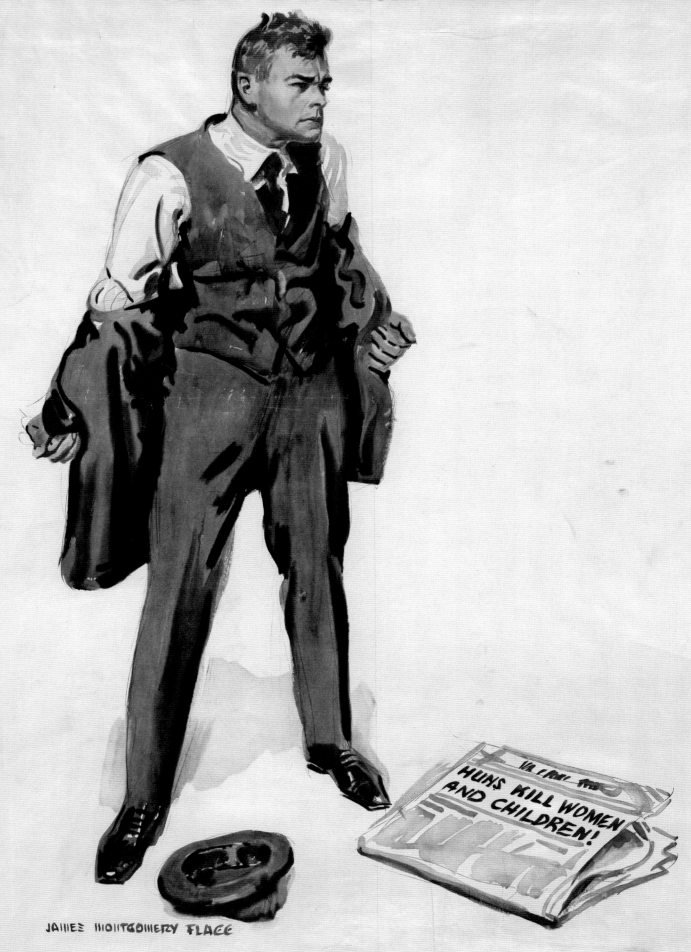

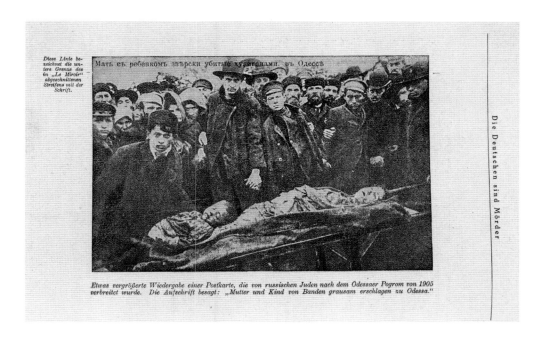

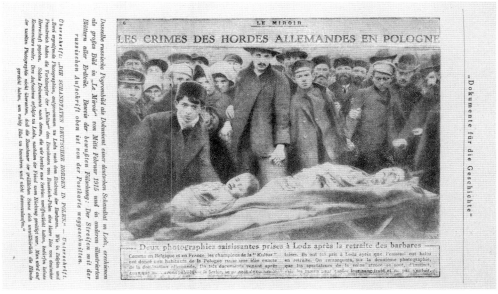

In the book *Die Mache im Weltwahn* (Sham in World Delusion), published in 1922, German art critic Ferdinand Avenarius demonstrated that French propagandists had recaptioned a photograph of Jewish victims of a prewar Russian pogrom (*above*) to read "The Crimes of the German Hordes in Poland" (*below*). *USHMM*

committed such wanton crimes. Just as importantly, they helped enlist new recruits.[18] In one of several studies of propaganda published in Germany after the war, German poet and art educator Ferdinand Avenarius, analyzing the "atrocity stories," exposed how French propagandists falsified photographs by changing captions and doctoring images of Russian pogroms against Jews to portray them as German atrocities.[19] The manipulation of photo captions and images later became a standard tool of the Nazis after they took power and during World War II and was a tactic also used during the war by the Allies fighting Germany.

Defeat in the war and the signing of the armistice on November 11, 1918, came as a great shock to many Germans. Equally traumatic were the abdication of the kaiser and the proclamation of a republic by the Social Democratic Party. In reality, even before the declared end of the war, the success of the Allied push in July 1918 had convinced many German officers that the military could not win the war. But as late as October of

OPPOSITE: Poster by artist James Montgomery Flagg, 1918. The newspaper headline demonizes Germany and uses the story of alleged German atrocities to boost enlistments in the U.S. Marine Corps. *LC, PPD*

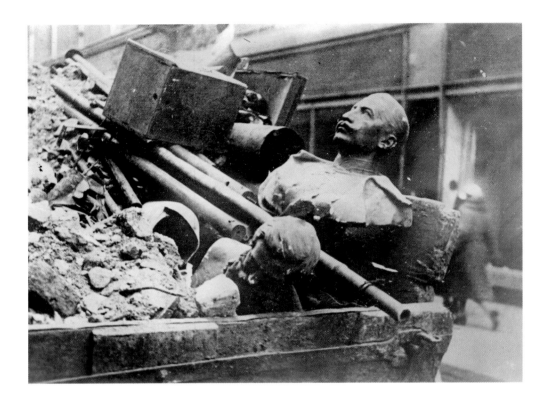

Discarded bust of Emperor Wilhelm II, Cologne, 1918. On November 9, 1918, revolutionaries overthrew the imperial regime, forcing the emperor into exile and proclaiming a democratic republic. For the Nazis and other right-wing nationalists, this event further proved that Germany had been "stabbed in the back" by internal enemies. *SVT Bild*

OPPOSITE: This German Nationalist People's Party election poster by artist Hans Schweitzer reminds voters of the "stab in the back," widely believed to have been a cause of Germany's defeat in World War I, November 1924. *BAK, Plak 002-029-031*

that year, some military leaders were still publicly promising victory. German troops occupied territory from Finland and the Ukraine to Belgium and northern France, and no Allied soldiers stood on German soil. Hitler later recalled that he heard news of the defeat while recuperating in a military hospital after being blinded in a gas attack in Belgium in 1918. In *Mein Kampf*, he characterized Germany's capitulation as "the greatest villainy of the century" and attributed to that act his decision to enter politics.[20]

The shame of defeat and the Versailles Treaty (1919)—which stipulated that Germany was to cede Alsace-Lorraine, Danzig, other territories, and all its overseas colonies; pay reparations; and have Allied troops occupy the Rhineland, among other terms—led to a wide reaction against the agreement in Germany. Hitler and other members of right-wing nationalist parties and organizations, invoking the humiliation of Versailles and rejecting the Weimar Republic, developed the myth that Germany's internal enemies—Social Democrats, liberals, pacifists, and Jews—had "stabbed the country in the back" just as Germany was on the verge of military victory. The political polarization that marked the Weimar era had emerged during the war, as the national unity that brought Germans together in August 1914 to support the Fatherland fractured during the prolonged conflict. In 1916, growing numbers of socialists in the Reichstag voted against military appropriations, pacifist groups stepped up calls to end the war, and demonstrations took place protesting the mass starvation resulting from an Allied blockade. Looking for a convenient scapegoat, right-wing politicians charged that Jews were shirking their military duty; rather than deflecting the scurrilous claim (12,000 Jews were to die at the front), the German military decided to take a census of Jewish soldiers. The results were not published during the war, allowing the accusation to fester, further fanning the flames of antisemitism.[21]

Wer hat im **Weltkrieg** dem deutschen Heere den Dolchstoß versetzt? Wer ist schuld daran, daß unser Volk und Vaterland so tief ins Unglück sinken mußte? Der Parteisekretär der Sozialdemokraten **Vater** sagt es nach der Revolution 1918 in Magdeburg:

"**Wir** haben unsere Leute, die an die Front gingen, zur Fahnenflucht veranlaßt. Die Fahnenflüchtigen haben wir organisiert, mit falschen Papieren ausgestattet, mit Geld und unterschriftslosen Flugblättern versehen. **Wir** haben diese Leute nach allen Himmelsrichtungen, hauptsächlich wieder an die Front geschickt, damit sie die Frontsoldaten bearbeiten und die Front zermürben sollten. Diese haben die Soldaten bestimmt, überzulaufen, und so hat sich der Verfall allmählich, aber sicher vollzogen."

Wer hat die **Sozialdemokratie** hierbei **unterstützt?** Die Demokraten und die Leute um **Erzberger.** Jetzt, am 7. Dezember, soll das Deutsche Volk den

zweiten Dolchstoß

erhalten. **Sozialdemokraten** in Gemeinschaft mit den **Demokraten** wollen uns

zu Sklaven der Entente machen,

wollen uns für immer zugrunde richten.

Wollt ihr das nicht,
dann
Wählt deutschnational!

2877

Nr. 306 Deutschnationale Schriftenvertriebsstelle G.m.b.H., Berlin SW11 Ⓟ Presse: Dr. Selle & Co. A.G., Berlin SW29

CONFLICTING MEMORIES AND REPRESENTATIONS OF THE WAR

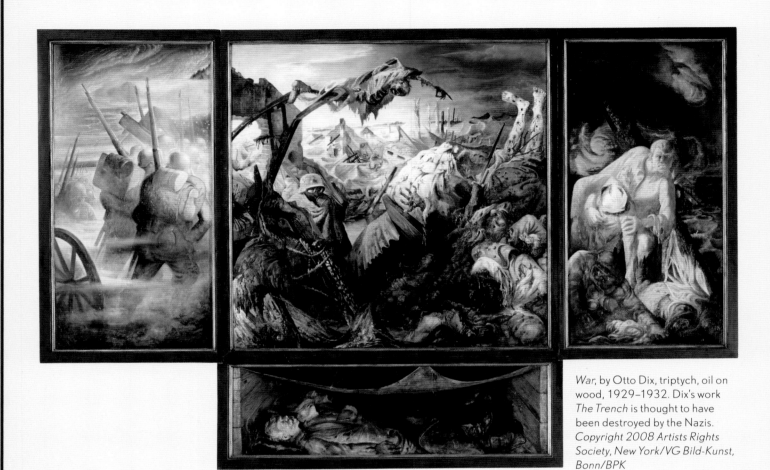

War, by Otto Dix, triptych, oil on wood, 1929–1932. Dix's work *The Trench* is thought to have been destroyed by the Nazis. *Copyright 2008 Artists Rights Society, New York/VG Bild-Kunst, Bonn/BPK*

During the Weimar years, reaching national consensus on the war and the new republic proved impossible. In 1924, on the tenth anniversary of the outbreak of the war, pacifists and militarists battled for control over national memory. A ceremony conducted by Social Democratic president Friedrich Ebert to unveil the new national memorial to the war dead quickly degenerated into a daylong riot between prowar and antiwar activists.[22] Pacifist Ernst Friedrich's powerful collection of censored wartime photographs and medical images of disfigured German soldiers, *Krieg dem Kriege!* (War against War), went through ten editions in six years and was translated into more than forty languages, but it earned him and his International Antiwar Museum in Berlin the hatred of right-wing nationalists. Those graphic depictions of mutilations, massive injuries, and atrocities shocked readers and visitors to the museum and led some veterans' organizations and newspapers to demand the destruction of the book and Friedrich's expulsion. In the war over the war, right-wing nationalists published their own photographic albums of the fighting, glorifying the heroism of the soldiers, the virtues of manliness, and "romantic, redemptive death."[23]

The battle over memory also shaped discussions of modern German art and film. Throughout the 1920s and early 1930s, artistic representations of the war often triggered heated argument, controversy, and scandal. In 1923–24, *The Trench*, a painting by former frontline soldier Otto Dix depicting the grisly aftermath of an Allied artillery attack on a German position, was praised by modern art critics and other artists but viciously attacked by conservatives and others. It was denounced as "propaganda" that only portrayed war as mass murder and an insult to those who died on the "altar of the Fatherland." As a result of the right-wing outcry, it was removed in January 1925 from the Wallraf-Richartz Museum in Cologne and returned to Dix's art dealer. The Dresden state art collection subsequently acquired it, but *The Trench* was not displayed again until the Nazis made it an object of ridicule in the "Degenerate Art" exhibition they mounted in 1937.[24]

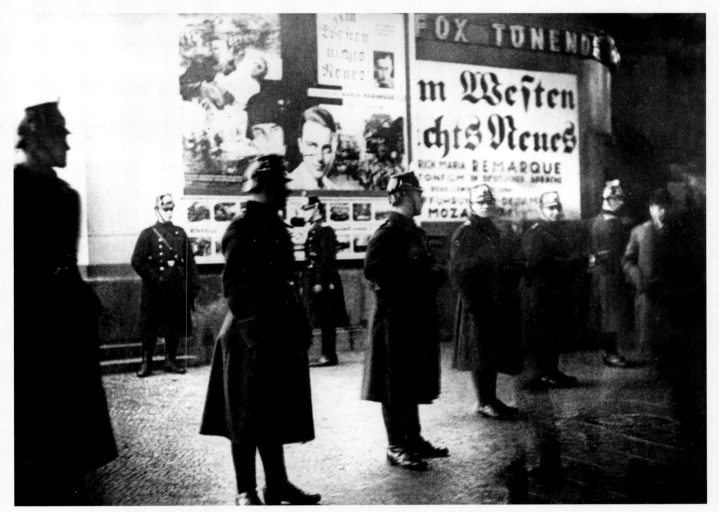

Police protection for the Berlin premier of *All Quiet on the Western Front*, December 9, 1930. *SZ Photo/Scherl*

The battle over the war's memory continued until the end of the Weimar Republic with the publication of Erich Maria Remarque's novel *All Quiet on the Western Front* (1929). A former frontline soldier himself, Remarque became a best-selling author with his first major work of fiction, but he was continuously attacked by ardent right-wing nationalists because his book suggested that the German military—and not a "stab in the back"—had lost the war. When the Hollywood version of his novel appeared in Germany in late 1930, the Nazis launched a campaign to shut it down, releasing mice and stink bombs at the opening and shouting insults during the showing. Ultimately, German authorities banned the movie as harmful to Germany's reputation.[25]

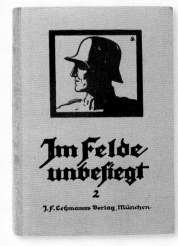
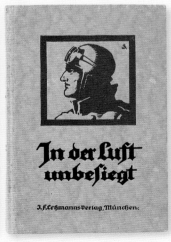
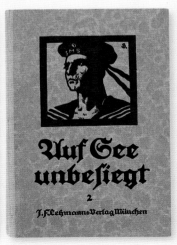

These books by Georg Paul Neumann, published in 1923, promoted the myth that German forces had been undefeated on the battlefield: *Im Felde unbesiegt* (Undefeated in the Field), *In der Luft unbesiegt* (Undefeated in the Air), and *Auf See unbesiegt* (Undefeated at Sea). *USHMM, the Abraham and Ruth Goldfarb Family Acquisition Fund*

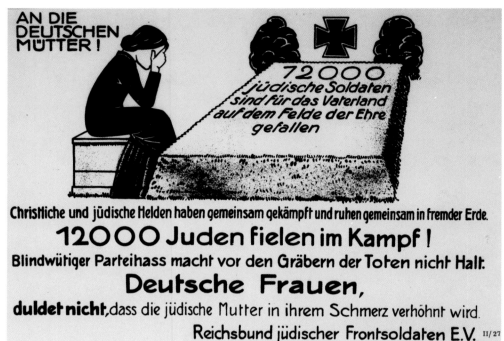

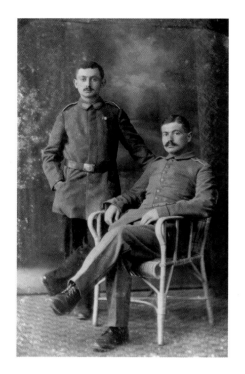

Although Hitler believed in "the stab in the back" myth, he also perceived that Allied propaganda, in the form of leaflets dropped from the air to soldiers in the trenches on the Western Front, had sapped Germans' will to fight: "With the year 1915 enemy propaganda began in our country, after 1916 it became more and more intensive, till finally, at the beginning of the year 1918, it swelled to a positive flood. . . . The army gradually learned to think as the enemy wanted it to."[26] German military leader Erich Ludendorff expressed similar sentiments, describing how the British blockade and resulting suffering created fertile ground for Allied propaganda, including pacifist and revolutionary ideas "preached" to German workers and military men by adherents to Russian Bolshevism. After the Bolshevik Party, led by Vladimir Ilyich Lenin, took power in November 1917, the new Soviet Communist regime negotiated peace with the Germans.[27] Hoping for national recovery from defeat, another German writer described propaganda as "the weapon by which we were defeated, the weapon that has been left to us, the weapon that will help us to rise once more."[28]

THE ROLE OF PROPAGANDA IN NAZI STRATEGY

When Adolf Hitler joined the German Workers Party in September 1919, it had only been in existence since January and had merely a few dozen members. Within weeks, Hitler helped expand the party's membership base and reach. He encouraged party leaders to take out advertisements in local newspapers and distribute leaflets promoting meetings. In doing so, Hitler likely drew on his earlier observations of mass mobilization in Vienna, where he also gained useful experience in a part-time job designing posters and advertisements for shopkeepers.[29] By early 1920, Hitler's skills in promotion and his appeal as a speaker had earned him the position of director of party propaganda. On February 24, 1920, he organized the party's first mass meeting, in Munich's famed Hofbräuhaus, where leaders renamed the party the

Leaflets dropped by Allies behind German lines during World War I, including one (*top*) warning German soldiers that more than 1.9 million U.S. soldiers were in France and more than ten times that number were standing ready to come. *NARA*

The Nazi Party's 25-point program, published on February 24, 1920, remained the party's official statement of goals until the party's demise in 1945. *USHMM, gift of Patrick Gleason*

THE GOALS OF THE NATIONAL SOCIALISTS

FROM THE PROGRAM OF THE NSDAP

1. We demand the union of all Germans, on the basis of the right of national self-determination, in a Greater Germany.

2. We demand the equality of rights for the German people vis-à-vis other nations and the abrogation of the peace treaties of Versailles and St. Germain.

◆ ◆ ◆

4. Only a national comrade can be a citizen. Only someone of German blood, regardless of faith, can be a citizen. Therefore, no Jew can be a citizen.

5. Whoever is not a citizen shall be able to live only as a guest in Germany and must be subject to legislation for foreigners.

◆ ◆ ◆

8. All further immigration of non-Germans is to be prevented. We demand that all non-Germans who have immigrated to Germany since August 2, 1914, be forced to leave the Reich immediately.

◆ ◆ ◆

23. We demand legal recourse against malicious political lies and their dissemination in the press. In order to facilitate the creation of a German press, we demand that

 a. All editors and employees of German-language newspapers must be racial comrades.

 b. Non-German newspapers must have the express permission of the State to be published. They may not be printed in the German language.

 c. Any financial interest in German newspapers or influence upon them by non-Germans is to be prohibited by law, and we demand as penalty for transgressions the closing of such newspaper enterprises as well as the immediate expulsion from the Reich of the implicated non-Germans.

 Newspapers that offend the common good are to be banned. We demand the legal prosecution of any artistic or literary tendency that exerts a disruptive influence upon our national life and the closing of institutions that violate the aforementioned requirements.

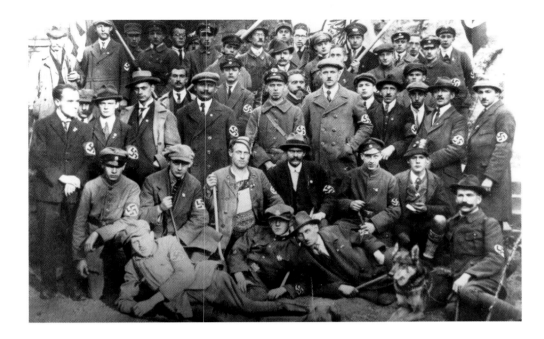

Nationalist Socialist German Worker's Party (Nazi Party) and presented the Twenty–Five Point Program. "Catchy advertising" developed by Hitler helped bring in two thousand people.[30] Although he was not the keynote speaker, Hitler, standing on a table to be seen, delivered an emotional speech that roused the crowd. His reputation as a political orator grew as he spoke that year at more than thirty mass meetings and many smaller ones. In early 1921, he attracted an audience of more than six thousand people at Munich's largest indoor hall, the Circus Krone.[31] In 1922, the party issued detailed guidelines aimed at maximizing the propaganda value of meetings organized by members to establish new local groups. The instructions advised that it was better to have no meeting than have a poorly prepared one and that a smaller hall fully

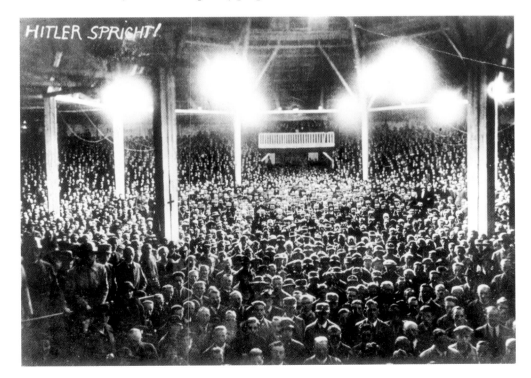

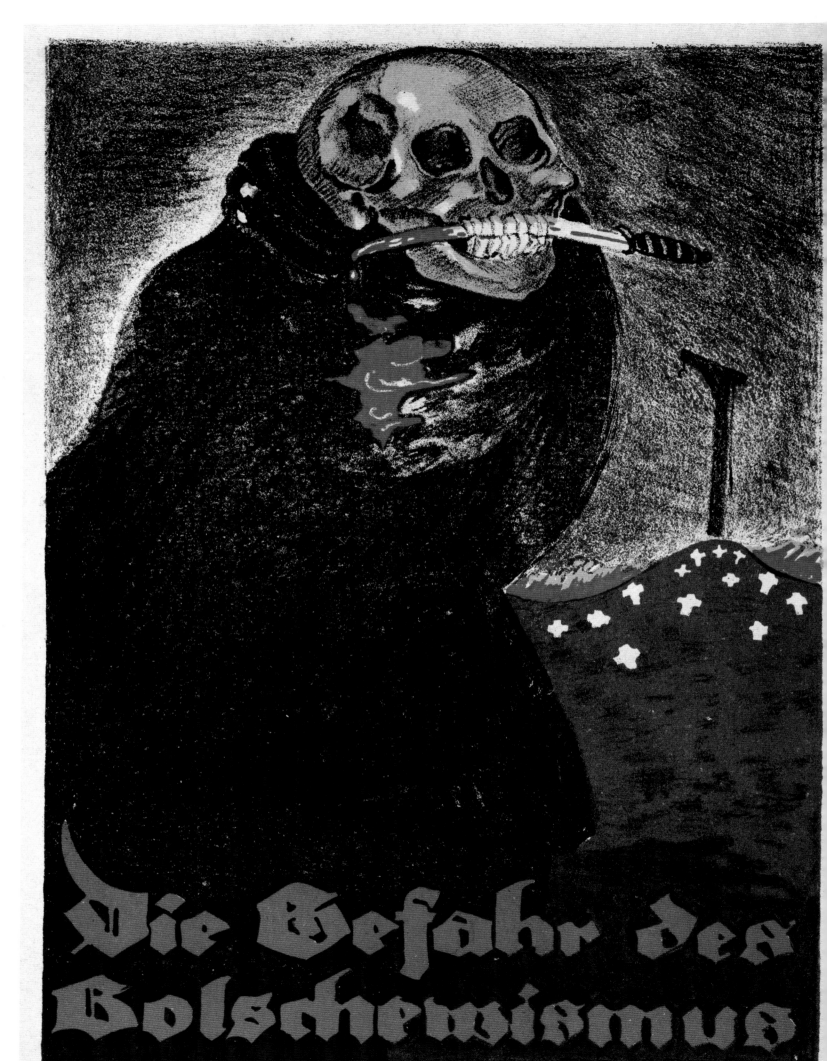

Die Gefahr des Bolschewismus

By the late 1920s, the Nazi Party had become a mass movement. Military-style uniforms and the movement's symbol, the swastika, were ever-present. Weimar, Germany, ca. 1931. *USHMM, gift of William O. McWorkman*

packed with people was preferable to one too large, which might appear half full or noticeably empty.[32]

The newspaper *Völkischer Beobachter* (People's Observer), which Hitler had purchased for the party in 1920, announced meetings and other news to members and extended the party's reach beyond the beer hall and party gathering. By 1923, circulation rose to thirty thousand copies—a respectable figure for a minor, regional party, even taking into account the party mandate that local groups buy a subscription.[33] In contrast to "the long, detailed articles and academic articles and academic discussion of economic and social problems" typically found in the political journals, *Völkischer Beobachter*, edited by the antisemitic writer Alfred Rosenberg, specialized in "short hyperboles" of the Nazis' favorite themes: "the humiliation of the Versailles Treaty, the weakness of Weimar parliamentarianism, and the evil of Jewry and Bolshevism all of which were contrasted with Nazi patriotic slogans."[34] (The Nazis and other antisemitic, anti–Communist groups in Germany saw Jews behind the Bolshevik Revolution of 1917 in Russia. This theme became for Hitler a particularly obsessive association imagined as part of an international Jewish conspiracy to dominate the world.)

As Nazi propaganda director, Hitler also created the party's flag—its advertising logo. He kept the red, white, and black colors of the flag of Imperial Germany but selected a new design: a black swastika on a white disc against a field of red. The crooked cross of the swastika had ancient roots—being found in diverse cultures from the Hindus in India to native Americans—and contemporary associations with

OPPOSITE: Poster "The Danger of Bolshevism," by artist Rudi Feld, 1919. *BPK*

German and Austrian right-wing groups. It had been used as the identifying emblem of a Bavarian, antisemitic precursor of the Nazi Party, the Thule Society.[35] Being closely identified with "Aryan" civilization in India (referring to Indo-European settlers in contrast to the indigenous population), the swastika was taken by those groups to represent the racial superiority of "Aryans," whom they equated with "Nordic" or "German-blooded" peoples, in contrast to Jews and other minorities. "As National Socialists, we see our program in our flag," Hitler wrote. "In *red* we see the social idea of the movement, in *white* the nationalistic idea, in the *swastika* the mission of the struggle for the victory of the Aryan man."[36]

Adolf Hitler as orator became one of the Nazi Party's most important propaganda tools, reflecting his belief that the mass meeting, as a means of exploiting the dynamics of crowd psychology, was "the only way to exert a truly effective . . . influence on large sections of the people."[37] The ideas he purveyed were not particularly original, being the currency of many other right-wing, nationalistic groups, including the Pan-Germans of prewar Austria. What was new was the attention Hitler paid to presentation, how he said something rather than what he said.[38] Hitler believed that unlike a newspaper, a film, or even a radio address, a speaker appearing before an audience could form a direct and personal contact with the listeners. As an orator, Hitler fed off and channeled the emotions of the crowd, avoided condescending to them, and strove to express people's own thoughts.[39] "The art of propaganda," he wrote in *Mein Kampf*, "lies in understanding the emotional ideas of the great masses and finding the psychologically correct way of gaining the broad masses' attention and hearts."[40] Drawing on modern advertising methods, the Nazi leader recognized that the propagandist, like the advertiser, had to sell an idea, a cause, and an organization to the targeted audience as the best possible choice—not to encourage reflection or deliberation about alternatives. He aimed "not to make an objective study of the truth, in so far as it favors the enemy, and then set it before the masses with academic fairness; [propaganda's] task is to serve our own right, always and unflinchingly."[41]

In his speeches, Hitler repeated a few points. "The masses are slow-moving, and they

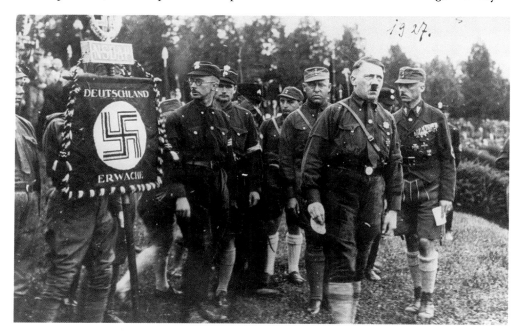

RIGHT: Adolf Hitler speaking at the third Nazi Party Congress, August 19–21, 1927. The banner reads "Germany Awake." *BAK, Bild 146-1969-054-53A*

OPPOSITE: Preprinted announcement "National Socialism Germany's Future!" for public meetings, 1931. Times and locations were filled in by hand. The bottom left notation reads "No Jews Allowed." *Hessisches Staatsarchiv Darmstadt*

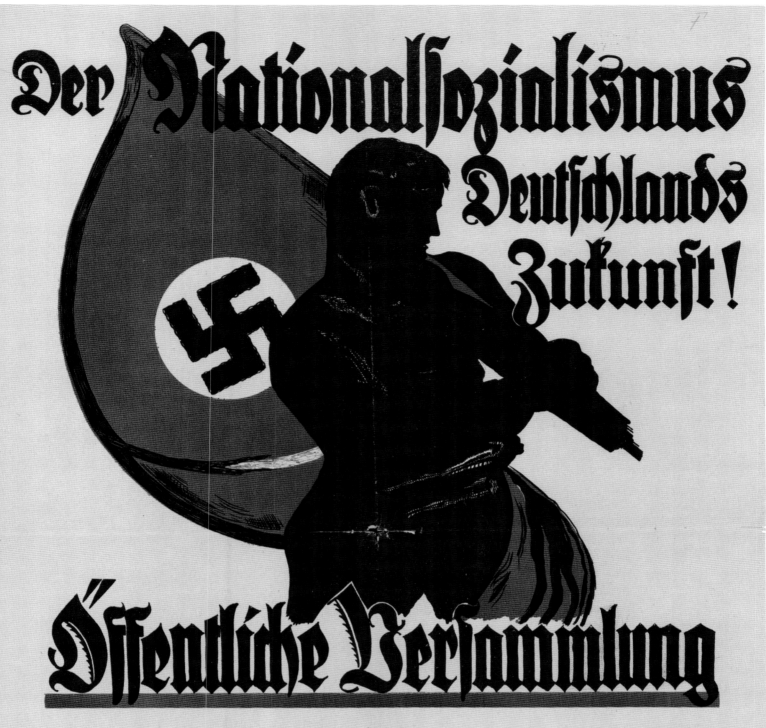

Der Nationalsozialismus Deutschlands Zukunft!

Öffentliche Versammlung

Am Sonntag den 23. Aug. 31 Nachmittags **Uhr**

spricht der Nationalsozialist

Bernhard Graf Solms.

und

Landwirt Seipel, Fauerbach. **in** auf dem Jagdhaus HUBERTUS

über *Bauer her zu uns*

KONZERT
der S.A.Kapelle!

Unkostenbeitrag 30 Pfg.
Kriegsverletzte u. Erwerbslose die Hälfte
Juden haben keinen Zutritt!

Nationalsozialistische Deutsche Arbeiter-Partei
(Hitler-Bewegung)

S.A. Sturm 55

Streiter Verlag, Fritz Tittmann, Treuenbrietzen (Mark) Plakat Nr. 34.

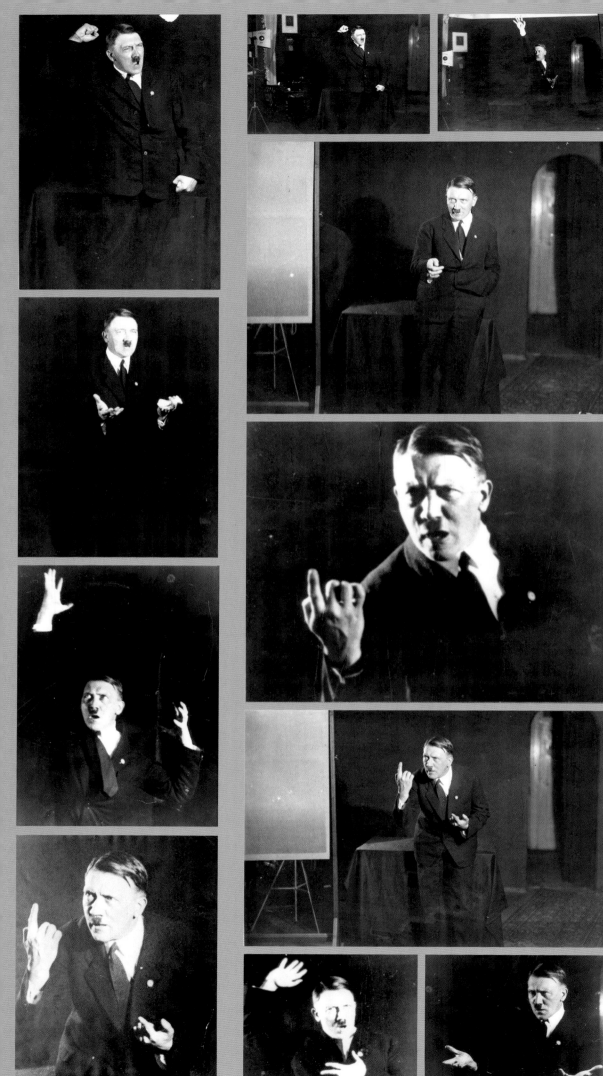
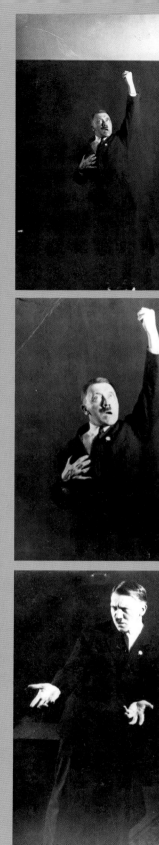

always require a certain time before they are ready even to notice a thing, and only after the simplest ideas are repeated thousands of times will the masses finally remember them."[42] How the speaker presented himself to the audience also mattered, as in the theater. Hitler's speeches before mass audiences were staged and choreographed performances. Martial music would begin the ceremony and then a warm-up speaker would build anticipation for Hitler's appearance. Once onstage, the Nazi leader began slowly and calmly; then, he worked up to an impassioned crescendo accompanied by theatrical gestures. After the speech, he immediately left the stage, accompanied by music. His exit was geared to preserving the magic of the performer and his work. Hitler did not believe in remaining in the room after the speech was over because it only led to a sense of anticlimax.[43] Through countless speeches to diverse audiences, Hitler sharpened his skills, aiming to tailor his speeches to listeners' particular backgrounds and interests. Whether he chose to wear a business suit or the party uniform and armband, or whether he spoke in a conversational or more strident tone of voice, depended on his assessment of the audience.[44]

During the early 1920s, Hitler continued to adopt elements of mass mobilization from the German "Marxist" parties—the Social Democrats and the new Communist Party—as well as from Benito Mussolini's newly founded Fascist movement in Italy. In their efforts to attract German workers, historically identified with the left-wing parties, the Nazis imitated those working-class parties by using striking red posters

"In the Beginning Was the Word," oil painting by Hermann Otto Hoyer, ca. 1937. Hoyer depicted a quasi-messianic Hitler mesmerizing an audience with his oratory in the 1920s. *U.S. Army Center of Military History*

OPPOSITE: Studio shots taken by Heinrich Hoffmann of Hitler practicing his oratory poses. *Bayerische Staatsbibliothek/ Fotoarchiv Hoffmann*

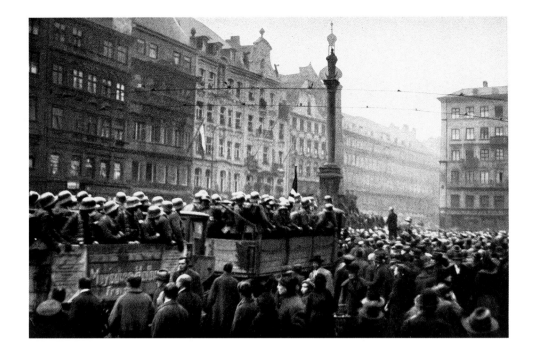

The arrival in Munich of troops supporting Hitler during the "Beer Hall Putsch," September 9, 1923. *USHMM, courtesy of William O. McWorkman*

ABOVE: Gregor Strasser, the leader of the social revolutionary north German wing of the Nazi Party and later head of the party's propaganda directorate, 1922. *NIOD*

OPPOSITE: Nazi Party poster depicting Hitler with tape over his mouth and calling on Germans to attend a meeting protesting the ban on Hitler's speaking, imposed after his 1924 conviction for high treason, 1926. *BAK, Plak 002-041-048*

and covering their trucks with red flags, broadsides, and blaring loudspeakers. The Nazis urged party members to wear informal clothing. Storm troopers roughed up opponents at meetings to gain press attention in rival newspapers, and Nazis went to other parties' public-speaking schools to learn their arguments beforehand.[45] Mussolini's Fascisti proved to be the inspiration for the Hitler salute—which the Fascists had borrowed from ancient Rome—and also for the party uniform, though the Nazis chose brown rather than black. In succession, the men became "The Leader" of their respective movements: Mussolini as Il Duce and Hitler as Der Führer.

Inspired by Mussolini's March on Rome in 1922 and against the backdrop of deep German unrest and suffering during the period of hyperinflation, Hitler planned a march on Berlin in November 1923 to depose the democratic government. Unlike the Fascists, however, the Nazis failed, never advancing beyond the early stages of this attempted coup d'état launched in a beer hall in Munich. Following the "Beer Hall Putsch," authorities arrested and imprisoned Hitler after convicting him of high treason. Bavarian state authorities banned the party and shut down its newspaper, the *Völkischer Beobachter.* Party members were forced to go underground, where they created new organizations with camouflaged names or joined other extremist right-wing groups.[46]

DEVELOPMENT OF A NATIONAL PROPAGANDA APPARATUS

In December 1924, Hitler was released early from Landsberg prison and dedicated himself to resurrecting the Nazi Party. After he pledged to pursue only a legal path to political power, the Bavarian government lifted the ban on the party and its *Völkischer Beobachter.* Barred from giving speeches until 1927, Hitler turned to penning articles for the Nazi press. In the party's effort to build a nationwide organization well beyond its regional base in Bavaria, Gregor Strasser, a war veteran and former pharmacist, began organizing campaigns in northern and western Germany.[47] Named head of the party's Reich Propaganda Directorate, Strasser worked with his younger colleague

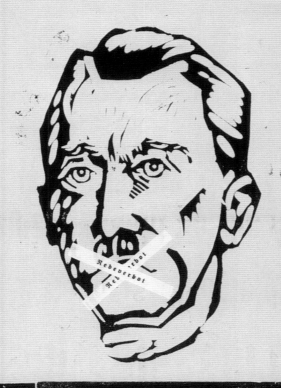

Schieber, Bonzen und Moßgoten Reden Deutschland schies und krumm

Hitler ist der Mund verboten Michel, Michel bist du dumm!

Michel, auf zur

Protestversammlg.

Dienstag **Schießwerder** 11. Mai

Dᴿ Göbbels-Elberfeld

der berühmte Vorkämpfer der Rhein=Ruhrbewegung, spricht über:

Der Weg zur Macht für die Arbeiter der Stirn und Faust

Kasseneröffnung 7³⁰ Beginn 8³⁰

Unkostenbeitrag 50 Pf. Erwerbslose Parteimitglieder frei. Erwerbslose 20 Pf. Juden haben keinen Zutritt!

Numm. Plätze 75 Pfg. Vorverkauf: Buchhandlung Steinke Sandstr. 9, Buchhandlung Morgenstern Ohlauerstr. 15 und Geschäftsstelle der NSDAP Bohrauerstr. 18

National-Sozialistische Deutsche Arbeiterpartei
Breslau, Bohrauerstr. 18

Volksproteft gegen das Redeverbot! Einzeichnungsstellen: Geschäftsstelle der NSDAP Bohrauerstr. 18, Buchhandlg. Steinke Sandstr. 9, Buchhandlg. Morgenstern Ohlauerstr. 15 u. Eisenhandlg. Kegel Höschenstr. 36-40

Aker"-Druck, Breslau 15

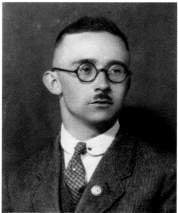

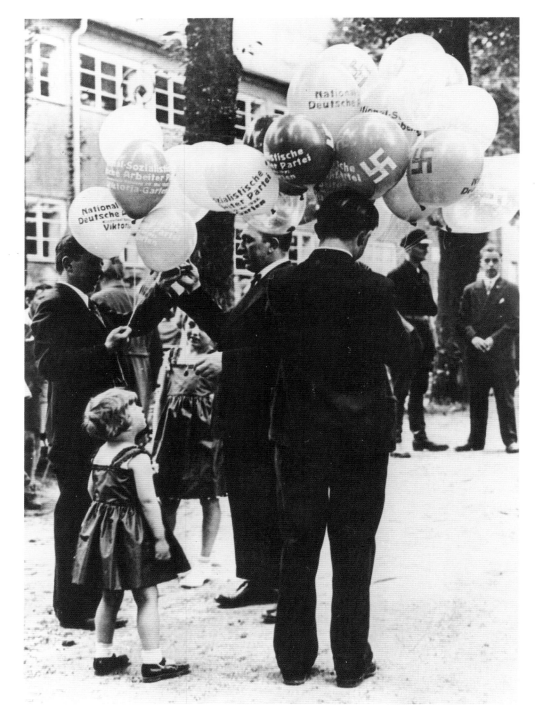

Heinrich Himmler to develop an efficient agency that organized recruitment and forged strong ties to local party groups, which, in turn, created their own propaganda departments and specialists.[48] A trained agricultural expert, Himmler also initiated recruitment and propaganda campaigns in rural areas.[49] By 1928, the Nazi Party was making inroads into national politics, winning twelve seats in the Reichstag, and the growth of support for the party accelerated dramatically after the onset of the Great Depression in 1929.

Beyond creating strong central and grassroots organizations, what methods did Nazi propagandists use to build popular support and win votes in elections? First,

the Reich Propaganda Directorate provided local Nazi organizations with detailed instructions on conducting campaigns. In special pamphlets, such as *Unser Wille und Weg* (Our Will and Way), precise directions left little to chance. Local organizers were told how and where to place party posters, how to tailor language for different targeted audiences—from workers to middle-class professionals—how to increase the chances that leaflets would be read by distributing them to passengers entering rather than exiting rail and subway stations, how to use certain colors to capture the observer's eye, and when to stack several versions of the same poster on a kiosk or when to use different posters. Nazi activists even calculated the number of kiosks available in Berlin.[50] Second, drawing on modern advertising techniques, Nazi propagandists moved away from the wordy broadsides with visually confusing images used by most of their political opponents to create posters with strong, vibrant, colorful images and simple slogans, like "Work and Bread," to catch the eye.

Importantly, to distinguish the Nazi Party from the dozens of other parties in Weimar Germany, propagandists focused on the person of Adolf Hitler. The Nazi Party, its posters showed, was the "Hitler Movement." Its propagandists carefully crafted images of the Führer that emphasized his charisma, his roots in the common people, his heroism as a soldier in World War I, his quasi-messianic status as savior, and his respectability. Following the party's impressive gains in the elections of 1930—when it received six million votes and earned 107 Reichstag delegates, making it the second-largest political party in the parliament after the Social Democratic Party—Adolf Hitler came to symbolize the hope of a new political era for millions of Germans.[51] Commenting on the scope of Nazi propaganda in the lead-up to the 1930 elections, the Prussian Ministry of Interior reported that "selected districts are veritably inundated and worked over with propaganda operations consisting of methodically and skillfully prepared written and verbal appeals as well as a schedule of meetings, all of which in terms of sheer activity cannot in the least be matched by any other party or political movement."[52] The Social Democratic Party leadership itself recognized the apparent appeal of the Nazis' messages and the efficacy of their propaganda methods, acknowledging in the party organ *Das Freie Wort* (The Free Word): "Nazi popularity comes not so much because they preach violence or are anti-parliamentarian, rather far more because they profess to fight for an idea. 'Public welfare stands above individual welfare' and similar idealistically constructed phrases will bring them unfortunately far more popularity than our individually appealing agitation for self-interest."[53]

How important was antisemitism to the Nazi Party's growing popularity? Antisemitism was always a central Nazi tenet, yet Hitler and other leaders realized that not all Germans responded to their strident anti-Jewish messages. To be sure, in some areas of Germany, anti-Jewish propaganda was pronounced. In Nuremberg, for example, since 1923 the regional party leader Julius Streicher had been producing the antisemitic and pornographic Nazi newspaper *Der Stürmer* (The Stormer), its subheading proclaiming, "Weekly Struggle for the Truth." Party campaigns were also

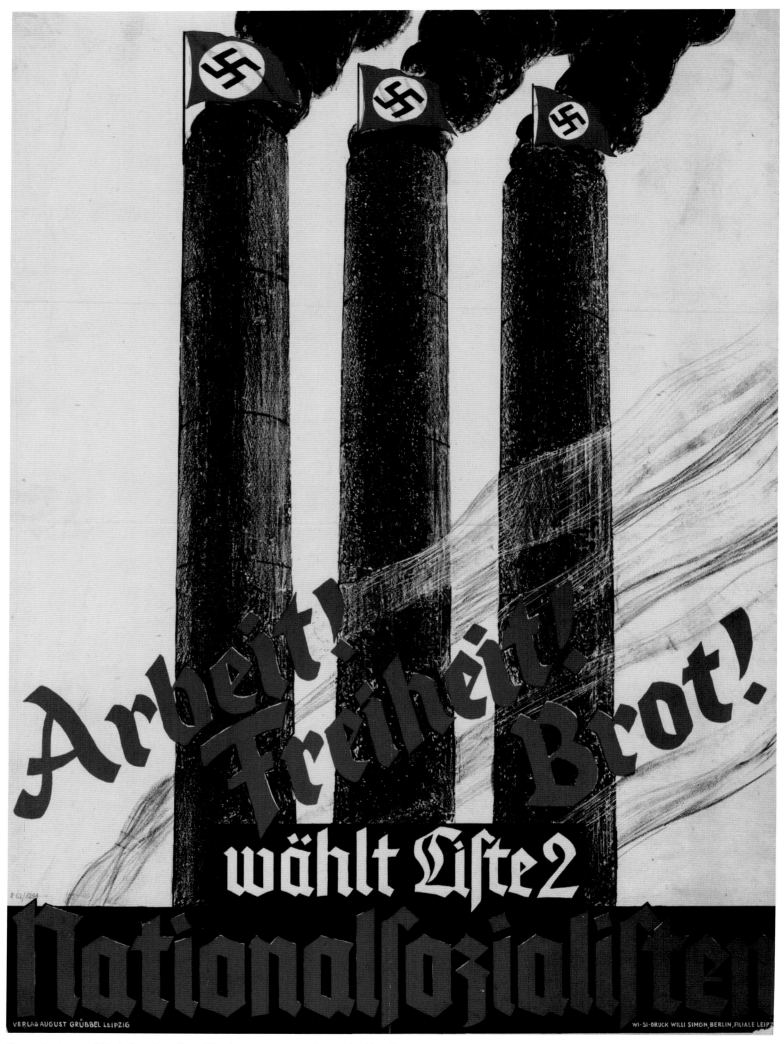

Campaign poster "Work, Freedom, Bread!" exhorting voters to choose the Nazi Party on slate 2 in the July 1932 Reichstag elections. *DHM*

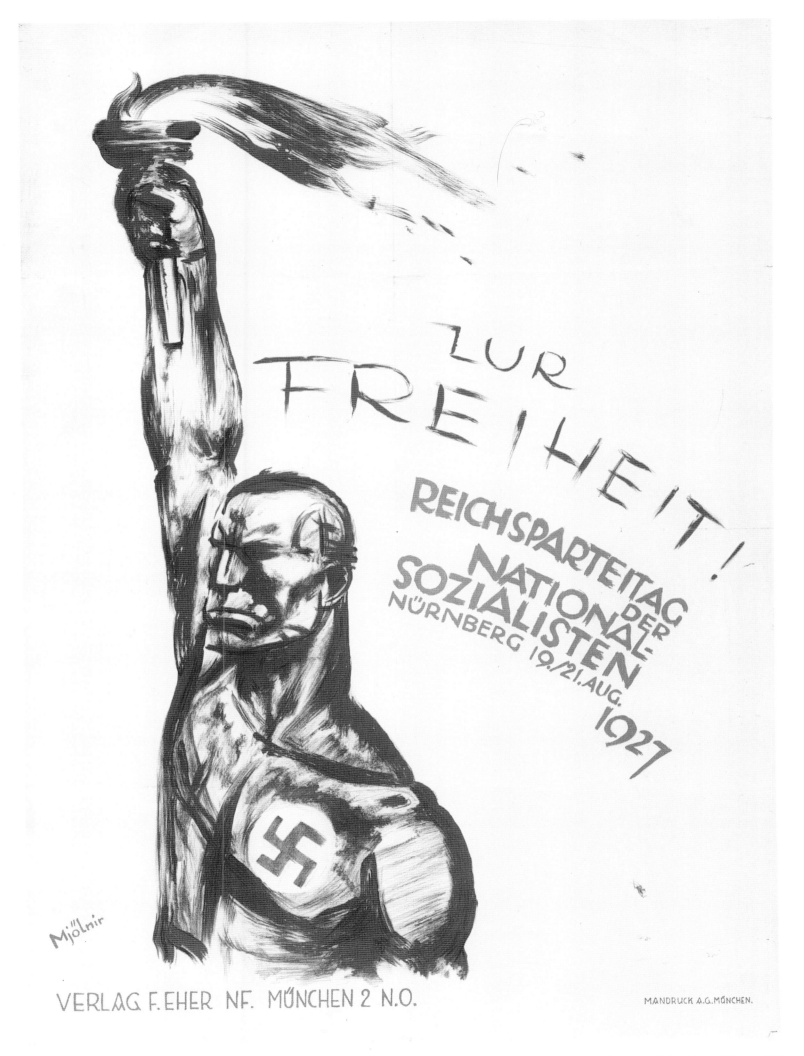

"To Freedom!" poster by artist Hans Schweitzer ("Mjölnir"), announcing the Nazi Party Congress in Nuremberg, August 19–21, 1927. *BAK, Plak 002-041-052*

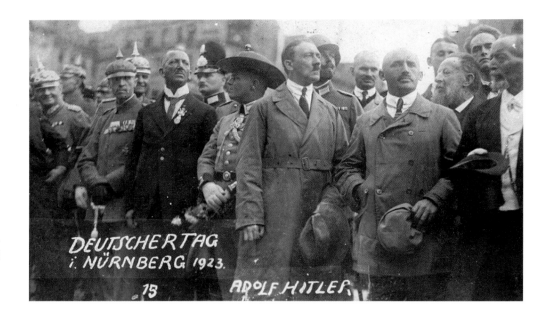

often blatantly antisemitic in Berlin under the leadership of Joseph Goebbels, whose newspaper *Der Angriff* (The Attack) bore the motto "For the oppressed, against the exploiters" and featured articles blaming Jews for most of Germany's ills. In other places, however, the Nazis played down antisemitism or left it out almost entirely from their propaganda campaigns. In certain locales, the propagandists stressed their "socialist" platform (distinguishing it from "Marxist" versions) while in still others, they invoked traditional values of nationalism, Christianity, and family. After 1928, when the party began to make its greatest strides at the ballot box, Hitler toned down his antisemitism and avoided any discussion of his future plans for German Jewry.[54] An astute politician, he understood that to gain respectability as a national leader, he had to suppress temporarily some of his vitriolic, anti–Jewish rhetoric.

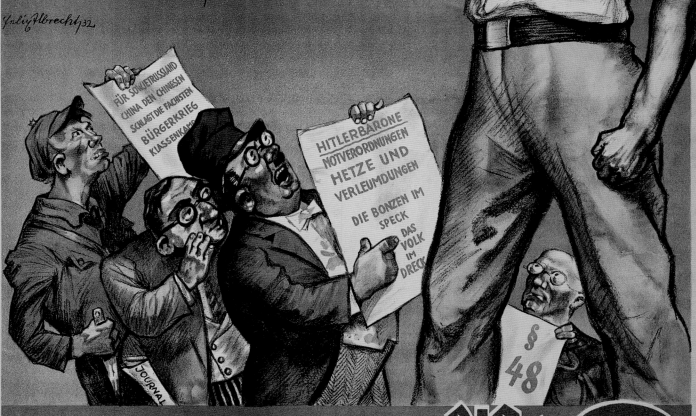

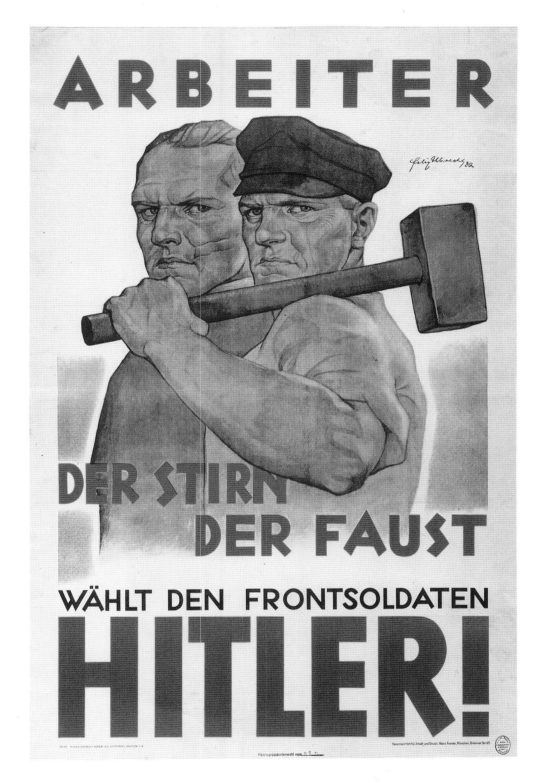

ARBEITER

DER STIRN
DER FAUST

WÄHLT DEN FRONTSOLDATEN

HITLER!

Rather than emphasizing a concrete strategy for solving Germany's problems, the Nazis preferred to keep their plans broad and amorphous. They understood that propaganda had to leave the German voter with a sense of hope that the party could lead the country to freedom, unity, and stability. Party activists in rural areas tended to use slogans, generalities, and oversimplifications. They hammered away at liberals and Jews and stoked fear of Communism, but they avoided making any firm commitments to agricultural policies so as not to be held to any concrete promises.[55]

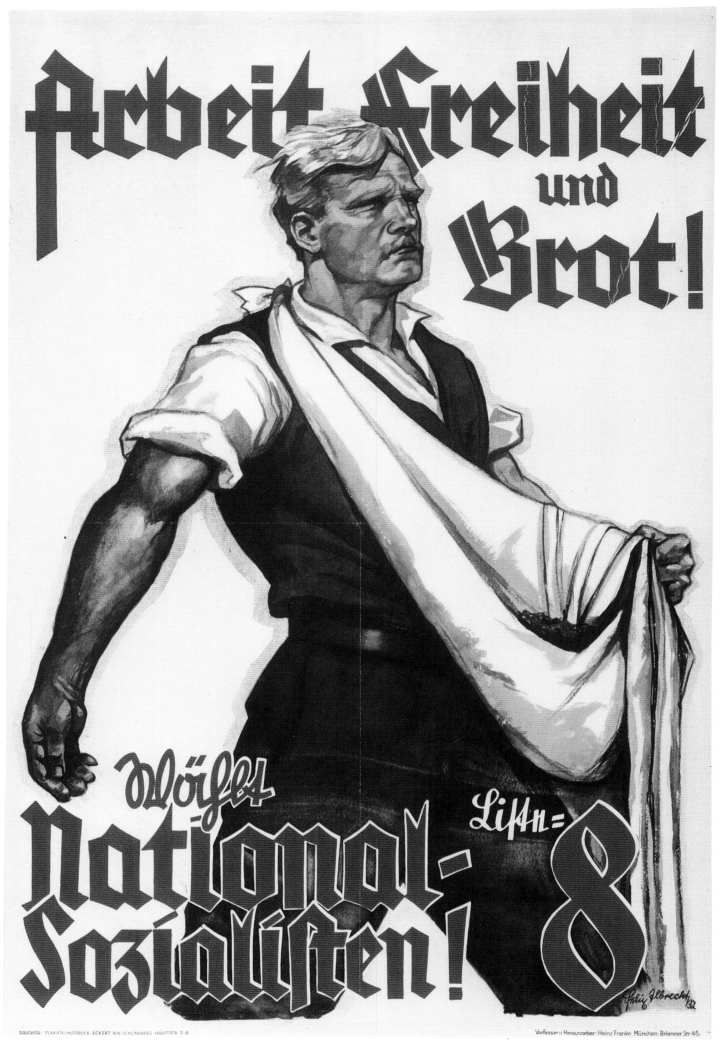

Nazi Party poster, by artist Felix Albrecht: "Work, Freedom, and Bread!" 1932. *BAK, Plak 002-040-010*

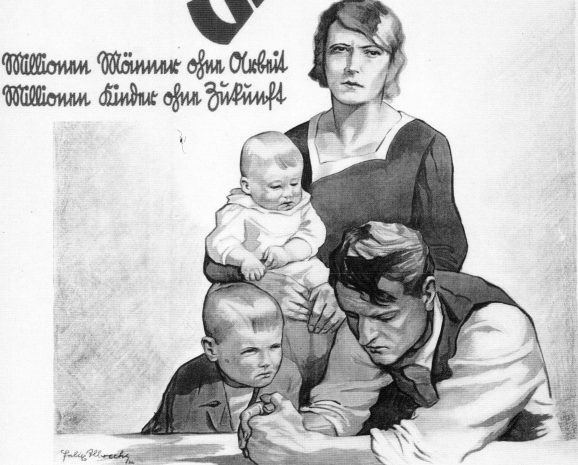

Männer!
Frauen!

Millionen Männer ohne Arbeit
Millionen Kinder ohne Zukunft

Rettet die deutsche Familie

Wählt
Adolf Hitler!

DRUCKER : PLAKATKUNSTDRUCK ECKERT BLN-SCHÖNEBERG HAUPTSTR. 7-8

Herausgeber : Heinz Franke, München, Brienner Str. 45

Election poster encouraging men and women to vote for Hitler: "Millions of Men without Work. Millions of Children without a Future. Save the German family," 1932. *BAK, Plak 002-016-048*

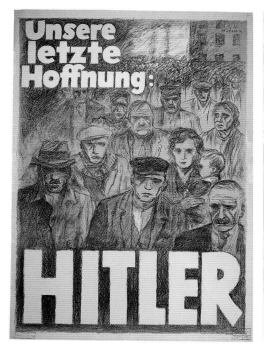

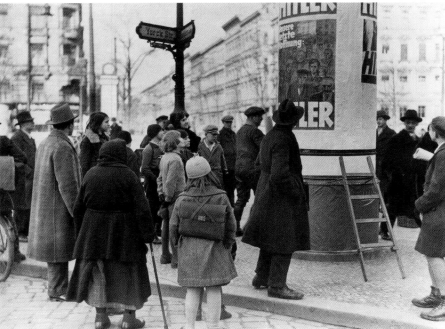

Germans voted for Hitler for a variety of reasons—the Nazi Party offered something for just about everyone.[56] Millions of people voted for the party, not because of antisemitism, but because they were searching for an end to the economic crisis and to political division and disorder. The Nazi Party, in clear distinction from other parties, cultivated an image of itself as standing above class, region, and confessional differences, as representing blue- and white-collar workers, peasants, soldiers, women, students, the middle class, Protestants, and Catholics.[57] The party appealed to young people, attracted by propaganda that portrayed Nazis as dynamic, heroic, and youthful—something none of the old, established parties could claim. The party spoke to nationalistic grievances rooted in memories of the war and the harsh terms of peace imposed by the victors upon the defeated nation. Through propaganda, party activists presented the party as the only viable political alternative. They emphasized an optimistic message: voters need not fall into despair; by casting a vote for the party, they were participating in the salvation of Germany. Of course, the party's underlying antisemitism did not stop those millions of Germans from voting for the Nazis.[58] Many Germans may have overlooked the party's antisemitism, thought it would disappear over time, or ignored it because it did not affect them.

THE SUCCESS OF NAZI PROPAGANDA

In the final years of the Weimar Republic, Germany was mired in a grave political and economic crisis that left the society verging on civil war. Street violence by paramilitary organizations on the Left and the Right increased sharply. Election campaigns in particular stimulated political violence. In the final ten days of the July 1932 parliamentary elections, Prussian authorities reported three hundred acts of politically motivated violence that left twenty-four people dead and almost three hundred injured. In the Nazi campaigns, propaganda and terror were closely linked. In Berlin, Nazi Party leader Joseph Goebbels intentionally provoked Communist

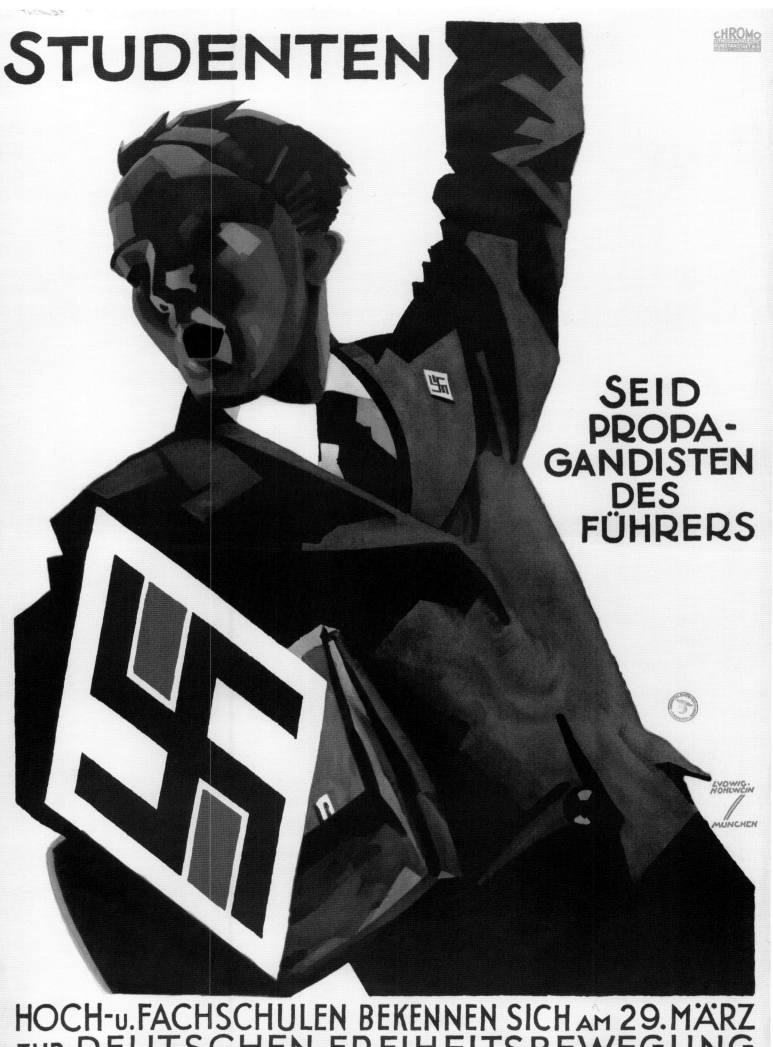

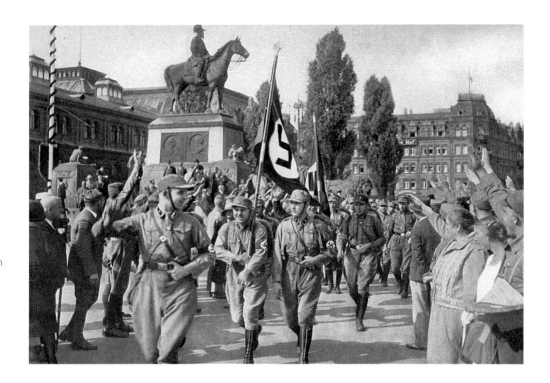

Reichstagswahl
Wahlkreis Dresden-Bautzen

1	Nationalſozialiſtiſche Deutſche Arbeiterpartei (Hitlerbewegung) Hitler — Dr. Frick — Göring — Mutſchmann	**1** ○
2	Sozialdemokratiſche Partei Deutſchlands Löbe — Tony Sender — Aezl — Dobbert	**2** ○
3	Kommuniſtiſche Partei Deutſchlands Thälmann — Rädel — Gräf — Olga Körner	**3** ○
4	Deutſche Zentrumspartei Dr. Brüning — Kirſch — Günther — Magda Fiſcher	**4** ○
5	Kampffront Schwarz-Weiß-Rot Dr. Hugenberg — Dr. Bang — Dr. Daebeling — Grellmann	**5** ○
7	Deutſche Volkspartei Dingeldey — Höhne — Müller — Elſa Pechmann	**7** ○
8	Chriſtlich-ſozialer Volksdienſt (Evangeliſche Bewegung) Behrens — Kunze — Gebhardt — Thomas	**8** ○
9	Deutſche Staatspartei Dr. Keßler — Lemmer — Pflug — Dr. Elſe Ulich-Beil	**9** ○
10	Deutſche Bauernpartei Dr. Fehr	**10** ○
15	Sozialiſtiſche Kampfgemeinſchaft Kreebaum — Breuer — Pülſchel — Läſcher	**15** ○

and Social Democratic actions by marching SA storm troopers into working-class neighborhoods where those parties had strongholds. Then he invoked the heroism of the Nazi "martyrs" who were injured or killed in these battles to garner greater public attention. Nazi newspapers, photographs, films, and later paintings dramatized the exploits of these fighters. The "Horst Wessel Song," bearing the name of the twenty-three-year-old storm trooper and protégé of Goebbels who was killed in 1930, became the Nazi hymn. The well-publicized image of the SA-man with a bandaged head, a stirring reminder of his combat against the "Marxists" (along with other portrayals of muscular, oversized storm troopers), became standard in party propaganda. In the first eight months of 1932, the Nazis claimed that seventy "martyrs" had fallen in battle against the enemy. Such heroic depictions—set against the grim realities of chronic unemployment and underemployment for young people during the Weimar period—no doubt helped increase membership in the SA units, which expanded in Berlin from 450 men in 1926 to some 32,000 by January 1933.[59]

The dual strategy of propaganda and street violence paid off for the Nazi Party, not just in increased recruitment of new storm troopers, but ironically, in winning respectability. Choosing their targets carefully, the Nazis attacked socialist and Communist paramilitary organizations and locales while avoiding direct violent confrontation with the police, the army, or other governmental agencies. The mainstream press and the authorities accepted the Nazi version of the events, that these were self-defense actions against Marxist provocations and "terrorism." Although many middle- and upper-class Germans found street violence disorderly and repellent, the thought of "Bolshevist" Germany was even more unacceptable. By portraying themselves as the only solid bulwark against Marxism, the Nazis gained respectability and votes.

By use of incessant propaganda to mobilize their base of supporters, now well rooted in the countryside, towns, and cities, the Nazis worked tirelessly to promote

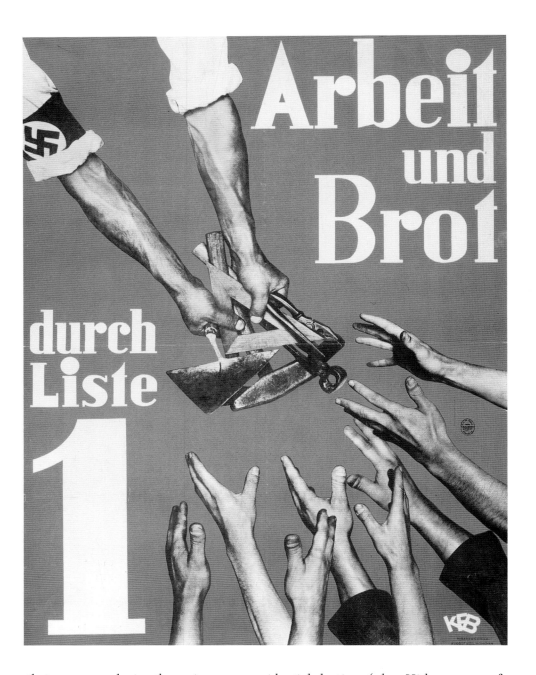

Arbeit und Brot

durch Liste 1

Nazi election poster "Work and Bread through Slate 1," October 1932. *BAK, Plak 002-042-155*

OPPOSITE: This election poster, by artist "Witte," reads "We Are Creating the New Germany! Remember the Victims," referring to storm troopers wounded or killed in street combat, 1932. *BAK, Plak 002-042-108*

their messages during the spring 1932 presidential elections (when Hitler was one of three candidates) and the July 1932 parliamentary elections. The real possibility of a Hitler victory propelled a number of the pro–Weimar Republic political parties, including the Social Democratic Party and the Center Party, to throw their support to venerated war hero Paul von Hindenburg, who prevailed over Hitler by winning 53 percent of the votes. Although the Nazi leader failed to win the presidency, the election campaigns increased his national exposure and popularity, achieved in part by something unique in German electioneering: the party chartered Lufthansa airplanes to fly Adolf Hitler around the country.[60] Hailed by his publicists as "Hitler over Germany," the innovative technique electrified Germans in cities and in rural areas. Hitler spoke at twenty rallies before huge audiences totaling nearly a million persons.[61]

Taking advantage of its better financial position, the Nazi Party ran an "American-style" presidential campaign that portrayed Hitler as the representative of the entire

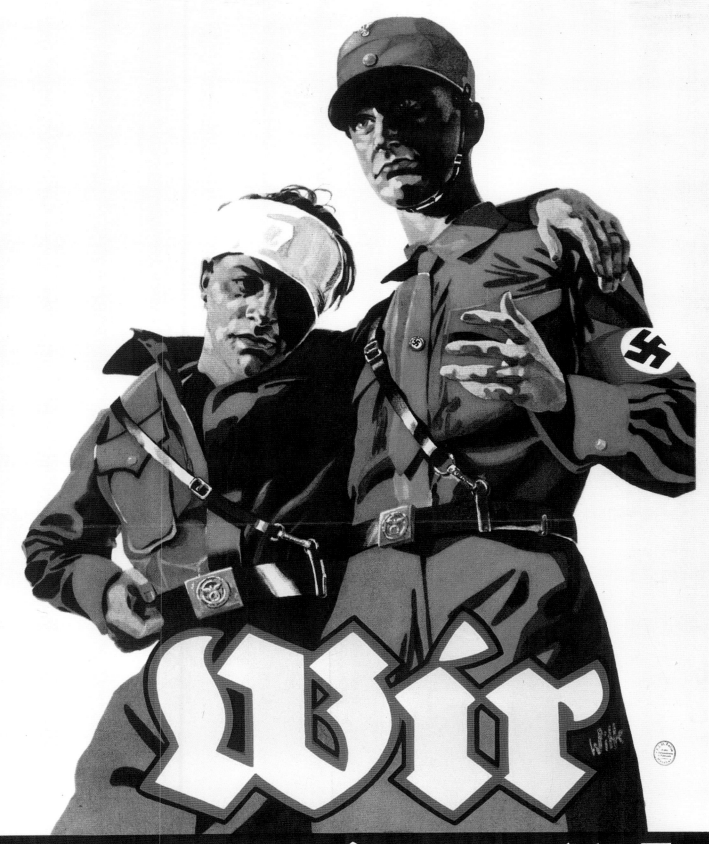

Wir

schaffen das neue Deutschland!
denkt an die Opfer –
Wählt Nationalsozialisten Liste 1

N.S.D.A.P. GAU HAMBURG, HAMBURG 13, TESDORPFSTR. 9 DRUCK: LANGEBARTELS & JÜRGENS, ALTONA NACHDRUCK VERBOTEN

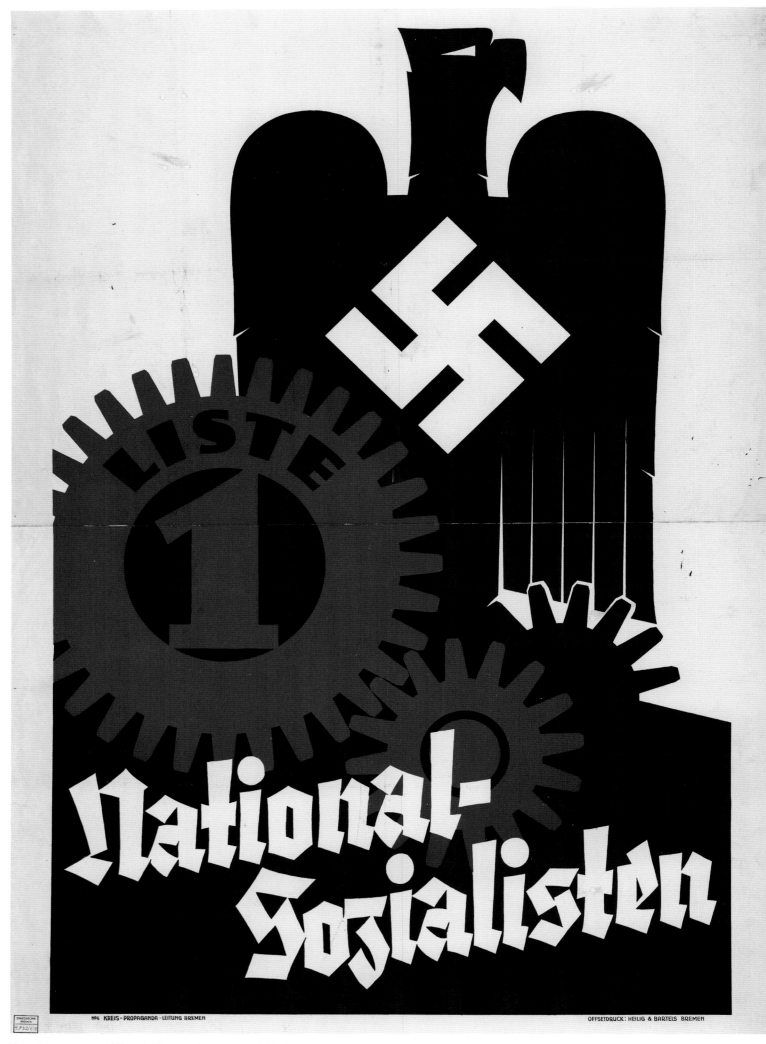

Nazi election poster, "Slate 1, National Socialists," 1932. *Staatsarchiv Bremen*

Campaign poster, "The People Vote Slate 1, National Socialists," by artist Willi Engelhardt, 1932. *USHMM*

ABOVE: Hitler and his driver consulting a map during Hitler's campaign for the presidency, April 1932. *USHMM, courtesy of Richard Freimark*

RIGHT: Cover image for Nazi Party political pamphlet "Hitler over Germany" detailing Hitler's 1932 election campaign for president, 1932. *Randall Bytwerk*

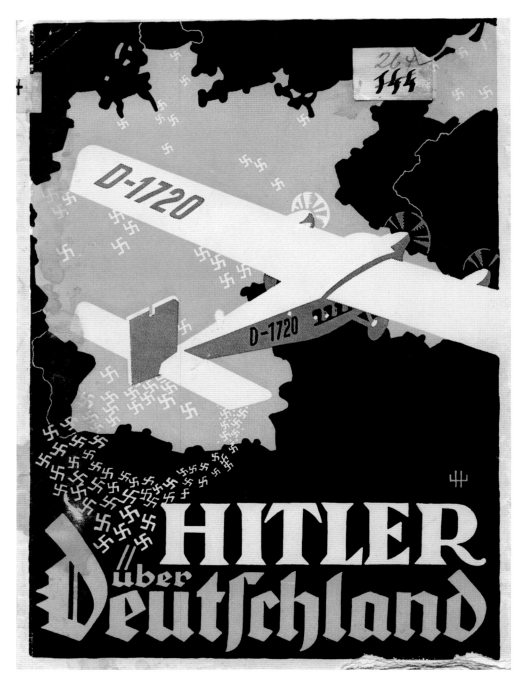

nation. It concentrated its efforts less on workers and more on middle-class voters and targeted specific groups, especially women.[62]

The party's press chief, Otto Dietrich, who accompanied Hitler on the electoral tour, attributed the success of the campaign not merely to the power of Hitler's personality to attract huge numbers of Germans from diverse backgrounds, but also to the skills and abilities of Joseph Goebbels and the party propagandists.[63] Goebbels, who had a doctorate in literature, was a writer, journalist, and clerk before joining the Nazi Party in 1924. As party leader in Berlin after 1926, he was effective in enlisting new members. In 1930, Hitler named Goebbels director of the party's national propaganda apparatus. Known for his fiery oratory and loyalty to the Führer, Goebbels organized the election campaigns of 1930 and 1932, including "Hitler over Germany."

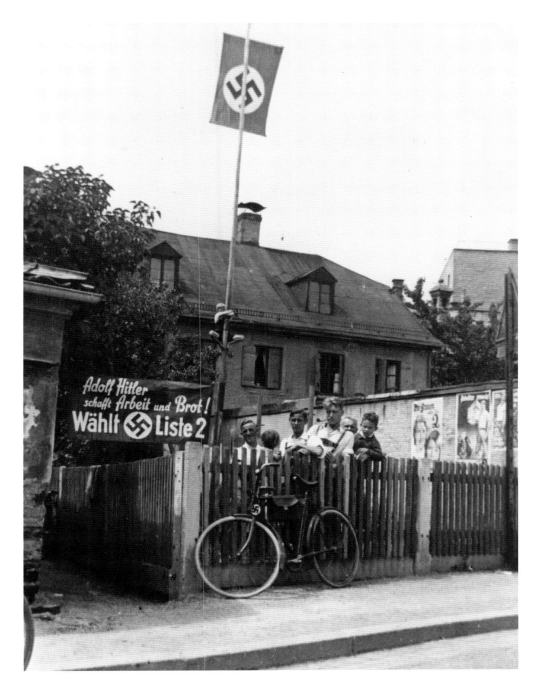

Goebbels also pioneered the use of radio and, as an inveterate film buff, had motion pictures produced of rallies, speeches, and other events to show at meetings to further inspire and mobilize core supporters.[64]

Although the Nazi Party made astounding electoral successes in the final years of the Weimar Republic, it never managed to win a majority of votes in any national election. Millions of Germans opposed Adolf Hitler and his extremist platform, and in the Reichstag elections of November 6, 1932, the Nazi Party won two million fewer votes than in 1930.[65] It remained the country's largest political party, but it did not have enough electoral support to establish a parliamentary majority or a national government. Nazi victory — neither inevitable nor preordained — ultimately depended less on the strength of its propaganda than on the willingness of President

Members of the SA campaigning in Berlin for the Nazi Party, which appeared on the voting ballot as slate 10, 1928. *USHMM, courtesy of Bud Tullin*

Paul von Hindenburg and the coterie surrounding him to appoint Hitler to the office of chancellor, which occurred on January 30, 1933. Propaganda had helped bring the Nazi Party close to power by making Hitler a popular candidate, but it could not get him elected.

The Nazis themselves considered this "period of struggle" as the golden era of their propaganda success. During the bleakest hours of World War II, Goebbels urged fellow

RIGHT: A Nazi trumpeter in the 1932 Prussian state election. *BAK, Bild 102-03126*

OPPOSITE: "The Third Reich? No!" The Social Democratic Party, which distributed this poster in 1932, was Germany's largest party during the 1920s and a vigorous opponent of Nazism. *BAK, Plak 002-037-008*

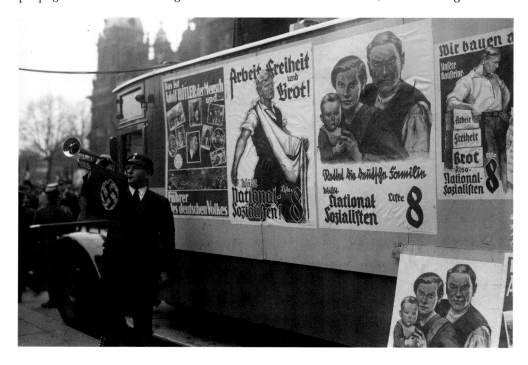

STATE OF DECEPTION: THE POWER OF NAZI PROPAGANDA

Das dritte Reich? NEIN!

Verleger: Richard Hauschildt, Berlin SW 68, Lindenstr. 3. Druck: Vorwärts Druckerei, Berlin SW 68, Lindenstr. 3

ERSCHEINT WÖCHENTLICH EINMAL ● PREIS 20 PFG., Kc. 1,60
30 GR., 30 SCHWEIZER RP. ● V. b. b. ● NEUER DEUTSCHER
VERLAG, BERLIN W8 ● JAHRGANG XI ● NR. 42 ● 16. 10. 1932

DER SINN DES HITLERGRUSSES:

Motto:
**MILLIONEN
STEHEN
HINTER MIR!**

Kleiner Mann bittet um große Gaben

Montage: JOHN HEARTFIELD

party members to return to the spirit and triumphs of the Weimar years. The rise of the Nazi Party from obscurity to political power convinced its militants that propaganda, properly crafted and disseminated, could work miracles. The "period of struggle" also provided the opportunity for young Nazi activists in the party's propaganda machine to hone their skills in "combat" against other political parties, to explore the use of modern technology and communications, and to learn to exploit unexpected developments. In 1933, when Hitler took power, he already had skillful, experienced propagandists and a centralized propaganda apparatus with strong connections to grassroots organizations.

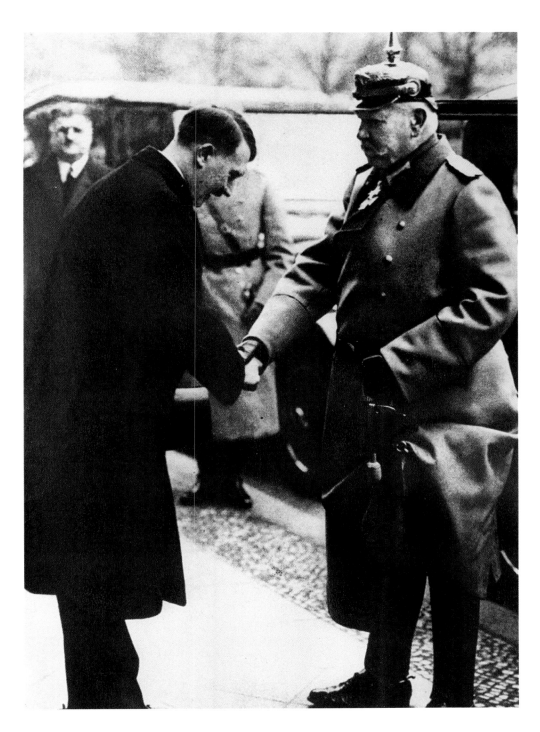

LEFT: Adolf Hitler greeting Reich President Paul von Hindenburg on the day Hindenburg appointed Hitler Chancellor of Germany, January 30, 1933. *Fédération Nationale des Déportés et Internés Résistants et Patriotes*

OPPOSITE: *Arbeiter-Illustrierte Zeitung* (AIZ; Illustrated Workers' Newspaper), October 16, 1932. In this issue of the popular Communist weekly, German Jewish artist John Heartfield portrayed the Nazi leader as a pawn of big business: "The Meaning of the Hitler Greeting: Small Man Asks for Big Donations. Motto: 'Millions Stand behind Me!'" *Copyright 2008 Artists Rights Society, New York/VG Bild-Kunst, Bonn/The Metropolitan Museum of Art, purchase, The Horace W. Goldsmith Foundation Gift through Joyce and Robert Menschel, 1987 (1987.1125.8) copy photograph copyright Metropolitan Museum of Art*

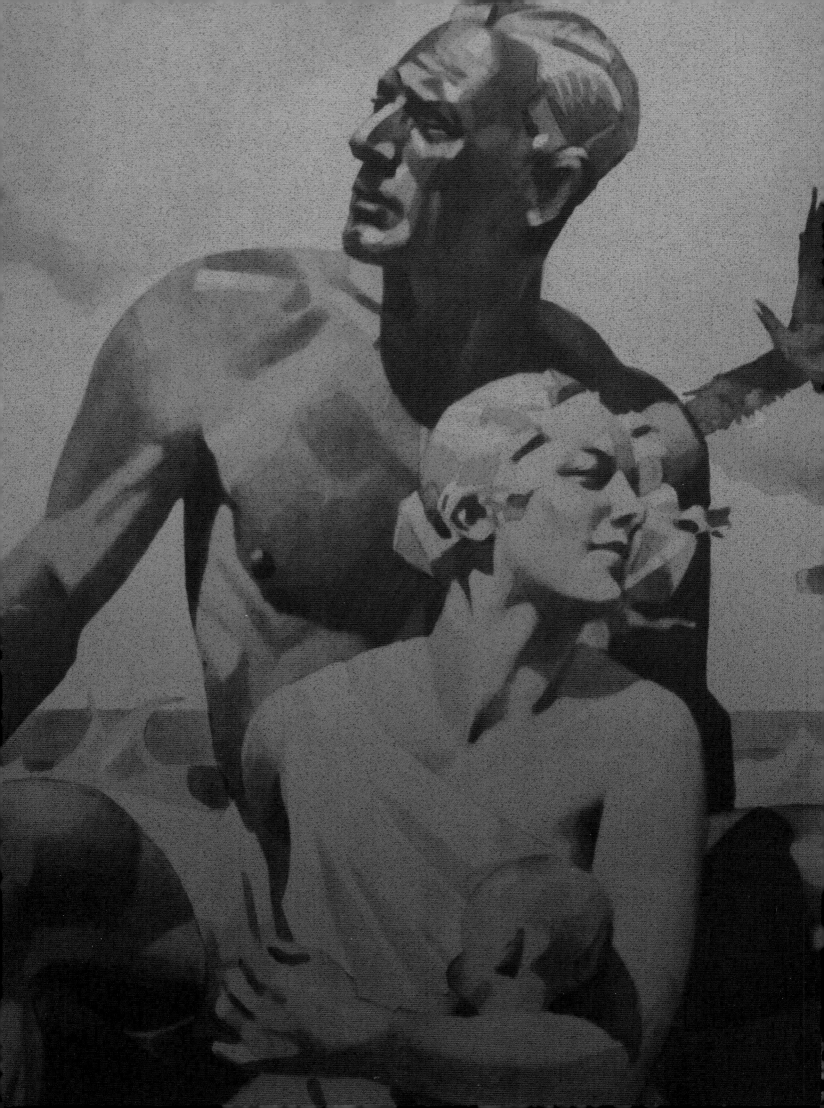

POWER AND PERSUASION IN THE RACIAL STATE

O nce in power, the Nazis sought to dismantle the remnants of parliamentary democracy and transform Germany into a one–party, racial state. Propaganda served as an important tool to win over the majority of Germans who had not supported Hitler and to push forward the Nazis' radical program, which required the acquiescence, support, or participation of broad sectors of the population. Combined with the use of terror to intimidate those who did not comply, a new state propaganda apparatus headed by Joseph Goebbels devoted itself to the task of manipulating and deceiving the German population and the outside world. At each step of the way, propagandists preached an appealing message of national unity that resonated with millions of Germans, and they waged campaigns that facilitated the persecution of Jews and others excluded from the Nazi vision of the "national community."

DISMANTLING THE INSTITUTIONS OF DEMOCRACY

On February 1, 1933, two days after becoming chancellor, Adolf Hitler addressed the nation in a radio broadcast. Like so many of Hitler's speeches, this one tempered hopes with fears; conveyed his force of personality; expressed his concern to maintain Germany's cultural, religious, and political legacy; and reiterated his dedication to solving the country's problems. Political consensus, not ideological radicalism, was the order of the day. Eschewing antisemitism, Hitler focused on a broad, conservative platform that many Germans could support. The new government, he pledged, would make Christianity the basis of "our entire moral code," defend the family as the "nucleus" of the body politic, forge ethnic and political unity, and make respect for "our great past" the foundation of educating German youth. The national government would "declare a merciless war against the spiritual, political, and cultural nihilism" that had infected German society to keep the country from sinking "into anarchistic Communism." Hitler then asked for four years to eradicate unemployment and pull the peasantry out of poverty. Fourteen years of Marxism had ruined Germany, he claimed, but one year of "Bolshevism" would destroy the nation.[1]

Over the next one hundred days, Hitler's regime deployed the radio, press, and newsreels to stoke fears of a pending "Communist uprising," then channeled popular

"People's receiver," 1933. *USHMM, gift of Deutsches Technikmuseum*

OPPOSITE: From the image of an idealized "Aryan" family of the type that pervaded Nazi propaganda, 1938. *Museum für Kunst und Gewerbe*

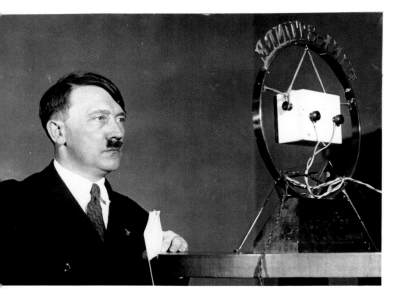

Hitler during his first radio speech as Reich Chancellor. February 1, 1933. *Bayerische Staatsbibliothek/ Fotoarchiv Hoffmann*

anxieties into political measures that eradicated civil liberties and democracy. Hitler dissolved the Reichstag and called for new elections. Using emergency constitutional powers, Hitler's cabinet issued the Decree for the Protection of the German People on February 4, 1933, which placed constraints on the press and authorized the police to ban political meetings and marches, effectively hindering electoral campaigning.[2] This temporary measure was followed by a more dramatic and permanent suspension of civil rights following the February 27 burning of the Reichstag building. Though the origins of the fire are still unclear, the Hitler regime blamed the Communists and used the event as a pretext to crack down on political opposition. The Decree for the Protection of the People and the State on February 28 suspended the rights to assembly, freedom of speech, freedom of the press, and other constitutional protections and permitted the regime to suppress publications and to arrest and incarcerate political opponents without a specific charge. Some four thousand Communist Party functionaries were arrested, and the party headquarters was shut down. The Nazi press, and even the independent news agencies, described the Reichstag fire as the work of the Communists and a signal for their planned uprising. Although the Communists had not, in fact, developed any plans for such an uprising, the impact of propaganda and terror on a population harboring exaggerated fears of a Communist takeover succeeded in convincing many Germans that Hitler's decisive action had saved the nation from "Bolshevism."

The Nazi Party did well at the polls in the last free elections of March 5, 1933. Winning more than seventeen million votes, or almost 44 percent of the total cast, enabled the party to maintain its coalition government with the ultraconservative German National People's Party. For Hitler and the Nazi leadership who had

RIGHT: An SA-man guarding members of the German Communist Party being held in the basement jail of SA barracks, Berlin, April 1, 1933. *BAK, Bild 102-02920A*

OPPOSITE: Poster for the exhibition *Bolshevism: Great Anti-Bolshevist Show*, 1937. *SuperStock*

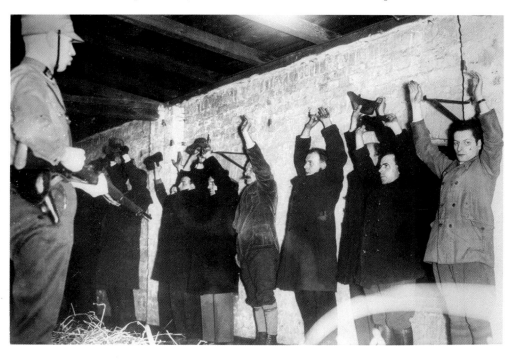

STATE OF DECEPTION: THE POWER OF NAZI PROPAGANDA

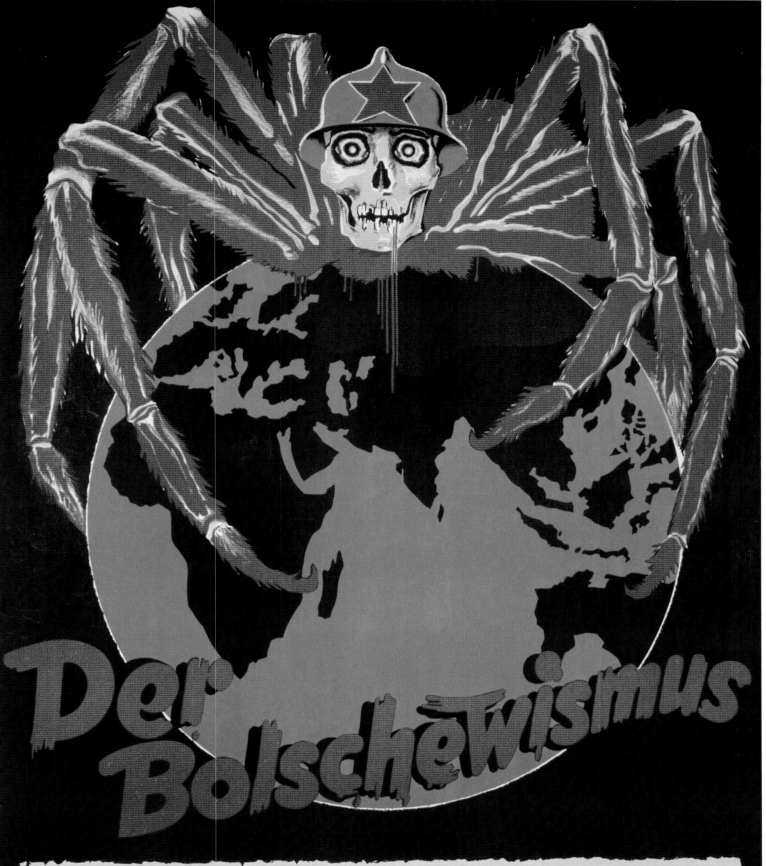

Der Bolschewismus

Große antibolschewistische Schau
Dortmund

Hochschule für Lehrerbildung **Dortmund** gegenüber der Westfalenhalle

Täglich von 10–22 Uhr geöffnet

Einlaßkarten zum Preise von RM 0,30 bei allen Dienststellen der Partei, an der Kasse RM 0,50

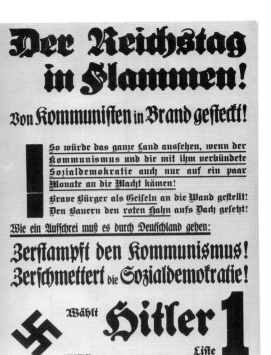

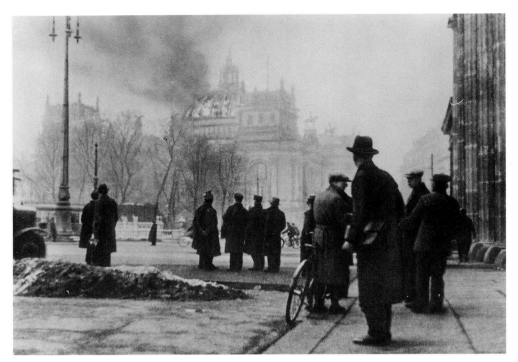

expected to win a substantial majority, the results were a disappointment, however. By late March, Hitler's regime successfully manipulated the Reichstag to vote itself out of existence by passing an Enabling Act that allowed the government to enact legislation without parliamentary approval. Of the 441 delegates in parliament, only the 96 delegates of the Social Democratic Party voted against the measure. A ban on the Communist Party, which received almost five million votes in the election, had prevented its 81 representatives from taking their seats.[3]

Over the same months, SA storm troopers and members of the Nazi elite paramilitary corps, the SS (Schutzstaffeln), took to the streets to brutalize or arrest political opponents and incarcerate them in hastily established concentration camps. Nazi thugs broke into political party offices, destroying printing presses and newspapers. On March 20, 1933, SS leader Heinrich Himmler announced the opening of the Dachau concentration camp near Munich. By July, the various camps held nearly twenty-seven thousand persons in "protective custody," that is, without indictment or trial. Germany was transformed into a single-party state; all other political parties were simply banned or hounded into "voluntary" dissolution.

As the Nazi regime consolidated political power and eliminated political opposition, it began the work of creating a state propaganda apparatus to mobilize the population and facilitate the implementation of new policies. On March 13, 1933, Hitler established the Ministry of Public Enlightenment and Propaganda and appointed Nazi Party propaganda director Joseph Goebbels as his minister. In the Nazi Party daily, *Völkischer Beobachter*, Hitler stated that the "political decontamination" of German public life was a priority for the government and that "the whole educational system, theater, film, literature, the press, and broadcasting" would be used "as means to the end" of preserving "the eternal values" of the German people.[4]

The public burning of tens of thousands of allegedly "un-German" books in Berlin and many other major German cities dramatically symbolized the dawn of

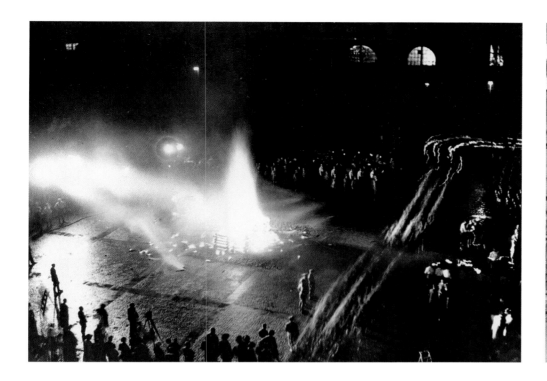

a new era of state censorship and control of culture. On May 10, 1933, right-wing university students marched in torchlight parades. Rituals scripted by the Nazi Student Association's press and propaganda section called for Nazi officials, university professors, and student leaders to address the crowds. At the meeting places, students threw the pillaged and unwanted books by Jewish, "Marxist," and pacifist authors into the bonfires with joyous ceremony, bands playing, parades, songs, and "fire oaths." The book burnings attracted widespread newspaper coverage. In Berlin and other places, radio broadcasts transmitted the speeches, songs, and ceremonial incantations live to countless German listeners. Speaking in Berlin, Goebbels said: "German men and women! The age of arrogant Jewish intellectualism is now at an end! . . . You are doing the right thing at this midnight hour—to consign to the flames the unclean spirit of the past. This is a great, powerful, and symbolic act. . . . Out of these ashes the phoenix of a new age will arise."[5]

NAZI CONTROL OF THE PRESS, RADIO, AND FILM

The book burnings coincided with a wider push to establish control over the instruments of mass communication, beginning with the press. When Hitler took power, the circulation of fifty-nine Nazi daily newspapers totaled only 782,121, representing less than 3 percent of German press readership.[6] The elimination of the multiparty system not only brought about the demise of hundreds of newspapers produced by outlawed political parties, but it also allowed the state to seize the printing plants and equipment of the Communist and Social Democratic Parties. These assets were often turned over to the Nazi Party. In the following months, the Nazis established control or exerted influence over independent press organs. Sometimes using holding companies to disguise new ownership, the party-owned publishing house, Franz Eher, established a huge empire that drove out competition and purchased newspapers

Poster "Out with the Jewish Haggling Mind," by artist Hans Schweitzer ("Mjölnir"), promoting the "Aryanization" of German businesses, ca. 1936–37. *USHMM*

at below–market prices. Some independent newspapers, particularly conservative newspapers and nonpolitical illustrated weeklies, accommodated to the regime through self–censorship or by taking the initiative in dealing with approved topics. Through measures to "Aryanize" businesses, the regime assumed control of Jewish–owned publishing companies, notably Ullstein and Mosse. Ullstein was the largest publishing company in Europe by 1933, employing ten thousand people. In 1933, the family was forced off the company's board and, a year later, made to sell its assets. In 1937, Ullstein was renamed *Deutsche Verlag*. Mosse owned a worldwide advertising agency and published a number of major liberal papers much hated by the Nazis, including the *Berliner Tageblatt* and the *Volkszeitung*. The Mosse family fled Germany soon after Hitler took power.[7]

The Propaganda Ministry, through the Reich Press Chamber, assumed control over the Reich Association of the German Press, the guild that regulated entry into the profession. Under the new Editors Law of October 4, 1933, the association kept registries of "racially pure" editors and journalists, thus excluding Jews and those married to Jews from the profession. Editors and journalists were expected to follow the mandates and instructions handed down by the ministry and had to be registered with the Reich Press Chamber to work in this field. Clause 14 of the law ordered editors to omit anything "calculated to weaken the strength of the Reich abroad or at home."[8] The Propaganda Ministry aimed further to control the content of news and editorial pages through directives distributed in daily conferences in Berlin and transmitted

JOSEPH GOEBBELS'S MINISTRY OF PUBLIC ENLIGHTENMENT AND PROPAGANDA

In the heady days after the Nazi electoral victories of July 1932, Hitler informed Goebbels that he intended to make Goebbels director of a new propaganda ministry when the Nazis took over the reins of national government. Goebbels soon envisioned an empire that would control schools, universities, film, radio, and propaganda. "The national education of the German people," he wrote, "will be placed in my hands."[9] Creating a propaganda ministry was a novel idea for a country at peace. Governmental propaganda organizations had tended to be temporary committees necessitated by war or disguised as ministries of information. Indeed, Goebbels initially opposed the term *propaganda*, recognizing that in popular usage, both in Germany and abroad, it was associated with lies. Even after the ministry had been in existence for a year, he proposed changing its name to Ministry of Culture and Public Enlightenment, but Hitler vetoed this proposal.[10] In addition, in keeping with his governing style of establishing ministries with overlapping responsibilities, Hitler retained propaganda offices that fell under others' control, including those of the ministries of Foreign Affairs and of Education. Even in the realm of culture and the arts, Goebbels's authority was far from absolute; Hitler, Nazi leader Hermann Göring, ideologue Alfred Rosenberg, and others created their own separate fiefdoms. Still, Goebbels wielded enormous clout. Film, radio, theater, and the press largely fell under Goebbels's jurisdiction (though he shared power over the press with the head of the Reich Press Chamber, Max Amann, the Nazi newspaper magnate, and after 1937 with Otto Dietrich, head of the Reich Press Office). Goebbels also continued as head of the party's propaganda apparatus that reached down to the local Nazi organizations. At the age of thirty-five, the youngest minister in the new cabinet, Goebbels became indispensable to the regime and to Adolf Hitler.

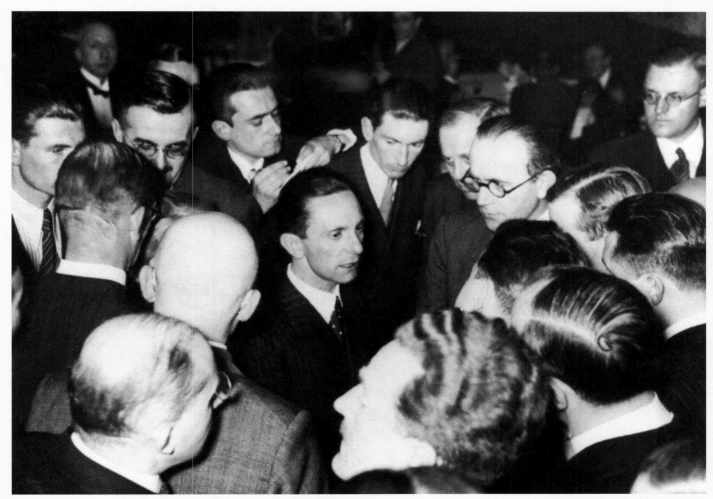

Goebbels answering journalists' questions at a press reception, Berlin, 1935. *BPK*

A Communist, artist John Heartfield (*left*) fled Germany in early 1933. He resumed work for the *Arbeiter-Illustrierte Zeitung* (Illustrated Workers' Newspaper) during his exile in Czechoslovakia. Prague, ca. 1936. *Akademie der Künste*

OPPOSITE: Advertisement for the "people's receiver": "Every National Comrade a Radio Listener!" ca. 1936. *BPK*

through the party propaganda offices to regional or local papers. Detailed guidelines stated what stories could or could not be reported and how to report the news. Journalists or editors who failed to follow these instructions could be fired or sent to a concentration camp. Reflecting in his diary on the press's loss of independence, Goebbels, a one-time journalist, wrote: "Any man who still has a residue of honor will be very careful not to become a journalist."[11]

If the Nazi Party had only limited access to radio broadcasts during the Weimar Republic, it gained, after 1933, almost complete control of this powerful, state-run medium. At the opening of the *Radio Exhibition* in Berlin in August 1933, Goebbels proclaimed that radio would be to the twentieth century what the press had been for the nineteenth, disseminating information even more rapidly to large numbers of people.[12] The director of the Propaganda Ministry's Broadcasting Department, Eugen Hadomovsky, said: "We radio people are marchers. We think of ourselves as the SA of propaganda. We march freely through the streets and enter every single house, so that the powerful current of National Socialist political and cultural ideas flows into each member of the nation. To work for the radio means: to work for the Party and the Führer."[13] To make German radio the tool of the Nazis required "cleansing" the Reich Broadcasting Company, the state agency that regulated German radio licensing and broadcasts, of noncompliant members. Goebbels encouraged company members to begin this purge themselves, warning that if they were unwilling or unable to do this, it would be done for them. Subsequently, hundreds of state radio employees were fired from their positions.[14] The directors of Reich Broadcasting's nine regional radio companies were brought under the Propaganda Ministry's control.[15] Goebbels restricted the airtime given to blatant political propaganda and expanded entertainment, including special programs for women and for children. Growing numbers of Germans bought inexpensive sets called "people's receivers" (*Volksempfänger*), making the radio audience the largest in the world after that in the United States. Even factories, offices, schools, and restaurants were equipped with radio receivers, and when a major announcement or Nazi speech was to be aired, "radio wardens" placed loudspeakers in public squares. Sirens would blare, and work would stop for the "national moment." This "community listening" strove to break down individualism and forge bonds of patriotic unity. The radio wardens, loyal Nazi Party members, encouraged people to listen to the broadcasts and reported listeners' comments on the programs. During the war, the wardens informed on individuals who illegally listened to foreign broadcasts.[16]

In the new age of motion pictures with sound, Germans flocked to film theaters, and Hitler and Goebbels recognized the enormous propaganda potential of the medium. Created on July 14, 1933, the Reich Film Chamber, like the Press Chamber, controlled entry into the business, determining who could direct, act, or otherwise participate in film production. Jews, political undesirables, and other "degenerate artists" were driven from the industry, while Nazi propagandists used the changes to stoke antisemitic feelings. The Propaganda Ministry also stepped up the censorship of films under the Reich Cinema Law of February 1934, a revision of an existing Weimar statute. A new position of pre-censor was created. This Reich Film Director had to approve a film concept before it was produced, and Goebbels acquired the right to ban any film, a power he used in an increasingly arbitrary

JEDER VOLKSGENOSSE
Rundfunkhörer!

REICHSVERBAND DEUTSCHER RUNDFUNKTEILNEHMER E.V.

UHLEN

DRUCK: HOLLERBAUM & SCHMIDT BERLIN N65

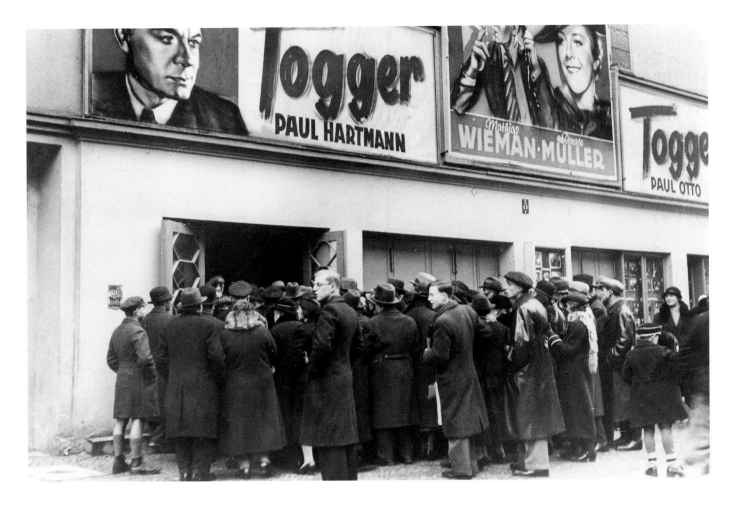

Moviegoers, Berlin, 1937. *Ullstein Bild/The Granger Collection, New York*

manner. The Nazi regime also slowly assumed direct control and ownership of private companies. In March 1937, it acquired Ufa (*Universum Film*), the largest German film company. By 1942, using a giant holding company known as Ufi, the regime had effectively nationalized the German film industry. By maintaining the illusion of a private film industry, the regime could also directly benefit from the profits of the sector.[17]

In the absence of public opinion polls, the Nazi regime relied on the regular "Situation" and "Morale Reports" of internal agencies (Party, State, Police, Justice, SS Security Service) to keep tabs on the population's response to its policies and propaganda. Officials themselves recognized the difficulty of obtaining honest comments from citizens or any comments at all because of people's fear of speaking openly but still found the reports vital. Even under the dictatorship, Nazi leaders could not totally ignore popular opinion, requiring at least the tacit consent if not the positive support of the population to administer policies. Thus a central Nazi Party directive of November 11, 1938, reminded regional leaders of the need for regular, truthful, and detailed reporting, because it "enabled the Head of the Party Chancellery to form a picture of the worries and needs of the people and to eliminate arising defects and shortcomings." The Nazi Party reports included a regular feature that covered evaluations of various propaganda measures, such as the effectiveness of films, broadcasts, and newspaper articles. First issued in February 1937, the reports of the Security Service (Sicherheitsdienst, or SD) generally delved deeper

TELEVISION'S INFANCY IN NAZI GERMANY

Nazi Germany pioneered in the field of broadcast television, although the medium never developed sufficiently to become a major instrument of propaganda. In the Weimar years, the national government heavily subsidized research and technological developments in communications, and the new regime built on this groundwork. In 1935, Eugen Hadomovsky, the Reich's Director of Broadcasting, announced the launch of the first regular television service in the world. The Nazi-controlled media hailed the new technology as a sign of Germany's economic strength and scientific achievements.[18] In contrast to the United States and Great Britain, television viewing in Nazi Germany was deemed to be a collective activity. To achieve this, special auditoriums were created that seated from several dozen to several hundred people. In 1936, Germans could watch the Berlin Summer Olympics on live television, as well as about three hours of daily broadcasts. This viewing time more than doubled by the early 1940s. Eventually, the government approved the manufacture of an inexpensive "people's television receiver" (*Fernseh-Volksempfänger*), but the product came too late. The outbreak of the war in 1939 curtailed this planned development; only about two hundred television sets were sold in Germany, compared to the millions of radios licensed for German homes. Wartime priorities took precedence, and the television technology was turned over for military production.[19]

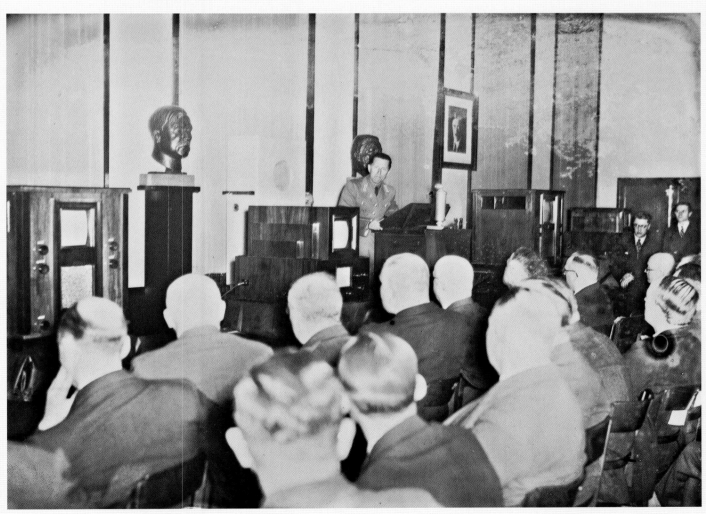

Communal television viewing room, ca. 1936–39. *NARA*

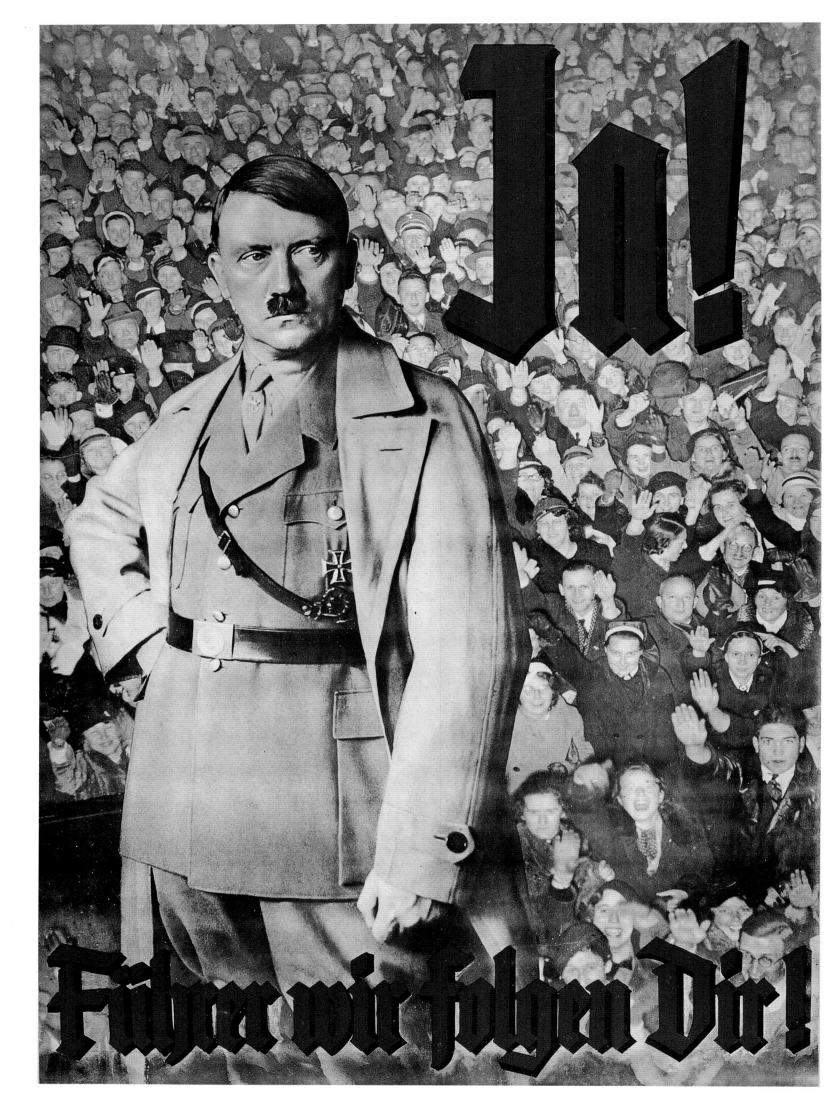

and better reflected the ups and downs of popular opinion, since they were not as biased toward presenting a positive picture of popular morale.[20] The SD reports reveal that people did voice criticisms of the regime's shortcomings, which sometimes spurred adjustments not only in propaganda messages and tactics but also in policy if it appeared that a particular approach was not working. [21]

WINNING THE MASSES: TWO PROPAGANDA MYTHS

With state control in place over the mass media and educational and cultural institutions, Nazi propagandists cultivated and helped sustain the popularity of two myths, those of *Der Führer*, the Leader, and of the *Volksgemeinschaft*, the national community. Both incorporated the ultranationalistic, antiliberal goals promoted by the Nazis during their rise to power by stressing the unity of all Germans and the value of the national collective over the individual. Although the Führer cult developed in the Nazi Party during the 1920s, after they came to power the Nazis aimed to transform Adolf Hitler from the leader of a popular political party into the leader of all Germans. The "Heil Hitler" greeting, made compulsory for party members in 1926, was now demanded of all Germans. The upraised-arm salute symbolized allegiance to the new regime and helped enforce political conformity. By refusing to salute, one was publicly expressing opposition to Hitler and Nazism, an offense punishable by separation from the national community. Pictures, posters, and slogans of Hitler provided an ever-present reminder of the need to show one's conformity. "One People, One Reich, One Führer" became the watchword of the day.[22]

While explicit and implicit coercion played a role in inducing Germans to conform to the new realities and party goals, Nazi successes in foreign policy, domestic social policy, and the economy reinforced the appeal of the messages. "It was fun to be a German again," one former member of the Hitler Youth recalled.[23] Hitler, as Nazi propagandists continually proclaimed, had initiated the rebirth of Germany, had broken the power of the Social Democrats and others accused of causing the nation's defeat in World War I, and was removing the shame of the Versailles Treaty. Goebbels's representatives incessantly promoted the "propaganda of the deed," contrasting the economic improvements of Germany under Hitler with the unemployment and pain of the Weimar Republic. This propaganda was not always successful, given the continuing real economic hardships that many Germans experienced. Goebbels's campaign in May 1933 to quiet reported discontent, for example, failed to change the population's mood, but unhappiness remained at the level of grumbling rather than political opposition.[24]

Propaganda linked to Germany's foreign policy successes and the cult of the Führer more successfully played to existing feelings. The reoccupation of territories occupied or lost during the war and the "peaceful" conquests in 1938 of Austria and the Sudetenland came at little cost to Germany and gave a tremendous boost to German national pride and self-esteem. Hitler was presented as a brilliant statesman, a figure picked by "destiny" to lead the nation out of misery, and a vehicle through whom the German people spoke. Hitler was "a man of the people" who restored German glory, created hope for the future, and sought to create a harmonious national community that would eliminate conflict between the working and middle classes, between

Bronze bust of Hitler, by Emil Hub. *U.S. Army Center of Military History*

OPPOSITE: Poster "Yes! Führer, We Will Follow You!" 1934. *Staatsarchiv Bremen*

An example of "propaganda of the deed," this poster by artist Werner von Axster-Heudtlass depicts the fulfillment of Hitler's promise to motorize Germany, 1936. *BAK, Plak 003-003-031*

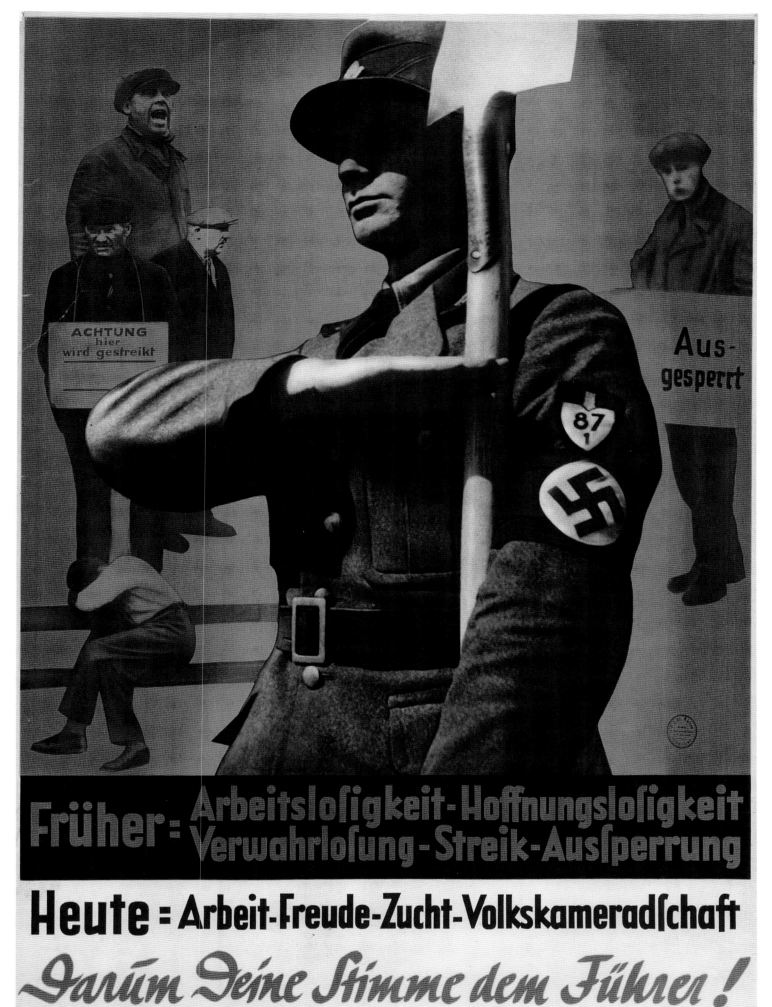

This poster proclaims "Before: Unemployment, Hopelessness, Neglect, Strikes, Lockouts; Today: Work, Joy, Order, National Camaraderie," 1936. *BAK, Plak 003-003-025*

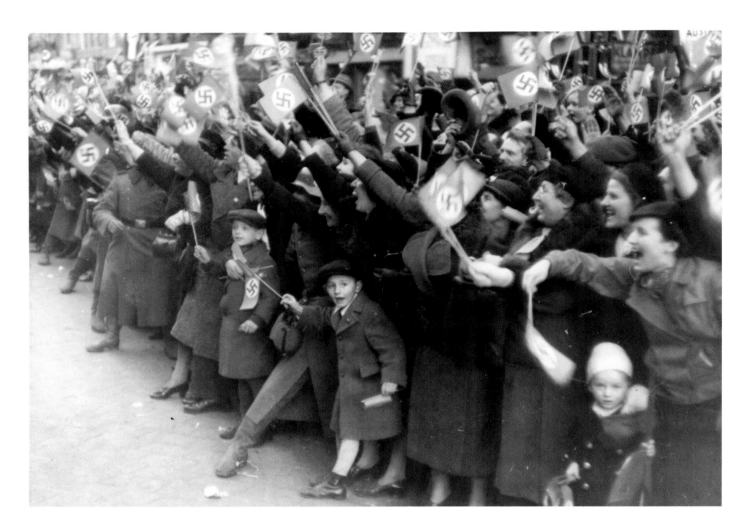

Members of the "national community" at a parade welcoming Hitler in the Sudetenland, October 1938. *Robert Hunt Library*

northerners and southerners, and between Protestants and Catholics for the benefit of all Germans.

Why was the vision of the national community, the *Volksgemeinschaft*, so appealing? Like many Nazi messages, this ideal inspired Germans for diverse reasons. The political and economic turmoil of the Weimar years undermined German support for democracy and created a yearning for stability, peace, unity, and order. The Nazi ideal of a cohesive community of the people drew on older German traditions promoting social harmony over conflict and extolling middle-class ideals of hard work, clean living, and law and order.[25] Another source of the concept's popular appeal came from its linkage to the first weeks of World War I, when all the German political parties seemingly suppressed their parochial interests to those of the nation and united in common cause.[26] Still others found the concept attractive not because of conservative yearnings looking backward, but because it promised a new order. Invoking negative memories associated with the war, the Nazis believed the kaiser's effort to form a *Volksgemeinschaft* failed both because it was too broadly defined, incorporating such racial and political elements as Jews and "Marxists" who undermined its very foundations, and because the interests it protected, those of the large industrialists and landowners, were too narrow and divisive.

One of the strongest elements in the Nazi appeal to Germans, particularly those born after 1900, was the claim to be engaged in creating a true *Volksgemeinschaft*,

the very existence of which would equitably reconcile competing economic interests within Germany while excluding "foreigners" from the racially defined nation (*Volk*). Young Germans seeking belonging in a group or community were especially receptive to this theme. "No catchword has ever fascinated me quite as much as that of the *Volksgemeinschaft*. I heard it first from the lips of [my mother's] crippled and care–worn dressmaker and, spoken on the evening of [Hitler's ascendancy to the chancellorship], it acquired a magical glow," recalled journalist Melita Maschmann, a former press and propaganda officer for the League of German Girls, who later tried to understand her attraction to Nazism. "The manner of my first encounter with it, fixed its meaning for me: I felt it could only be brought into being by declaring war on the class prejudices of the social stratum from which I came and that it must, above all, give protection and justice to the weak. What held my allegiance to this idealistic fantasy was the hope that a state of affairs could be created in which people of all classes would live together like brothers and sisters."[27]

The Nazi Party considered itself the party of youth and viewed young Germans as critical to the development of the "new Germany." By introducing the subject of racial biology into the school curriculum, mandating the teaching of the doctrine of the national community in this and other classes such as history, and setting the contents of textbooks, the Ministry of Education disseminated the new regime's messages to youth.[28] The virulently nationalistic youth organizations created by the Nazi Party

Girls hanging a poster advertising the League of German Girls: "Girl, Come. You, Too, Are Part of Us." *BAK, Bild 133-130*

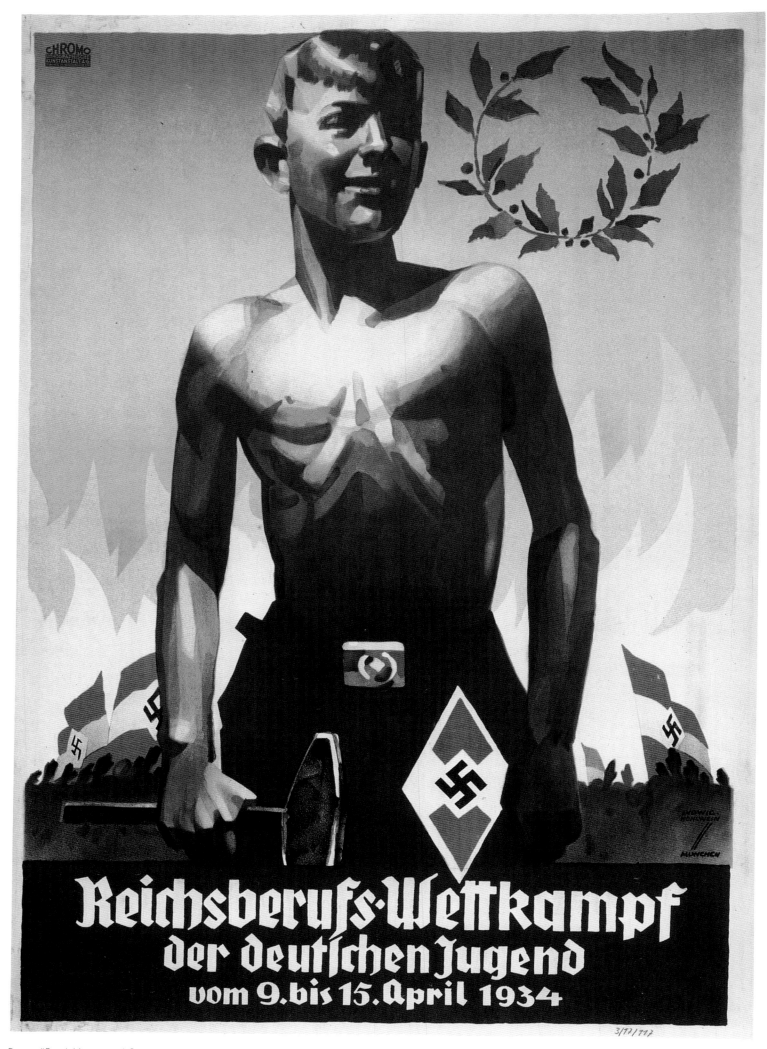

Poster "Reich Vocational Competition for German Youth," by artist Ludwig Holbein, 1934. *BAK, Plak 003-017-117*

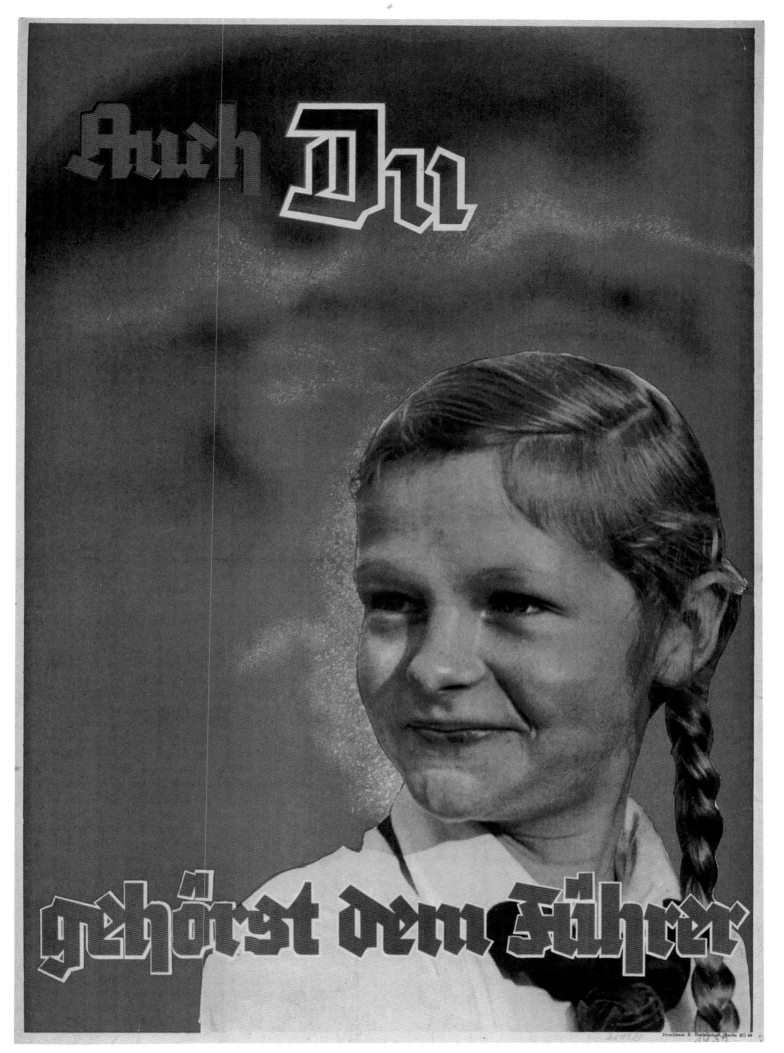

Poster "You, Too, Belong to the Führer," 1937. *BAK, Plak 003-011-009*

Hitler Youth armband. *USHMM, gift of William and Joyce Becker*

before 1933, the Hitler Youth and the League of German Girls, attracted many new adherents, and membership became compulsory in 1939 after most Catholic and other non-Nazi youth groups had been abolished. The British historian Stephen Roberts, a foreign observer writing in 1937, found "distressing" German students' "worship" of Hitler: "It is this utter lack of any objective or critical attitude on the part of youth, even with university students, that made me fear the most for the future of Germany. They are nothing but vessels for State propaganda."[29]

The myths of the Führer and the *Volksgemeinschaft* as well as the Nazi movement's appeal to youth were well captured in the film *Triumph des Willens* (Triumph of the Will), produced by Leni Riefenstahl. Commissioned by Hitler for the purpose of propaganda and released in 1935, this documentary of the 1934 Nazi Party rally in Nuremberg was a box-office success, contributing to the glorification of Hitler, and continued to be shown in Germany until 1945.[30] Hitler's architect, Albert Speer, designed the theatrical setting for the rally, which included speeches by Hitler and other Nazi leaders, a Hitler Youth gathering, and torchlight parades. *Triumph of the Will* opens with Hitler's plane descending, godlike from the clouds, floating over the assembled masses, and ends with stirring music by Richard Wagner, Hitler's speech, and the crowd singing, as one, the "Horst Wessel Song." The film portrayed the Nazi Party as the embodiment of the nation's resurgence and Hitler as the savior of the "new Germany." *Triumph of the Will* captured the Gold Medal at the 1935 Venice Film Festival and the Grand Prix at the 1937 Paris Film Festival.[31] In 1937, Riefenstahl

Toy figurines with moveable right arms. *USHMM, gift of Christine Heiberg*

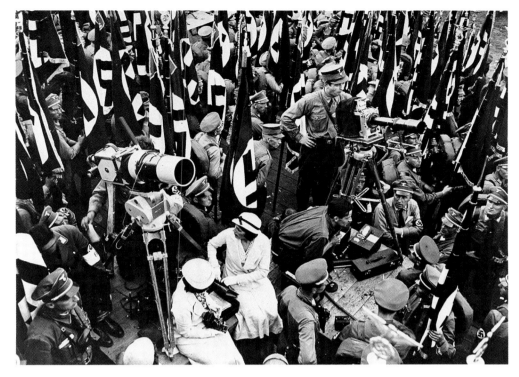

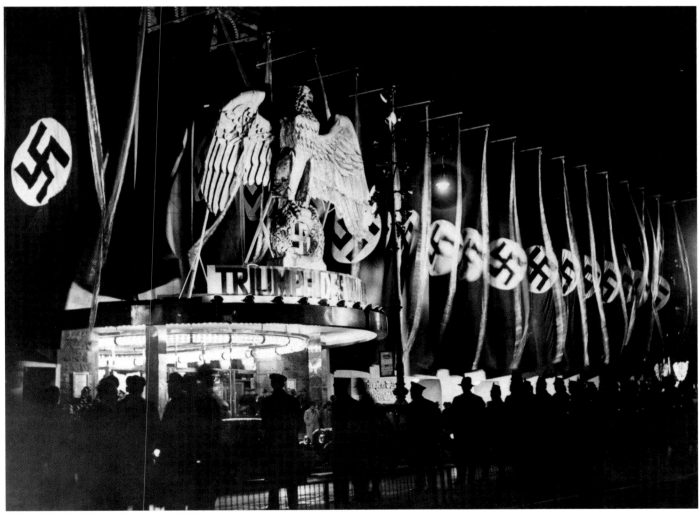

THE 1936 OLYMPICS: SHOWCASING THE "NEW GERMANY"

The 1936 Olympics offered Nazi Germany a superb propaganda opportunity. The participation of the United States, Great Britain, France, and forty-five other nations in the Summer Games in Berlin lent legitimacy to the new regime both domestically and internationally. The International Olympic Committee had chosen Berlin as the site for the games before the Nazis seized power: because the Nazis held in low regard the internationalism represented by the Olympics, Hitler was not initially convinced that Berlin should in fact host the games. Once Goebbels convinced Hitler of the propaganda dividends that the games might bring, the regime provided full financial support, twenty million reichsmarks ($8 million), including the construction of a new stadium. Visiting athletes and spectators were struck by the organization, modern facilities, and dazzling German hospitality. Everything was done to create a positive impression—and to deceive visitors. Antisemitism was downplayed. Anti-Jewish signs

Reporters at the Olympic Stadium covering the Berlin games, August 1–16, 1936. *NARA*

were removed from major roads and other places likely to be viewed by tourists.[32] In order not to draw attention to Germany's rearmament program, the Propaganda Ministry's Reich Press Chamber instructed newspapers: "The northern section of the Olympic village, originally utilized by the Wehrmacht [German armed forces], should not be referred to as Kaserne [barracks], but will hereafter be called North Section Olympic Village." Other directives warned editors about language to use in stories on Jesse Owens and other African American Olympians: "The racial point of view should not be used in any way in reporting sports results; above all Negroes should not be insensitively reported"; "Negroes are American citizens and must be treated with respect as Americans."[33] In Berlin, the rabidly antisemitic *Der Stürmer* was removed from public display. After the closing ceremonies for the games, U.S. journalist William Shirer observed in his diary, "I'm afraid the Nazis have succeeded with their propaganda. First, the Nazis have run the Games on a lavish scale never before experienced, and this has appealed to the athletes. Second, the Nazis have put up a very good front for the general visitors, especially the big businessmen."[34]

Berlin street scene during the 11th Olympiad, August 1–16, 1936. *SZ Photo/Scherl*

Poster advertising "The Gods of the Stadium," part two of the documentary film *Olympia*, directed by Leni Riefenstahl, 1938. *USHMM*

finished editing an award-winning documentary of the 1936 Olympics in Berlin. *Olympia*, released in 1938, provided the Hitler regime another propaganda tool to promote Nazi Germany at home and abroad.

ANTI-JEWISH PROPAGANDA CAMPAIGNS

Determining who was and who was not a full-fledged member of the national community, and what to do with those who were not "national comrades" (*Volksgenossen*) became key issues for state and party bureaucrats, the police and the SS, as well as propagandists. Propaganda publicly identified who would be excluded from the new society and justified measures against the "outsiders": Jews, Gypsies (Roma and Sinti), homosexuals, political dissidents, and Germans viewed as genetically inferior and harmful to "national health" (persons with mental illness and disabilities, or epilepsy, congenital deafness and blindness, chronic alcoholism, drug addictions, and others). "I became a National Socialist because the idea of the national community inspired me. What I had never realized was the number of Germans who were not considered worthy to belong to this community," said Melita Maschmann in her postwar memoirs written in the form of a report to a former Jewish friend. "The fact that you, for example, were not allowed to belong to the national community I overlooked for as long as I could."[35]

Exploiting preexisting images and stereotypes, Nazi propagandists portrayed Jews as an "alien race" that fed off the host nation, poisoned its culture, seized its economy, and enslaved its workers and farmers. This hateful depiction, although neither new nor unique to the Nazi Party, now moved from the realm of the party

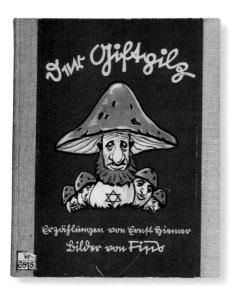

ABOVE: The antisemitic children's book *Der Giftpilz* (The Poisonous Mushroom), distributed by *Der Stürmer*'s publishing house, 1938. *USHMM*

RIGHT: German children reading the antisemitic schoolbook, *The Poisonous Mushroom*, 1938. *Stadtarchiv Nürnberg, E39 Nr. 2381/5*

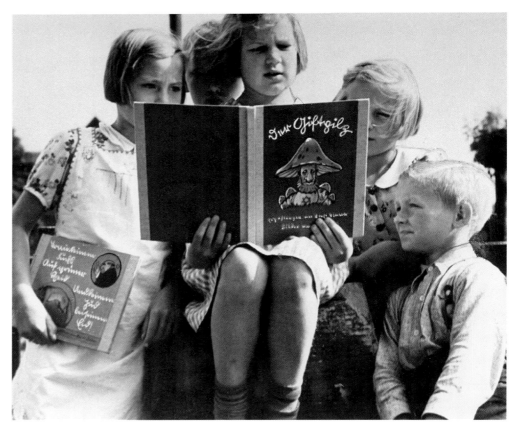

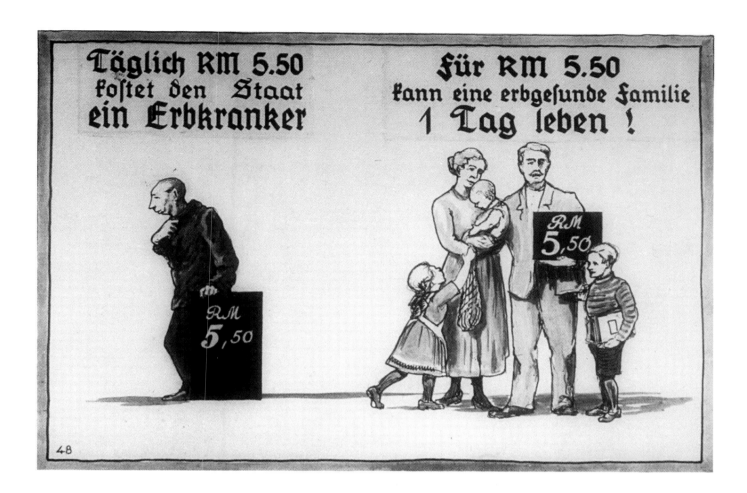

Täglich RM 5.50 kostet den Staat ein Erbkranker

Für RM 5.50 kann eine erbgesunde Familie 1 Tag leben!

48

Propaganda slide produced by the Reich Propaganda Directorate stating that the daily cost of feeding a person with a hereditary disease is the same as that for an entire family of healthy Germans, 1936. *USHMM, courtesy of Roland Klemig*

press to become a major component of a state-supported ideology. Nazi changes to the educational curriculum brought antisemitic content into the school classroom, most overtly through science classes in which teachers used instructional materials that portrayed Jews as a mixture of non-European races and depicted the "mixing" of Jews with "German-blooded" persons as a threat to racial purity and national "health." As the Nazi regime's control over the press and publishing tightened after 1933, propagandists tailored messages to diverse audiences, including the many Germans who were not Nazis and who did not read the party papers. The Nazis offered antisemitic language and viewpoints in more subtle tones for educated, middle-class Germans offended by the crude caricatures and sensationalist stories of *Der Stürmer*. In biology, criminology, and anthropology textbooks, writers presented antisemitic ideas under the guise of objective research, and antisemitic propaganda similarly gained respectability and seemed more credible when university professors and religious leaders incorporated it into their lectures and church sermons. Nazi control of cultural institutions, such as museums, through the Reich Chamber of Culture created new opportunities to disseminate anti-Jewish propaganda in exhibitions, notably *The Eternal Jew*, which attracted 412,300 visitors, more than five thousand per day during its run at the Deutsches Museum in Munich from November 1937 to January 1938; the exhibition was accompanied by special performances of the Bavarian State Theater reiterating the exhibition's main themes.[36] The Nazis also associated Jews with "degenerate art," the subject of another exhibition in Munich seen by two million people.[37]

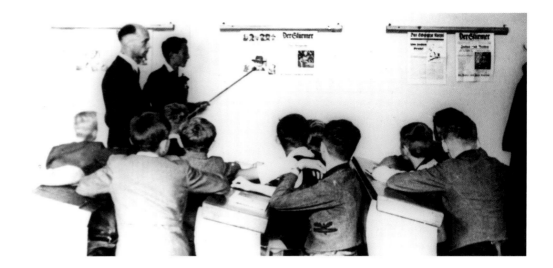

Teacher using the antisemitic *Der Stürmer* as educational material, 1935. *BPK*

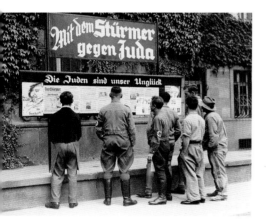

ABOVE: Public display of *Der Stürmer*, Worms, August 1935. The case headers read "With *Der Stürmer* against World Jewry" and "The Jews Are Our Misfortune." *BAK, Bild 133-075*

RIGHT: Visitors lining up at the entrance of *Der ewige Jude* (The Eternal Jew) exhibition held at the library of the Deutsches Museum in Munich, November 8, 1937. *BAK, Bild 119-03-16-06*

OPPOSITE: Poster, by artist Hans Stalüter, advertising the exhibition *The Eternal Jew*, Munich, 1937. *USHMM, courtesy of Julius Goldstein*

During periods preceding legislative or executive measures against Jews, propaganda campaigns created an atmosphere tolerant of violence against Jews or encouraged passivity and acceptance of the impending measures if the public viewed them as a way to restore order. Beginning with the first major anti–Jewish measure, the boycott of German–Jewish businesses organized by the Nazi Party for April 1, 1933, propagandists tried to shape public opinion, by calling the boycott a response to the atrocity stories that "world Jewry" had spread about Nazi Germany. The propaganda was not wholly successful, as many Germans continued to patronize Jewish businesses. The failure of the boycott did not prevent one of Germany's Protestant leaders, Bishop Otto Dibelius, from defending the Nazi measure in a radio broadcast on April 4 to the United States. A few days later, he declared himself an antisemite in an Easter letter sent to his pastors, writing, "One cannot ignore that Jewry has played a leading role in all the destructive manifestations of modern civilization."[38]

Propaganda also helped lay the groundwork for the promulgation of major anti–Jewish statutes at Nuremberg on September 15, 1935. The decrees followed violent

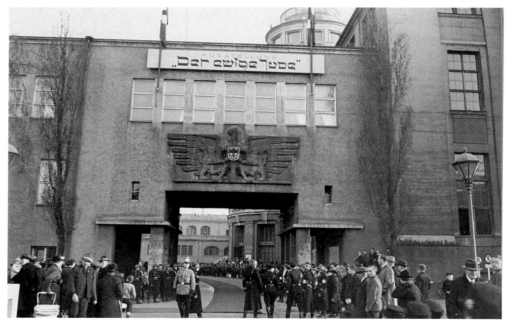

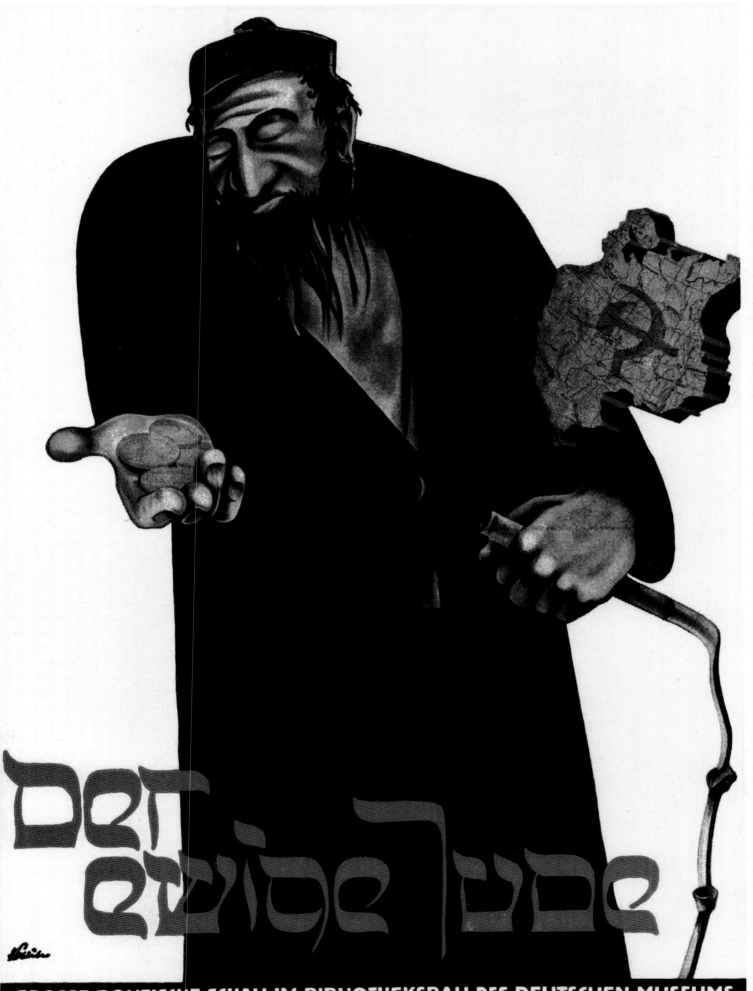

DER EWIGE ‏יהודה‏

GROSSE POLITISCHE SCHAU IM BIBLIOTHEKSBAU DES DEUTSCHEN MUSEUMS
ZU MÜNCHEN · AB 8. NOVEMBER 1937 · TÄGLICH GEÖFFNET VON 10-21 UHR

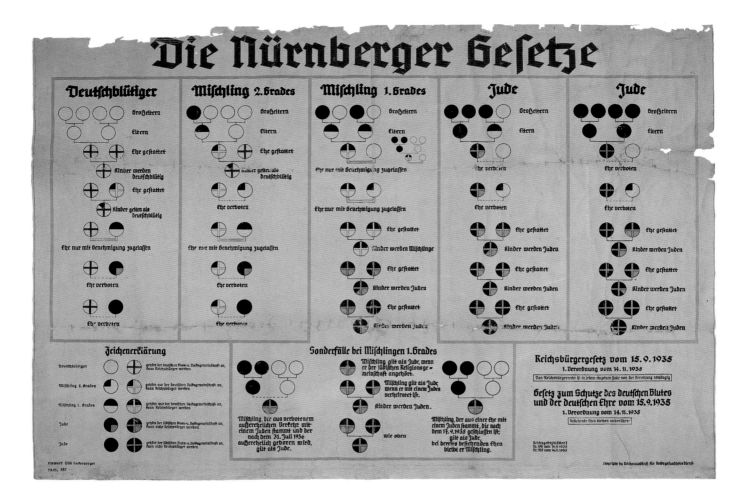

attacks on Jews perpetrated by impatient party radicals. The Law for the Protection of German Blood and Honor prohibited marriage and extramarital sexual relations between Jews and persons of "German" or "related blood," and the Reich Citizenship Law defined Jews as "subjects" of the state, a second-class status. The laws affected some 450,000 full Jews (those with four Jewish grandparents and belonging to the Jewish religion), and 250,000 others (including converted Jews and *Mischlinge* who had some Jewish parentage), altogether slightly more than 1 percent of the German population. For months before the announcement of the "Nuremberg Laws," the Nazi Party press "spared no effort to fan the fury" of Germans against racial pollution, with the presence of Jews in public swimming pools becoming a major theme.[39]

Hitler himself linked the new laws to the danger of Bolshevik agitation. But indicative of a climate that saw some Jews returning to Germany, believing that the worst was over and "order" restored by the racial laws, Hitler showed relative restraint in public remarks on the "Jewish-Bolshevist" threat. His first strident public attack on "world Jewry" did not come until two years later, when he gave a major speech before the party congress on September 13, 1937, invoking the threat of "Jewish Bolshevism" to

ABOVE: Teaching chart "The Nuremberg Laws," ca. 1936–1939. *USHMM, gift of the Hillel at Kent State University*

BELOW: *Der Stürmer* photograph of Jewish children being ejected from a public swimming pool in Bad Herweck, Mannheim, 1935. *Wiener Library, London*

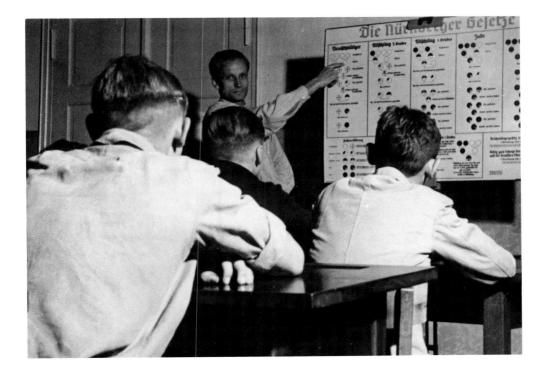

Teacher at a Hitler Youth camp explaining racial categories ("German-blooded," "Mischling 2nd degree," "Mischling 1st degree," and "Jew") applied by officials implementing the Nuremberg Laws, September 1939. *SZ Photo/Scherl*

"Europe's civilized nations."[40] In this 1937 speech, he said: "National Socialism has banished the Bolshevist world menace from within Germany. It has ensured that the scum of Jewish *literati* alien to the *Volk* does not lord it over the proletariat, that is the German worker. . . . It has, moreover, made our *Volk* and the *Reich* immune to Bolshevist contamination."[41]

Although many Germans found this political rhetoric tedious, just as most disapproved of anti–Jewish violence, the dislike of Jews, easily stirred up in hard times, extended far beyond Nazi Party stalwarts.[42] The majority of Germans at least passively accepted the discrimination against Jews. Four months after the promulgation of the Nuremberg Laws, an underground report prepared in January 1936 by an observer from the Socialist Democratic Party for party leaders in exile noted: "The feeling that the Jews are another race is today a general one."[43] While many Jews in Germany, like their non–Jewish neighbors, hoped that the legal framework of segregation signaled the end of violence, some individuals, like prominent surgeon Georg Klemperer, made plans to emigrate because he did not want "to live under the guillotine."[44]

MANIPULATING THE PRESS: *KRISTALLNACHT*

The events of November 9–10, 1938, marked the culmination of a year of increasing street violence against Jews and a turning pointing in the anti–Jewish policy of the Nazi regime. On that night and continuing into the next day, the Nazi leadership unleashed a nationwide series of pogroms against the Reich's Jews in response to the assassination two days earlier in Paris of a German diplomat, Ernst vom Rath, by a young Jewish refugee, Herschel Grynszpan. Disguised as civilians, SA– and SS–men along with other party members took to the streets of Germany's cities, damaging and destroying some 7,500 Jewish businesses, setting ablaze hundreds of synagogues, and destroying countless Jewish homes. The Gestapo (Secret State Police) rounded up

almost thirty thousand Jewish males and transported them to the Dachau, Buchenwald, and Sachsenhausen concentration camps. Nazi thugs killed more than ninety Jews in this day of massive violence. After *Kristallnacht* (commonly known as "The Night of Broken Glass" for the destroyed shop windows), the pace of Jewish emigration rapidly increased, as did Jewish suicides.

A propaganda offensive accompanied the events surrounding *Kristallnacht*. Just as Nazi leaders had set the anti–Jewish pogrom into motion, they dictated the press coverage of *Kristallnacht*. First, although the assassin, Grynszpan, was a lone shooter avenging the Nazi government's deportation of his parents (along with between twelve thousand and seventeen thousand other Polish Jews residing in the Reich) across the German border into Poland, the Propaganda Ministry instructed the press to portray the murder as the act of a terrorist linked to an émigré Jewish clique. At the same time that the Paris event captured German headlines, newspapers linked the new story to the 1936 murder of a Nazi Party official in Switzerland by a Jewish student, presenting both assassinations as elements of a concerted Jewish campaign to murder German politicians. Second, reflecting concern with the negative foreign and domestic reactions to the violence, directives instructed the German press not to publish any photographs of the damaged Jewish property, to bury the story on back pages, and to minimize the extent of the destruction. Newspapers were urged to describe the events

More than 10,000 German Jews arrested during the *Kristallnacht* pogrom were imprisoned in Buchenwald, ca. November 10, 1938. *American Jewish Joint Distribution Committee*

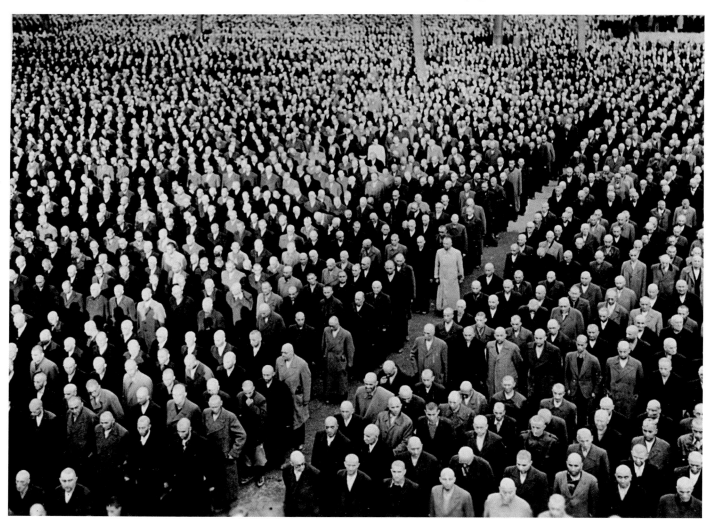

STATE OF DECEPTION: THE POWER OF NAZI PROPAGANDA

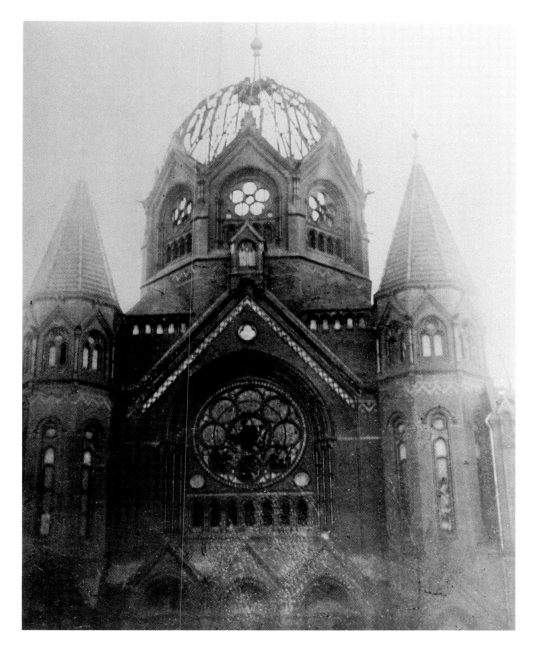

Synagogue destroyed by fire in
Königsberg, November 9–10,
1938. *Leo Baeck Institute, New York*

as the "spontaneous outrage" of the German people against the Jews for their criminal actions. Later directives ordered the press to publish the "punishments" to avenge vom Rath's murder, including an atonement tax of one billion reichsmarks levied on the Reich's Jews to cover damages done largely to their own property and the exclusion of Jewish children from German schools.

Throughout the globe, world leaders, prominent journalists, intellectuals, clergymen, and others expressed their shock at Nazi brutalities against the Jews. In the United States, public opinion turned firmly, and permanently, against Nazi Germany, as almost one thousand editorials appeared on *Kristallnacht* and numerous U.S. newspapers published front-page stories. Although editors and journalists differed on how they interpreted the events and what actions the United States should take, they almost all rejected Goebbels's claims that the violence was the result of spontaneous demonstrations of German popular rage. Informed by diplomats who also saw through

the propaganda minister's deception, President Franklin D. Roosevelt recalled the U.S. ambassador from Germany and publicly stated that he "could scarcely believe that such things could occur in a twentieth-century civilization."[45] German propagandists also deftly responded to mounting criticism from abroad, channeling and misdirecting the public's attention to other events and targets. Locked into a morally indefensible position by their government's actions, German newspapers were instructed to run stories of British atrocities in Palestine, under such headlines as "Concentration Camps for Arabs" and "British Starving out Arabs," and to publish articles indicating that other countries, such as Romania and France, were eager to solve their own "Jewish Questions." The Nazi government recalled its ambassador from Washington, while Nazi publications mocked Roosevelt's comments. The SS newspaper *Das Schwarze Korps* (The Black Corps) lambasted the democracies for their hypocritical attacks on the Reich by reminding readers of the lynchings of African Americans and the use of capital punishment in the United States. In later issues, *Das Schwarze Korps* published photographs of Jews arrested on *Kristallnacht* and transported to concentration camps. Presented in their prisoner uniforms, the individuals were identified and singled out by the captions as criminals.[46]

In the weeks and months following *Kristallnacht*, the Propaganda Ministry sought to create a favorable atmosphere for making Germany *judenrein*—"free of Jews"—through forced emigration. Many Jews, deprived of their property and livelihoods as a result of the implementation of anti-Jewish measures in the years leading up to *Kristallnacht* and

The Dallas Morning News, November 11, 1938. Reprinted with permission of The Dallas Morning News/AP Images

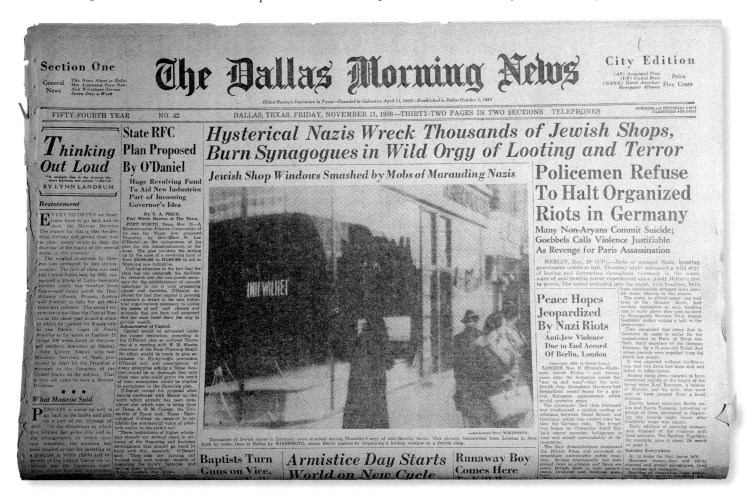

STATE OF DECEPTION: THE POWER OF NAZI PROPAGANDA

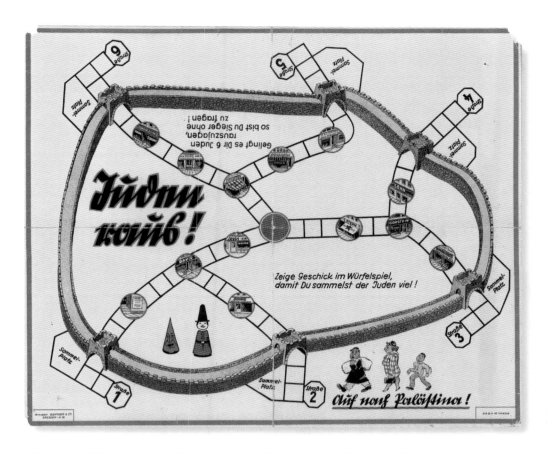

German board game titled "Jews Out!" *Leo Baeck Institute, New York*

the weeks following the violent attacks, did leave the Reich, driven by fear. The press was ordered not to print stories that might make German Jews hesitate to leave. In June 1939, when 907 mostly Jewish passengers of the MS *St. Louis* were denied entry into Cuba and the United States, the German media initiated a news blackout, fearing that such stories would discourage Jews from leaving.

PROPAGANDA, FOREIGN POLICY, AND THE DRIFT TOWARD WAR

Following the Nazi takeover in early 1933, a key element of German national policy was rearmament, which the German leaders hoped to achieve without precipitating preventive military intervention by France, Great Britain, or the newly created states on Germany's eastern borders, Poland and Czechoslovakia. The regime also did not want to frighten its own population, which was not eager to go back to war. To justify his stated goal and policy with minimal risk, Hitler played upon the injustice of the Versailles Peace Treaty, worked to isolate his potential enemies, and negotiated unilaterally with skeptical neighbors to prevent collective action against a Germany rendered militarily weak by the restrictions of the postwar treaty system.

Nazi propagandists succeeded not merely in convincing Germans to support Adolf Hitler or acquiesce in his foreign policy moves, but also in deceiving foreign politicians and the German public about the nature of the regime's true goals. Hitler played a double-sided game: he proclaimed his desire for peace while Germany rearmed for war.[47] During the Weimar years, Hitler had earned an international reputation as a rabble-rouser who condemned the Versailles Treaty and Allied policies toward a

PROPAGANDA AND PLEBISCITES

In October 1933, Germany withdrew from the League of Nations. Hitler put the matter before Germany in a plebiscite, an election by which the German populace could express their support or disfavor of this decision. A 1935 plebiscite dealt with the status of the Saarland, German territory adjacent to France and governed by the League of Nations under the Versailles Treaty, to determine whether the territory's residents should return the region to German sovereignty. Before each of these plebiscites—one national and one regional—Propaganda Minister Joseph Goebbels waged tireless campaigns to generate German support. The regime also hoped the plebiscites would show the world that the German nation stood behind Adolf Hitler. The plebiscites were resounding successes. In the vote on November 12, 1933, to ratify Germany's withdrawal from the League of Nations, 43.5 million Germans participated, approximately 96 percent of those eligible, and 40.5 million, or 95 percent of the voters, registered their support for Hitler's decision. Fifteen months later, 91 percent of the Saar's electorate—including two-thirds of the former supporters of the left-wing political parties—chose to "return to the Reich." The Nazi regime successfully continued its pre-1933 electoral strategy of tying arguments justifying its measures to themes and terms that most Germans would support.

One contemporary American political scientist expressed his amazement at the sophistication behind the mobilization of voters in the 1933 League of Nations plebiscite: "To mobilize almost forty-five million voters and so regiment their opinions on international and constitutional issues as to secure a favorable verdict little short of unanimity is a political achievement with few, if any, parallels. Should any doubts remain as to the practical political value of the Nazi propaganda ministry, or as to its effectiveness, these referenda must certainly dispel them." The author cautioned, however, that another lesson was to be drawn from Nazi plebiscites: "These same referenda . . . confirm the truth of the observation that liberal suffrage laws and success to 'getting out the vote' do not guarantee genuinely democratic government; that, on the contrary, such government depends primarily upon certain intangibles such as a free press and impartial officials, and above all upon an informed and critical electorate."[48]

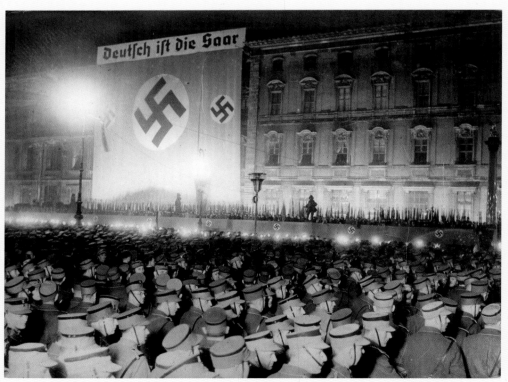

Storm troopers celebrating the return of the Saarland to the Reich ("The Saar Is German"), Berlin, January 1, 1935. *Ullstein Bild/The Granger Collection, New York*

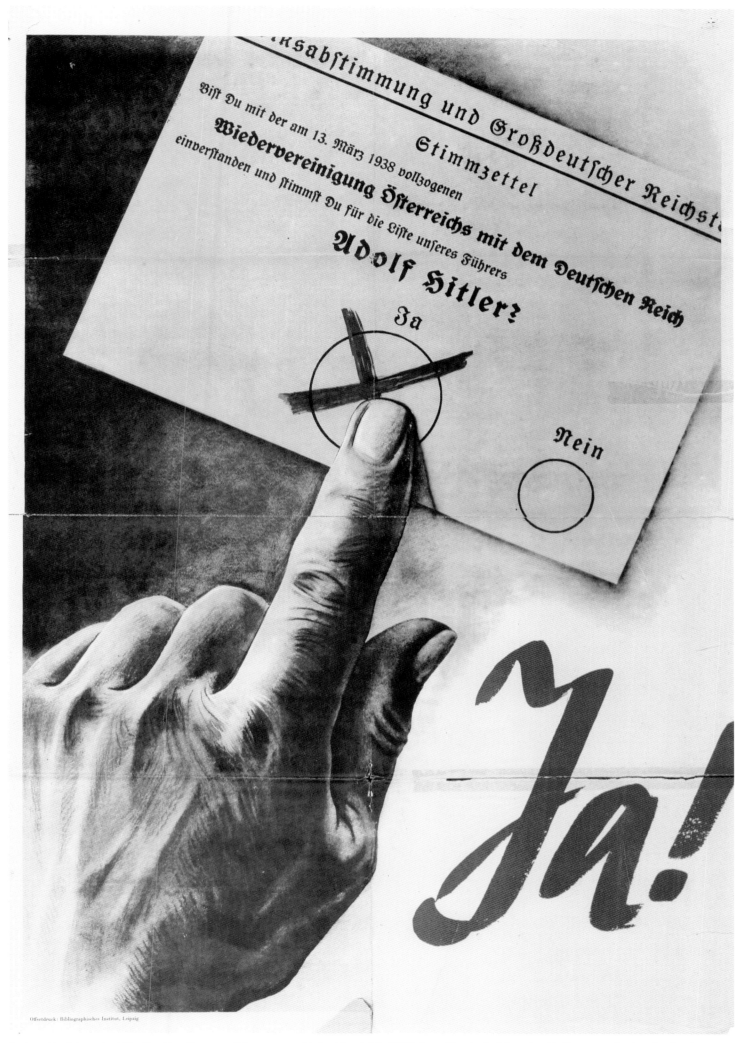

Poster of ballot marked "Yes!" asking Germans if they agree with the March 13, 1938, "reunification" of Austria with Germany. *Stadtarchiv Bamberg*

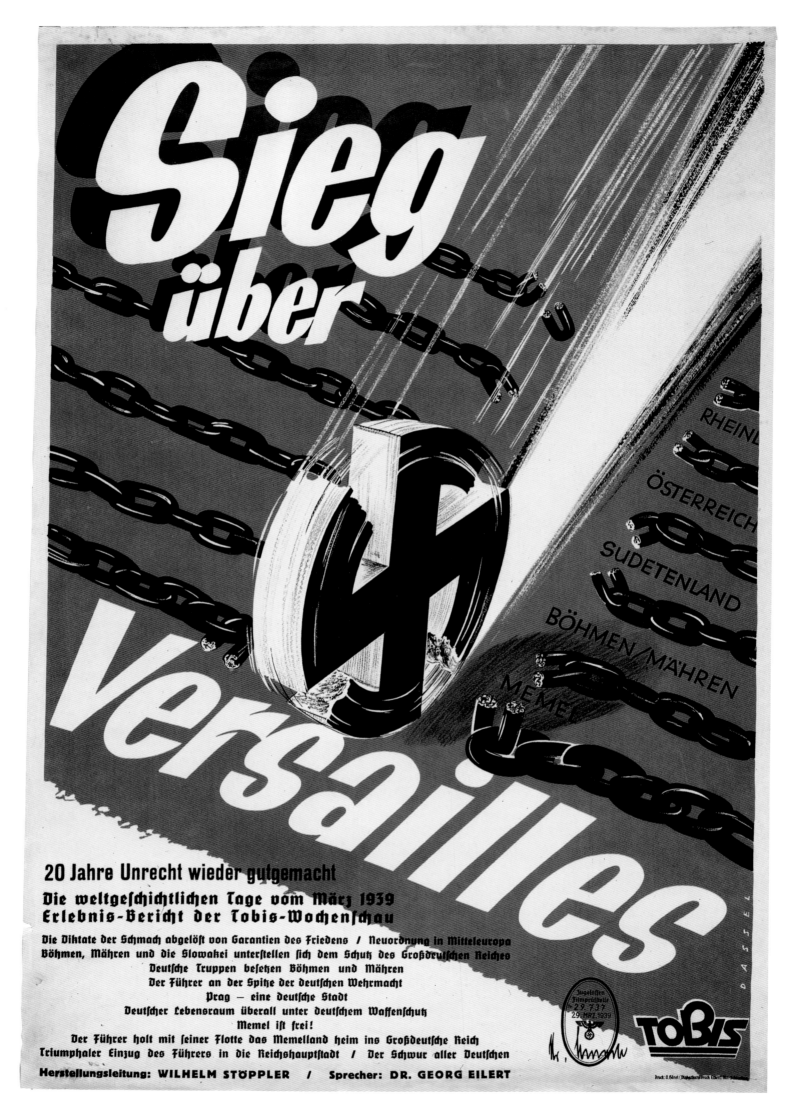

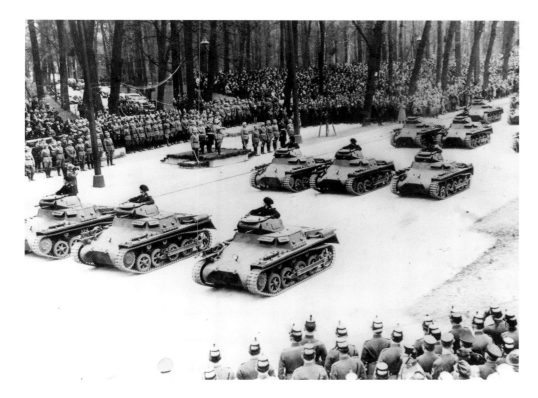

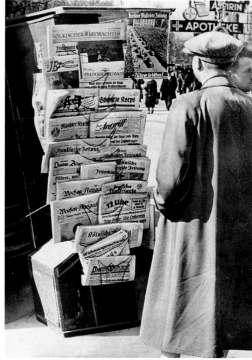

defeated Germany. But once in power, he played the responsible statesman who tempered boisterous demands for a revision of the peace treaty by an apparent willingness to conclude binding agreements with individual European powers. In early 1934, Germany signed a ten-year nonaggression pact with Poland and pledged to respect the rights of the Polish minority in the mixed border regions. In March 1935, Germany introduced universal military conscription, a key step toward reestablishing German military might. Three months later, Hitler signed an agreement with Great Britain that set limits on the size of the German Navy but permitted Germany to create a navy in direct violation of the Versailles Treaty. Quickly, resolutely, and virtually without material or human cost to the vast majority of the German people, Hitler achieved one foreign policy success after another: the remilitarization of the Rhineland beginning on March 7, 1936; the incorporation (Anschluss) of Austria into the Reich after the German occupation of March 12–13, 1938; the annexation of the Sudetenland with the blessing of the British and the French and the dismemberment of the rump Czecho-Slovak state on March 14–15, 1939; and the annexation of Memel (Klaipėda, part of Lithuania) on March 22, 1939.

To achieve his core goals, including the territorial ambitions of the Nazi regime, however, Hitler needed war, and with it propaganda to justify the need for military intervention and sustain popular support or tolerance for a protracted conflict. Goebbels and other propagandists developed new lines of propaganda suited to the war effort while retaining as a key weapon in their arsenal "positive" propaganda characterized by invocations of the *Volksgemeinschaft* and the cult of the Führer. Both held sway until the end of the Hitler regime, when the two myths dissipated dramatically with the collapse of the Reich. At the same time, Nazi propagandists intensified "negative" messages aimed at furthering Nazi anti-Jewish policies and the exclusion of other targeted groups from the *Volksgemeinschaft*, in line with the Nazi radicalization of racial policies during the war.

ABOVE, LEFT: German tanks parade past Hitler on Vienna's Ringstrasse during the celebration following Austria's union (Anschluss) with Germany, ca. March 12, 1938. *Corbis*

ABOVE: Soon after the Anschluss, German newspapers replaced Austrian publications. *AP Images*

OPPOSITE: "Victory over Versailles," poster for a documentary film depicting the Reich's reassertion of control in the Rhineland and territorial expansion into Austria, Czechoslovakia (the Sudetenland and Bohemia-Moravia), and Lithuania (Memel), 1939. *The Wolfsonian—Florida International University*

PROPAGANDA FOR WAR AND MASS MURDER

German forces invaded Poland on September 1, 1939. The war the Nazi regime unleashed would bring untold human suffering and loss. Following the German invasion of the Soviet Union in summer 1941, Nazi anti-Jewish policies took a radical turn to genocide. What role did Nazi propaganda play in preparing the German population for war and encouraging the mass murder of Europe's Jews and others? How did the German people and other Europeans respond to Nazi messages in wartime? Did those messages persuade them to accept or participate in the brutalities on the battlefield and against their Jewish neighbors? Or did propaganda mainly encourage indifference to the plight of others that created the conditions for the Nazi state to carry out genocide?

LESSONS FROM WORLD WAR I PROPAGANDA

During World War II, propaganda was an important weapon in the Nazi arsenal. Adolf Hitler, haunted by the German defeat of 1918, which he attributed to a combination of successful Allied propaganda and a "stab in the back" carried out by Jews, Marxists, liberals, and others, vowed to his compatriots, "there never will be another November 1918 in German history."[1] Nazi propagandists, building upon the lessons they derived from World War I, aimed first to explain to Germans why they had to go to war. The war aims professed at each stage of the hostilities almost always disguised actual Nazi intentions of territorial expansion and racial warfare. This was propaganda of deception, designed to fool or misdirect the populations in Germany, German-occupied lands, and neutral countries. Second, the Nazi propaganda machine strove to claim the moral high ground by portraying German military actions as justified.[2] Throughout the 1930s, Hitler portrayed Germany as a victimized nation, held in bondage by the chains of the Versailles Treaty and denied the right of national self-determination. Throughout the war, Nazi propagandists continued this strategy, depicting each new aggressive widening of the war as an act of self-defense.

The third crucial element of Nazi wartime propaganda was the creation of a potent image of the enemy. The lessons learned from the idea of "the Hun" in Allied

Poster "One Battle, One Victory!" by artist Hans Schweitzer ("Mjölnir"), 1943. *BAK, Plak 003-029-038*

OPPOSITE: From a Nazi poster aimed at enlisting Dutch men into the Waffen SS, 1941. *BAK, Plak 003-025-063*

Hinter den
Feindmächten:
der Jude

propaganda during the World War I convinced many German propagandists of the need to develop and disseminate a believable, morally reprehensible, evil enemy that aimed to destroy civilization, enslave Germans and other Europeans, and envelop the globe in its conspiratorial web. That archenemy was "the Jew." Nazi propagandists portrayed "the Jew" or "international Jewry" as directing "Bolshevism" and "Western plutocratic democracies" (depicted as being ruled by the wealthy few) not to achieve the goals of either Communism or capitalism but to attain world domination. These stereotypes, standard currency of right-wing politicians before 1933, permeated the Reich after the Nazi regime attained control over propaganda, the media, and education. During the war, Nazi propagandists updated them and added a nefarious twist, "the Jew" as warmonger and as progenitor of genocide. "The Jew" was hardly the only enemy depicted in Nazi propaganda, but at every stage of the war, this mythic image reminded Germans, both at home and serving on the front, of the purportedly deadly threat. For Adolf Hitler, Propaganda Minister Joseph Goebbels, and other Nazis who held radical antisemitic beliefs, eliminating the "Jewish enemy" became a goal inseparable from winning the war.[3]

SELLING THE WAR: STORIES OF "POLISH ATROCITIES"

Before the German invasion of Poland on September 1, 1939, an aggressive Nazi media campaign aimed to build public support for a war that few Germans desired.[4] To present the invasion as a morally justifiable, defensive action, the German press played up "Polish atrocities," referring to real or alleged discrimination and physical violence directed against ethnic Germans residing in Poland. The press also deplored Polish "warmongering" and "chauvinism" and attacked the British for promising to defend Poland in the event of a German invasion.[5] The German propaganda campaign against Warsaw climaxed in the days before the invasion, featuring such headlines as "All Poland in a War Fever," "Terror by Poles [against ethnic Germans] Grows Day by Day/Polish Bandits Murder Five-Month-Old Infant," and "Poland Rejects Negotiations." The German newsreel released August 23, 1939, showed ethnic German men, women, and children fleeing their homes in Poland for the safety of refugee camps in Germany and recounted Warsaw's territorial ambitions toward Germany. Finally, the Nazi regime staged a border incident to make it appear that Poland attacked first. On August 31, 1939, SS men dressed in Polish army uniforms "attacked" a German radio station at Gleiwitz.[6] The next day, Hitler announced to the German nation and the world his decision to send troops into Poland in response to Polish "incursions" into the Reich. The Reich Press Office instructed the press to avoid the use of the word *war*; they were to report that German troops had simply beaten back Polish attacks, a tactic designed to underscore that Germany was the victim of aggression.[7] The onus for declaring war would be left to the British and French.

Having secured Soviet neutrality on August 23, 1939, by concluding a nonaggression pact, known as the Molotov-Ribbentrop Pact, Germany invaded

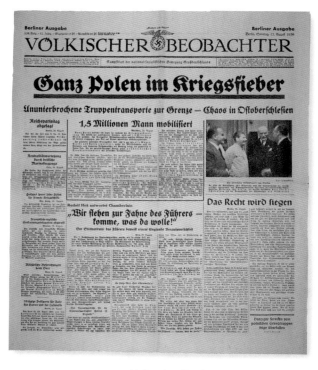

Völkischer Beobacher headline "All Poland in a War Fever," August 27, 1939. Prior to the German invasion of Poland, Nazi propaganda leaders directed the German press to run headline stories detailing Poland's plans for aggression against Germany and Polish brutalities against ethnic Germans. *DHM*

OPPOSITE: Antisemitic poster stating "Behind the Enemy Powers: the Jew," by artist Bruno Hanisch, ca. 1942. *USHMM, gift of Helmut Eschwege*

Goebbels reviewing propaganda materials. *NARA*

Poland on September 1, and German forces made rapid inroads into Poland. In a secret codicil to the pact, the two powers agreed to partition Poland. On September 17, Soviet troops invaded Poland from the east. On September 27, Warsaw capitulated to the Germans. By October 5, 1939, the Polish campaign was over: the Germans and the Soviets dismembered the country and occupied their respective territories. Following the German troops into Poland were special mobile SS units, the Einsatzgruppen. The Einsatzgruppen commanders were tasked with identifying, arresting and imprisoning, and killing teachers, journalists, and other members of the educated elites deemed potential leaders of a Polish national resistance to German rule. Supported by police battalions and ethnic German militiamen, the Einsatzgruppen commanders shot or killed by other means tens of thousands of Poles whom they identified as a source of "danger" to the German occupation authorities. Many ethnic Germans also carried out individual acts of vengeance upon their Polish neighbors.

In an effort to shape public opinion at home and abroad in the wake of harsh German measures against Polish civilians, the Nazi propaganda machine played up stories of new "Polish atrocities." They publicized the attacks on ethnic Germans in towns such as Bromberg (Bydgoszcz), where fleeing Polish civilians and military personnel killed between five thousand and six thousand ethnic Germans, who, in the

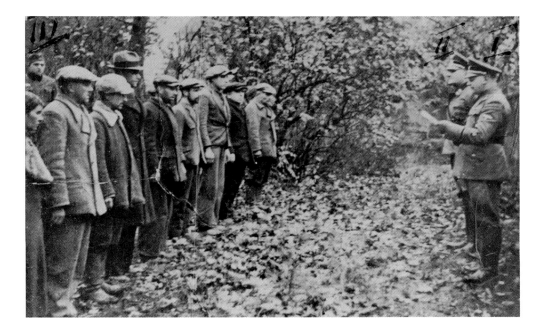

An officer of the German Security Police (SD) reads a list of charges against a group of Polish civilians just prior to executing them in the forest near Szubin, Poland, October 21, 1939. *Instytut Pamięci Narodowej*

heat of the invasion, were perceived as fifth-column traitors, spies, Nazis, or snipers.[8] By exaggerating the actual number of ethnic German victims killed in Bromberg and other towns to fifty-eight thousand, Nazi propaganda inflamed passions, providing "justification" for the numbers of civilians that the Germans intended to kill. German newsreels in September 1939 showed ethnic German farms allegedly torched by Poles. One episode showed columns of Polish Jews in Bromberg with a narrator accusing the Jews of inciting a war of extermination against the German people. Goebbels organized special visits to the "atrocity" sites for foreign journalists and had German photographers take pictures of them as they viewed the corpses.[9] (Far earlier than the Allies, the Nazis recognized the propaganda value of using photo documentary evidence of "atrocities" and of placing contemporaries in the frame to indicate that they were not recycled images from an earlier day.) German spokesmen deflected criticism by underscoring the hypocrisy of the British for decrying German "atrocities" while

BELOW, LEFT: German Security Police (SD) and regular army troops arrest a group of men, including some Jews, and seize a radio receiver, during the first days of the occupation of Warsaw, October 1939. *USHMM, courtesy of Jerzy Ficowski*

BELOW, RIGHT: Two Poles arrested by German soldiers for killing an ethnic German civilian (*Volksdeutsche*) being prepared for execution by firing squad in Cycow, Poland, September 1939. *Instytut Pamięci Narodowej*

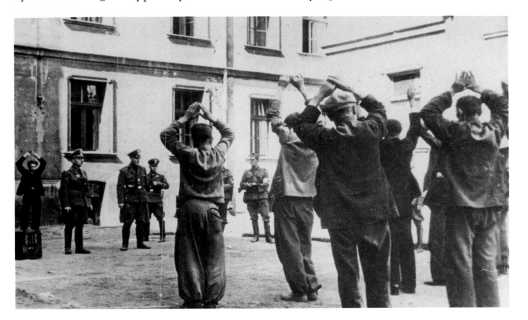

ABOVE: A German soldier mocks a Jew wearing religious garb by photographing him against a haystack, Poland, ca. 1939–41. *Muzeum Niepodległości*

BELOW: German soldiers guarding Jews rounded up shortly after the German invasion of Poland, September 1939. The photograph, from the album of a German soldier in the 1st Mountain Division, was captioned "Jewish riffraff." *Yad Vashem Photo Archives*

exploiting the colonial peoples in their empire.[10] German radio's English-language service described British claims of German crimes in Poland in January 1940 as "fairy tales." Throughout the war, the Propaganda Ministry urged Reich citizens not to believe rumors of German atrocities, reminding them of World War I British and U.S. "atrocity propaganda."

Nazi propagandists seemed to have convinced some Germans that the invasion of Poland and subsequent occupation policies were justified. For many others, the propaganda reinforced deep-seated anti-Polish sentiment. Letters written by German soldiers who served in Poland reflect support for German military intervention to defend ethnic Germans. Some soldiers expressed their hatred for the "criminality" and "subhumanity" of the Poles, and others viewed the resident Jewish population with disgust, comparing Polish Jews to images published in *Der Stürmer* or displayed in *The Eternal Jew*, the title of both the Nazi exhibition that opened in 1937 and a Nazi film released in 1940. The soldiers' letters often described Poland's citizenry as impoverished, backward, dirty, and in need of civilization brought by German troops. One soldier wrote: "We recognize the necessity for a radical solution to the "Jewish Question." Here one sees houses occupied by beasts in human form. In their beards and kaftans, with their devilishly grotesque faces, they make a dreadful impression. Anyone who was not yet a radical opponent of the Jews must become one here."[11] These accepted stereotypes, some dating back decades but all reinforced by Nazi propaganda, may help explain the actions of the German units, whether SS and police, armed forces (Wehrmacht), or ethnic German auxiliaries, who killed tens of thousands of civilian

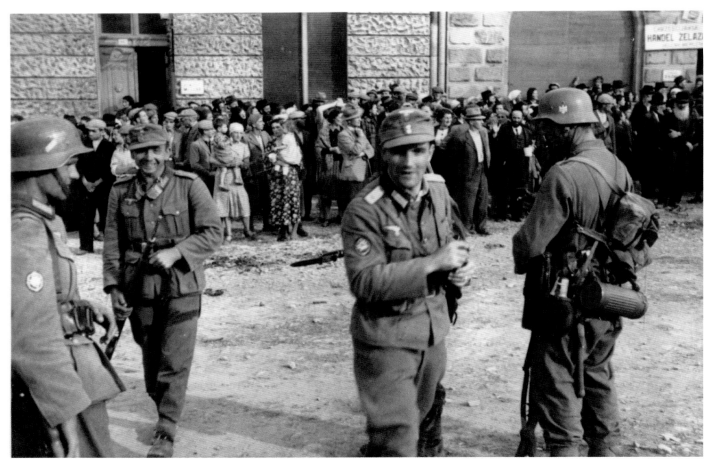

STATE OF DECEPTION: THE POWER OF NAZI PROPAGANDA

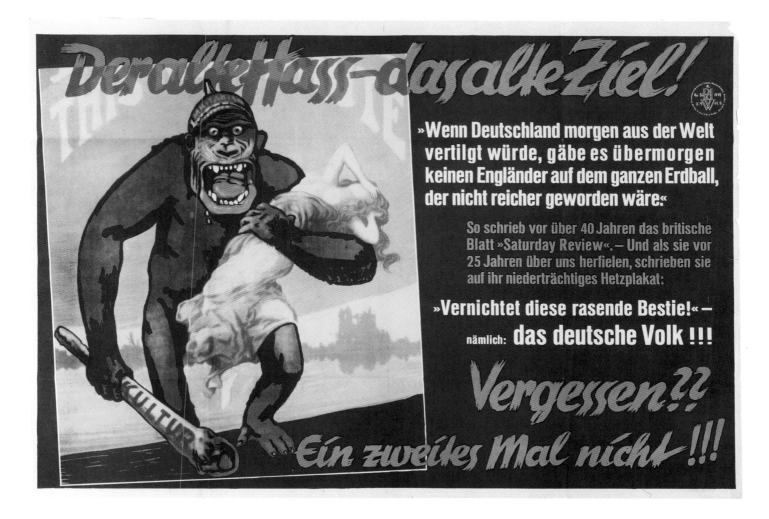

Der alte Hass – das alte Ziel!

»Wenn Deutschland morgen aus der Welt vertilgt würde, gäbe es übermorgen keinen Engländer auf dem ganzen Erdball, der nicht reicher geworden wäre.«

So schrieb vor über 40 Jahren das britische Blatt »Saturday Review«. – Und als sie vor 25 Jahren über uns herfielen, schrieben sie auf ihr niederträchtiges Hetzplakat:

»Vernichtet diese rasende Bestie!« – nämlich: das deutsche Volk !!!

Vergessen??
Ein zweites Mal nicht !!!

Poles and Jews in 1939 and 1940. Inhibitions against killing deriving from fear of legal consequences dissolved in light of Hitler's secret decree of October 4, 1939, which asserted that German soldiers who committed violent acts against Poles because of "rage at the atrocities perpetrated by the Poles" at Bromberg and elsewhere would not be prosecuted. The decree also amnestied those perpetrators already in custody or on trial.[12]

CONTROLLING INFORMATION

Aiming to prevent enemy propaganda from reaching the German population, the Nazi regime issued a special decree on September 1, 1939, that made listening to foreign broadcasts a criminal offense, carrying severe punishments. To justify this measure, Nazi propagandists reminded Germans of the damage inflicted by the enemy propaganda during the World War I with "the poison of lies and rebellious provocation—methods that led to [defeat]. . . . Only one thing carries weight: The Word of the Führer."[13] During World War II, airwaves became the battleground for a war of words between the belligerent powers. Radio stations in Berlin, Moscow, London, and Bari, Italy, broadcast propaganda messages, often disguised as news broadcasts, musical offerings, and even humor. By 1939, an estimated 70.5 million radios played to an audience of 250 million people worldwide.[14] The British Broadcasting

"Slogan of the week" issued on a poster by the Nazi Party Central Propaganda Directorate reads "The Old Hatred—the Old Goal! Will We Forget?? Not a Second Time!!!" September 1939. This poster aimed to remind Germans of Allied propaganda in World War I designed to foment hatred through falsehoods and frightening "Hun" imagery. *BAK, Plak 003-009-139*

PROPAGANDA AND THE PERSECUTION OF POLISH LABORERS

Beginning in March 1940, Nazi Germany began to deport Poles to the Reich for forced labor. The SS and police issued strict regulations for segregating the Polish laborers from the German population, including marking them with a special badge and particularly restricting the opportunities for social contact. The Nazi regime used "Polish atrocity" stories to influence German behavior toward Polish laborers. Leaflets cautioned Germans to remember the murder of the "fifty-eight thousand" *Volksdeutsche* (ethnic Germans) of Bromberg and other towns and to treat the Polish workers with appropriate reserve, discipline, and disdain.

Badge issued to Joseph Wardzala, a Pole conscripted for labor in Germany, ca. 1940–44. *USHMM, courtesy of Joseph Wardzala*

That same year, work began on an emotionally charged feature film, *Heimkehr* (The Return Home), that depicted the mistreatment of ethnic Germans in a Polish town in 1939. Though praised by Goebbels, *The Return Home* proved less popular with audiences because of the weak story line and cast, and it was released in 1941 when Germans had more pressing concerns, such as dealing with Allied bombing raids, food shortages, and the loss of loved ones fighting on the Eastern Front. Young people, however, responded eagerly to the film.[15] Ironically, the movie prompted Polish workers to identify their own plight as forced laborers in Germany with the brutalized ethnic Germans. As a result, the German authorities had to forbid Polish workers from viewing the film.[16]

Propaganda facilitated the persecution of Poles by portraying them as politically dangerous and racially inferior. During the war, German officials added Poles to the groups—Jews, Gypsies (Roma and Sinti), and Blacks—prohibited from marrying or having sexual relations with Germans. Though classified as "Aryans," Poles were considered a biological threat to the Reich because of their supposed inferiority, greater fertility, and innate hostility to the Germans. Even minor infractions led to the imprisonment or execution of Poles.

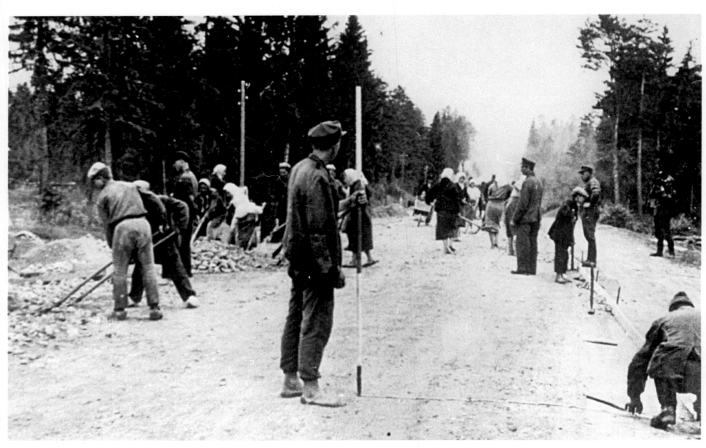

Polish men and women in Germany at forced labor building a section of the autobahn, 1941. *BPK*

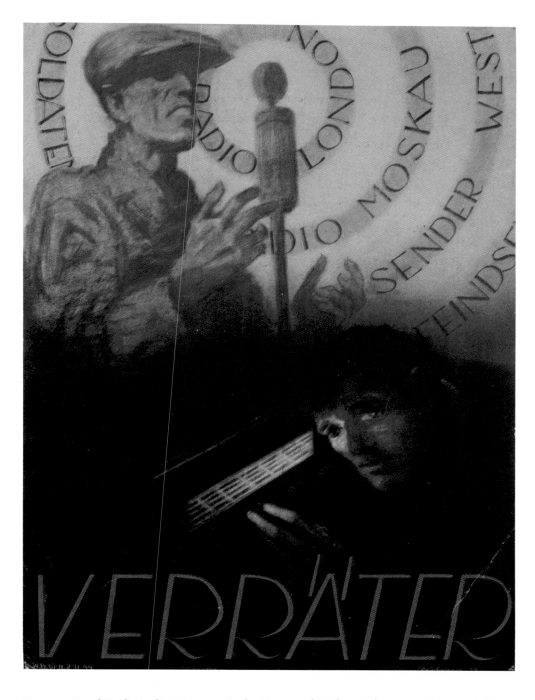

Poster captioned "Traitor," depicting a German citizen listening to foreign radio broadcasts, 1944. *BAK, Plak 003-027-001*

Corporation (BBC), Radio Moscow, Radio Bari, and Radio Berlin created powerful transmitters and employed large staffs to broadcast in dozens of languages. With military conquests, the Germans took over Radio Luxembourg, the continent's most powerful radio station, as well as stations in Athens, Oslo, Warsaw, and Paris.

Preventing millions of Germans from listening to foreign broadcasts proved impossible, however. The BBC estimated in 1944 that between ten million and fifteen million Germans, from all segments of society, listened to its broadcasts daily.[17] They were willing to risk the punishments publicized by Goebbels in the press and communicated in posters, leaflets, and even children's games. Because detection of illegal listening was difficult, relatively few people were actually punished: 36 people were convicted under the law in 1939, 830 in 1940, 721 in 1941, and 1,117 in 1942.

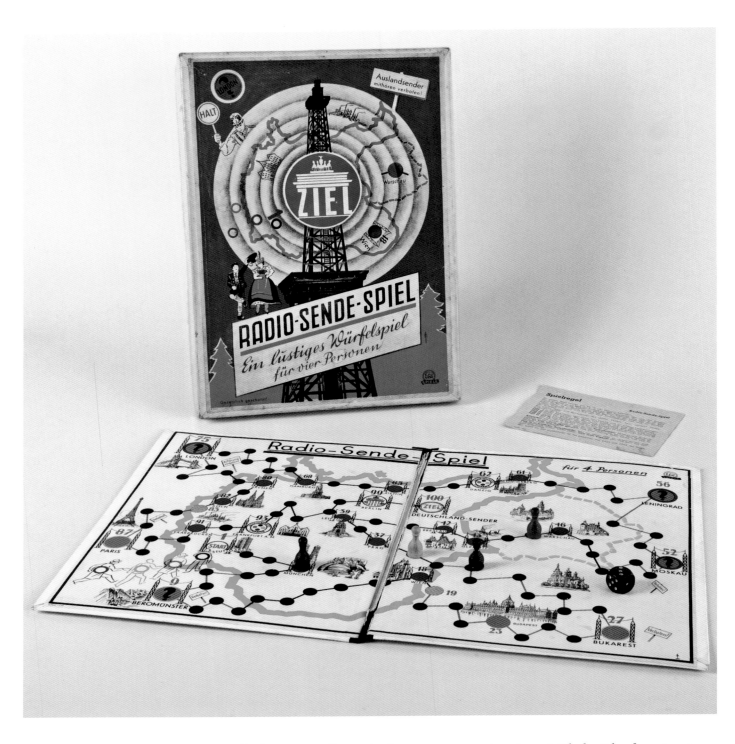

German board game encouraging players to listen to German stations by punishing those who land on foreign radio stations with losing a turn, paying a fine, or being expelled from the game. *USHMM, The Abraham and Ruth Goldfarb Family Acquisition Fund*

Defendants normally received one or two years in prison. With the tide of war turning against the Reich, German courts handed out eleven death sentences for this offense in 1943.[18] Most of the people caught were victims of denunciation, usually by a neighbor, co-worker, or family member seeking revenge.[19] Jews had been ordered to turn in their radios soon after the war began. In occupied Poland, German representatives confiscated radios belonging to Poles and set up loudspeakers so radio information would come only from German or German-controlled sources.

German newsreels also became crucial to Goebbels's efforts to form and manipulate public opinion during the war. To exercise greater control over newsreel content after

the conflict began, the Nazi regime consolidated the country's various competing news-reel companies into one, the *Deutsche Wochenschau* (German Weekly Show). Goebbels actively helped create each installment, even editing or revising scripts. Twelve to eighteen hours of film footage shot by professional photographers and delivered to Berlin each week by courier were edited down to between twenty and forty minutes. Distribution of newsreels was greatly expanded as the number of copies of each episode increased from four hundred to two thousand, and versions were produced in thirty-six different foreign languages.[20] Mobile cinema trucks brought the newsreels to rural areas.

MILITARY INVINCIBILITY AND THE FÜHRER MYTH

Nazi war propaganda was most effective when reinforced by rapid military conquest on the battlefield. Between 1939 and 1942, the German military went from victory to victory and seemed unstoppable. Surprisingly rapid victories in the west, ending with the defeat of France in June 1940, reinforced the myth of Hitler's infallibility. Countless posters, paintings, photographs, and newsreel footage depicted the Führer as a masterful warlord and military strategist. Wearing a simple military tunic, Hitler presented himself as the common soldier and a man of the people who rose to be supreme commander of the German armed forces. The period 1939 to 1941 marked the pinnacle of his popularity in Germany. Propaganda portrayed the Nazi leader

Hitler at the Front, oil painting by Emil Scheibe, 1942. During the war, Nazi propagandists embellished the Führer cult by transforming the German chancellor into a supreme and infallible warlord who would guide the nation to final victory. *U.S. Army Center of Military History*

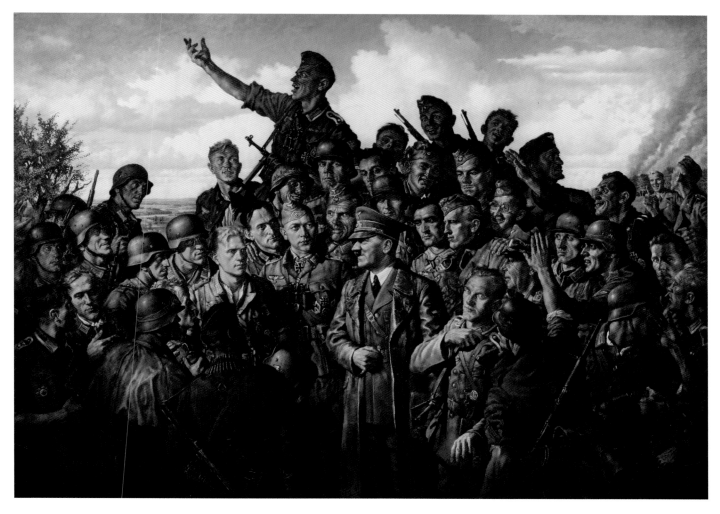

as resurrecting the nation from the misery of the Weimar democracy, restoring Germany's honor, and trampling the nation's foes.[21] After news of the cease-fire in France reached Germany, flags appeared everywhere, and crowds assembled to express their thanks.[22] Despite the setback of the Battle of Britain in 1940, military victories in Yugoslavia and Greece in April 1941 enhanced the propagandists' claims of Hitler's genius. In newsreels and feature "documentary" films, such as *Feldzug in Polen* (Campaign in Poland), *Feuertaufe* (Baptism of Fire), and *Sieg im Westen* (Victory in the West), armed conquest was presented as glorious achievements, including long lines of Allied prisoners, destroyed equipment, and continually advancing German troops. Dead or wounded German soldiers were nowhere to be seen. That the German military suffered relatively few casualties and German civilians endured relatively

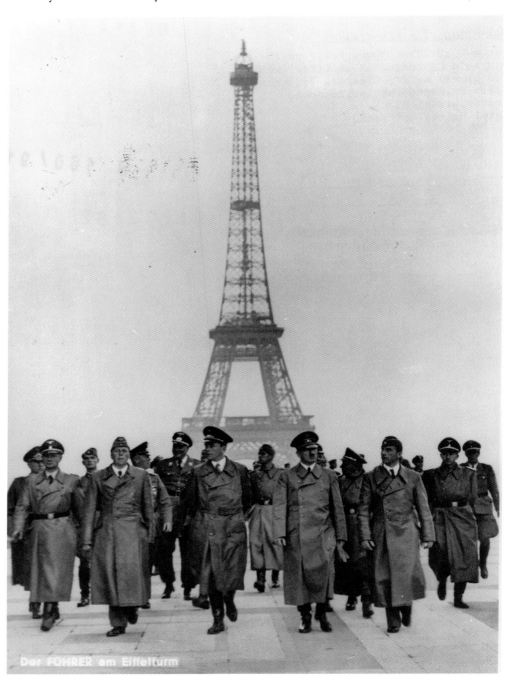

Photographs such as this and film footage of Hitler in Paris shortly after the fall of France were widely distributed for propagandistic purposes, June 28, 1941. *BPK*

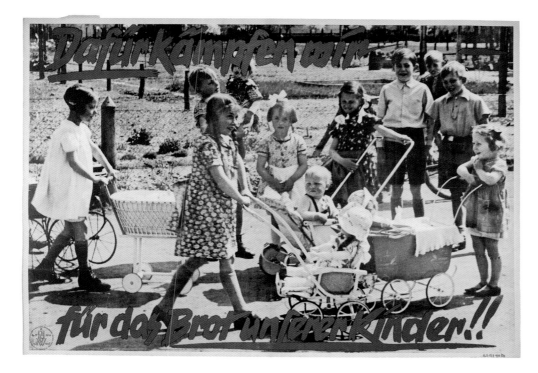

Document "*Why* We Fight—for *Our Children's Bread!!*" distributed as the "slogan of the week" by the Nazi Party Central Propaganda Directorate, March 11, 1940. The text and images imply that Germany's actions are purely defensive, aimed at preserving the nation's future. *USHMM*

few hardships in the first years of the war only reinforced the propaganda messages of invincibility.

In combination with propaganda to sustain support for the war, the Nazi regime bolstered the military effort by dealing severely with acts of desertion, cowardice, self-mutilation, or refusal to serve. During the war, the Nazi judicial system sentenced some fifty thousand persons to death—nearly seventeen thousand by civilian courts and approximately thirty-three thousand by military courts—of whom an estimated 90 percent were executed.[23] An individual who expressed himself or herself in a manner that could be interpreted as defeatist or critical of the Führer could wind up before the People's Court, in a proceeding that often concluded with a conviction and a death sentence. After 1941, members of the SS suspected of engaging in homosexual acts were subject to capital punishment. Later in the war, SS authorities offered previously convicted homosexuals, repeat criminal offenders, and some political prisoners opportunities to "redeem" themselves by serving as "cannon fodder" on the front line.

Manuals instructing concentration camp guards on their duties served as vehicles of indoctrination. They included characterizations of camp prisoners as "criminals, asocials, sexual deviants, enemies of the state, idlers, thieves, security risks, politically unreliable persons, antisocial parasites, and others" deemed to be "very dangerous," especially in wartime, because they "destroy the unity of our people, cripple our power, and endanger victory." Just as their "comrades at the front were defending the homeland from the external enemy," the camp guards had to defend against the "internal enemy" that had been instrumental in Germany's defeat in World War I.[24]

REVERSING THE SHAME OF VERSAILLES:
THE ARMISTICE AT COMPIÈGNE

In an event replete with symbolism that the Nazis milked for its propaganda value, Hitler staged the French surrender in the same railcar in Compiègne, outside Paris, where the armistice of November 11, 1918, had been signed. Hitler ordered the railcar used in that event removed from the French museum where it was being displayed and transported to the forest of Compiègne. On June 21, 1940, with newsreel cameras rolling and German and foreign journalists on hand, Hitler acted out the role of conqueror, even sitting in the same seat from which the World War I Allied commander in chief, General Ferdinand Foch, announced the terms of the armistice treaty to the defeated Germans in 1918. As he walked past a German honor guard, Hitler passed the monument to Foch, which was left standing and uncovered, and stopped at the French memorial that read: "Here on November 11, 1918, was vanquished the criminal insolence of the German Empire by a free people whom it sought to victimize." Hitler and other German military leaders entered the car, followed by the French delegation. After solemn salutes and bows, German general Wilhelm Keitel read the preamble to the conditions for a cease-fire. The statement, carefully crafted by Hitler, gave vent to the German leader's obsession with Germany's defeat in the World War I and traced his propagandistic version of the outbreak of World War II.[25] Then Hitler left the car while a German band played *Deutschland, Deutschland Über Alles* (Germany, Germany over All). In this one moment, the Nazi leader exacted his revenge for the public humiliation accorded the German delegation at Compiègne in 1918 and Versailles in June 1919. Journalists recorded Hitler's look of triumph as he exited.[26] The next day, June 22, 1940, the French signed the armistice. Hitler later ordered the railcar brought to Berlin, along with the memorials.[27]

General Wilhelm Keitel reading the preamble of the Armistice terms handed to French military officers in the same railroad car in which the Germans signed the Armistice of 1918. Hitler is seated to Keitel's right. Compiègne, France, June 21, 1940. *Corbis*

INCITING HATRED: ANTI-JEWISH PROPAGANDA

From 1939 until October 1941, the publicly stated goal of anti-Jewish policy within the Reich was the forced emigration of Jews. The war, however, greatly hindered the emigration of Jews from the Reich and occupied territories, as the United States, Great Britain, and other potential refugee havens restricted further immigration. Moreover, fewer passenger ships were available, and the closing of borders shut off travel routes. Some Nazi leaders proposed that Germany's Jewish population, in part, could be deported to newly established ghettos in occupied Poland. SS and party officials also began implementing plans to expel Jews from the western Polish territories incorporated into the Reich eastward to a new "Jewish reservation" near Lublin, Poland. Though still publicly professing to favor forced emigration as a solution to the so-called Jewish Question, Nazi propagandists continued to demonize the Jews, a tactic that also served to prepare the German population for harsher, new anti-Jewish measures such as deportation.[28]

Propaganda referencing "Judeo-Bolshevism" was generally absent between August 1939 and June 1941, when Germany was allied with the Soviet Union. "Jewish conspirators" were primarily linked instead to the Western democratic "plutocracies," with Jewish capitalists portrayed as dictating or influencing Allied policy. Three films released in 1940 reflected this theme. *Jud Süss* (The Jew Süss) and *Die Rothschilds* (The Rothschilds) transformed historical episodes into contemporary commentaries on the "Jewish Question." In the first film, Joseph "Süss" Oppenheimer, a court Jew in eighteenth-century Württemberg, aids in the corruption of the ruling prince while despoiling the land of its wealth. In the end, Süss is executed and the Jews expelled from the principality. *The Jew Süss* was a box-office success, and Himmler even ordered every SS man to see it.[29] *The Rothschilds* focuses on the financial schemings of the Jewish banking family, shown using its "international" business ties to speculate successfully on the outcome of the Battle of Waterloo in 1815. Like Süss, the London-based Nathan Rothschild apes the manners of the British upper class but cannot remove "the stink of the ghetto." Ultimately, however, the family gains political influence and power in

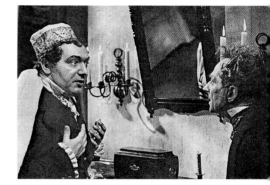

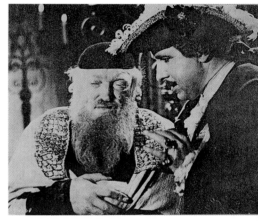

TOP: Scene from the German antisemitic and anti-British film *The Rothschilds*, 1940. *LC, PPD*

ABOVE: Werner Krauss, as Rabbi Loew, and Ferdinand Marian, as Süss Oppenheimer, conspire in the film *The Jew Süss*, 1940. *LC, PPD*

LEFT: A marquee advertising the antisemitic film *The Jew Süss* at a Dutch cinema, ca. 1940–43. *NIOD*

Poster advertising the antisemitic film *The Jew Süss*, by artist Bruno Rehak, 1940. *LC, PPD*

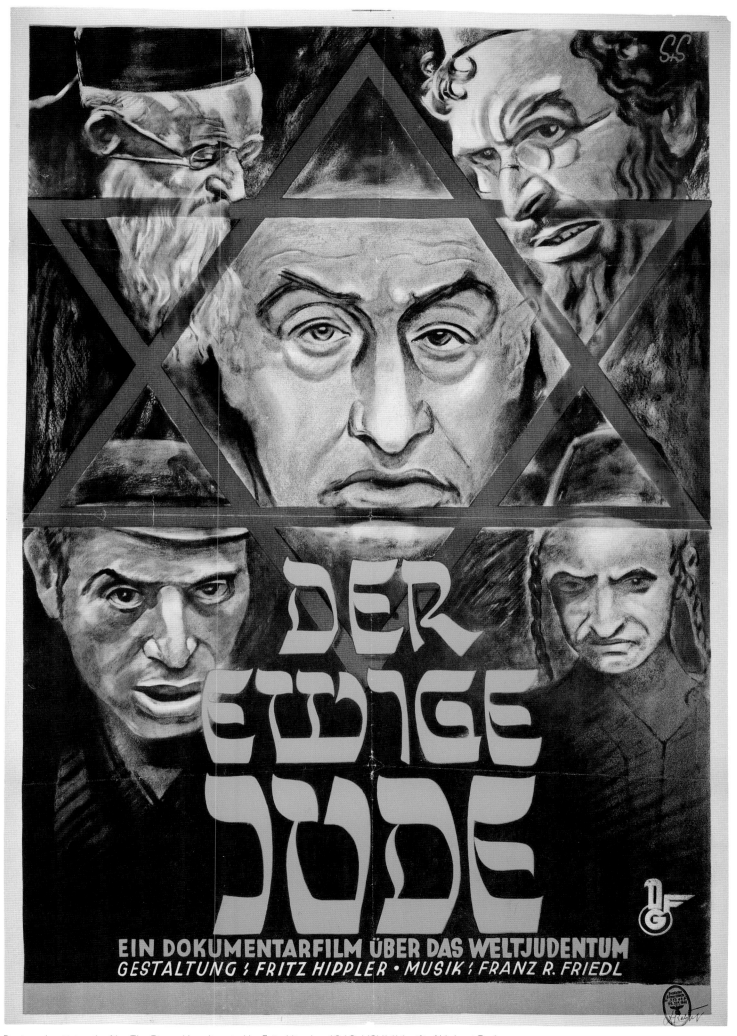

Poster advertising the film *The Eternal Jew* directed by Fritz Hippler, 1940. *USHMM, gift of Helmut Eschwege*

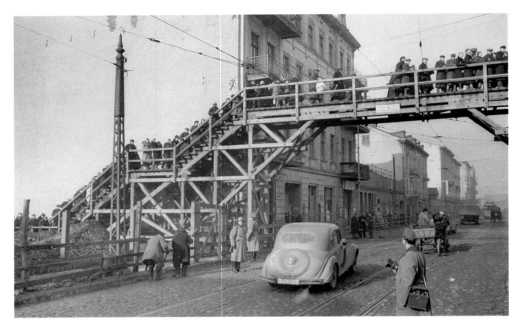

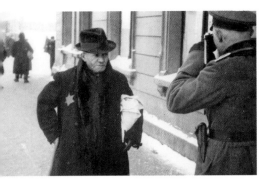

ABOVE: German soldier photographing a Jew in the Lodz ghetto, ca. 1940–44. *Beit Lohamei Haghetaot*

RIGHT: Jews of the Lodz ghetto, occupied Poland, crossing the bridge that segregated them from the city streets outside the ghetto borders, 1941. In the foreground, a Wehrmacht photographer of the scene holds his movie camera at his side. *BAK, Bild 101I-133-0703-21 Fotograf: Zermin*

England, joining the ruling "plutocrats." Their goal is not to strengthen Great Britain but to realize the age-old dream of Jewish world domination, symbolized in the film by showing a map with the location of Rothschild banks connected with Palestine to create the six-pointed Star of David. Both the official and popular responses to *The Rothschilds* were mixed, in part because shifting Nazi policy toward Great Britain resulted in a muddied plot that included both likeable and unsympathetic British characters. In contrast to *The Jew Süss*, which concludes with the execution of the villain and the expulsion of the Jews, *The Rothschilds* ends with Jewish triumph; the film failed to depict a strong counterweight to the power of the banking family.[30]

A third film, *Der ewige Jude* (The Eternal Jew), was directed by Fritz Hippler, president of the Reich Film Chamber, with Goebbels's input. A pseudodocumentary, it included scenes of Jews filmed in Warsaw and Lodz by propaganda company crews attached to the Wehrmacht. One of the film's most notorious sequences compares Jews

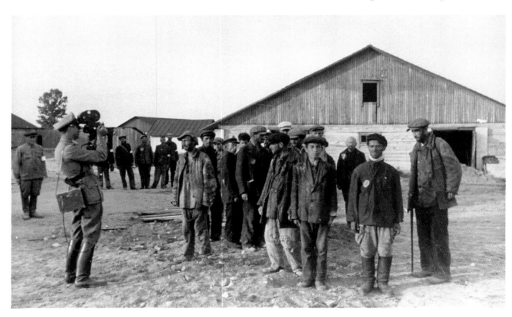

Germans filming Jewish prisoners in an unidentified camp in Poland, ca. 1940–43. *BAK, Bild 146-1981-041-06A*

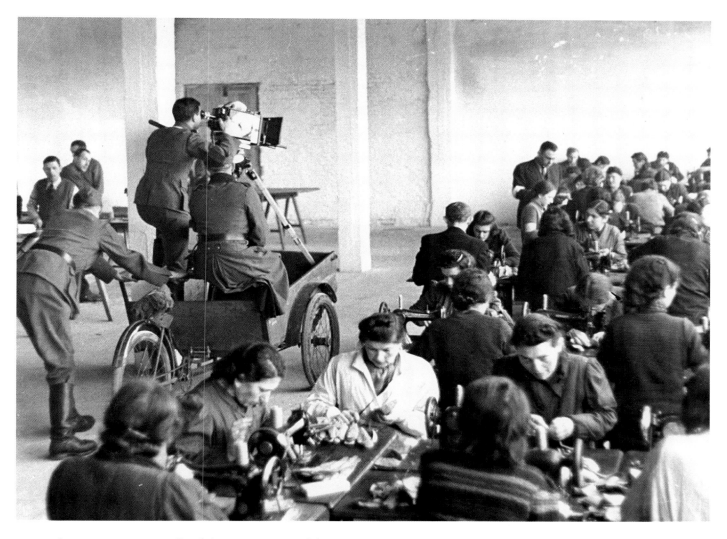

to rats that carry contagion, flood the continent, and devour precious resources. *The Eternal Jew* is distinctive not only for its crude, vile characterizations made worse with its gruesome footage of a Jewish ritual butcher at work slaughtering cattle, but also for its heavy emphasis on the alien nature of the eastern European Jew. In one of the film's sequences, "typical" Polish Jews with beards were shaven clean and transformed into "Western-looking" Jews. Such "unmasking" scenes aimed to show German audiences that no difference existed between Jews living in eastern European ghettos and those inhabiting German neighborhoods.

The Eternal Jew ends with Hitler's infamous speech to the Reichstag of January 30, 1939: "If international Jewish financiers inside and outside Europe should succeed in plunging the nations once more into a world war, then the result will not be the victory of Jewry but the annihilation of the Jewish race in Europe."[31] Hitler reiterated this "prophecy" five times during the war. Himmler referred to it repeatedly in his speeches to the SS, and versions of it were printed in news for the troops. The speech appeared to herald a radicalization of the remedies for the "Jewish Question" in the coming "Final Solution" and provided a foreshadowing of mass murder.

In occupied Poland, the Germans ordered Jews to move into specially demarcated areas, usually the poorest sections of towns and cities. Nazi propaganda supported the policy of confining Jews to such ghettos by portraying them as a health threat

ABOVE: Wehrmacht crew filming the operations of a sewing workshop in the Warsaw ghetto, 1941. *BAK, Bild 101I-134-769-39H, Fotograf: Cusian/Knobloch*

BELOW: Cameramen and officers with a Wehrmacht propaganda unit on a visit to the Lodz ghetto, ca. 1941. *BAK, Bild 101I-133-0703-33, Fotograf: Zermin*

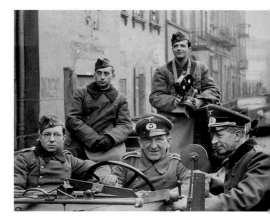

FEATURE FILMS AS PROPAGANDA

Goebbels considered feature films an important propaganda tool. Movie attendance in Germany more than doubled during the war, climbing to over one billion visits between 1939 and 1945. The Nazi propagandists exploited the growing popularity of moviegoing to create cinema that combined entertainment—costume dramas or fictional narratives—with either explicit or implicit propaganda messages. By 1942, propaganda films made up about one-fourth of Germany's total film production.[32]

Motion pictures depicting historical figures were used to illuminate the nation's present while glorifying its past. Educational films for German youth, although not produced under the Propaganda Ministry, dealt with history and

Poster advertising the feature film *Ohm Krüger* (Uncle Kruger), 1941. *Gillespie Collection*

political themes that contained favorable propagandistic messages.[33] The ministry also used historical dramas to portray the nation's enemies in a bad light. The 1941 film *Ohm Krüger* (Uncle Kruger) centers on Paul Kruger, the South African leader of the Transvaal (1880–1900). Kruger retells the story of British territorial ambitions against the Boers after the discovery of gold. The film details how the British erected concentration camps to imprison Boer women and children and portrays a caricature of Winston Churchill as a hateful concentration camp commandant who orders the killing of female prisoners.[34]

The 1941 film *Ich klage an* (I Accuse) was produced to encourage support for or acquiescence in the regime's "euthanasia" murder program, which began in fall 1939. Facilitated in part by Hitler's written order shielding participating physicians from future prosecution for murder, the "euthanasia" operation resulted in the murder of an estimated two hundred thousand institutionalized Germans, including psychiatric patients, adults and children with mental and physical disabilities or epilepsy, and others deemed "incurably ill" and a burden on German society. German physicians and other medical personnel killed more than seventy thousand people in 1940 and 1941, selecting them to be killed and deporting them to six special facilities within the Reich equipped with gas chambers disguised as showers. After growing awareness of the "secret" program had created public unease, *I Accuse* became part of the propaganda effort for "euthanasia" by conflating in the public's mind the Nazi murder program with "merciful death." The film portrayed a beautiful woman stricken with multiple sclerosis who desires to end her suffering through death. Her husband, a scientist by training, works desperately to find a cure but is unsuccessful and decides to permit his wife's death. Official monitoring of public reactions to the film revealed that *I Accuse* left a strong impression on viewers. Many reportedly supported the film's message, although other influences convinced many viewers otherwise. Catholic clergy voiced disapproval of the "euthanasia" program and of the film and tried to shape their parishioners' opinions. With almost all other networks of dissent shut down, the Catholic Church remained the one major conduit for voicing public opposition to some Nazi policies.[35] Hitler halted the gassing program in 1941, but German health care professionals continued up to the end of the war to murder Germans deemed "incurably ill" in many hospitals and clinics by means of drug overdoses, lethal injections, and starvation.

Poster advertising the 1941 propaganda film *I Accuse* that aimed to blur the line between a merciful euthanasia for a consenting terminally ill patient and the Nazi regime's secret mass murder of institutionalized Germans. *Deutsches Filminstitut–DIFe.V./Deutsches Filmmuseum*

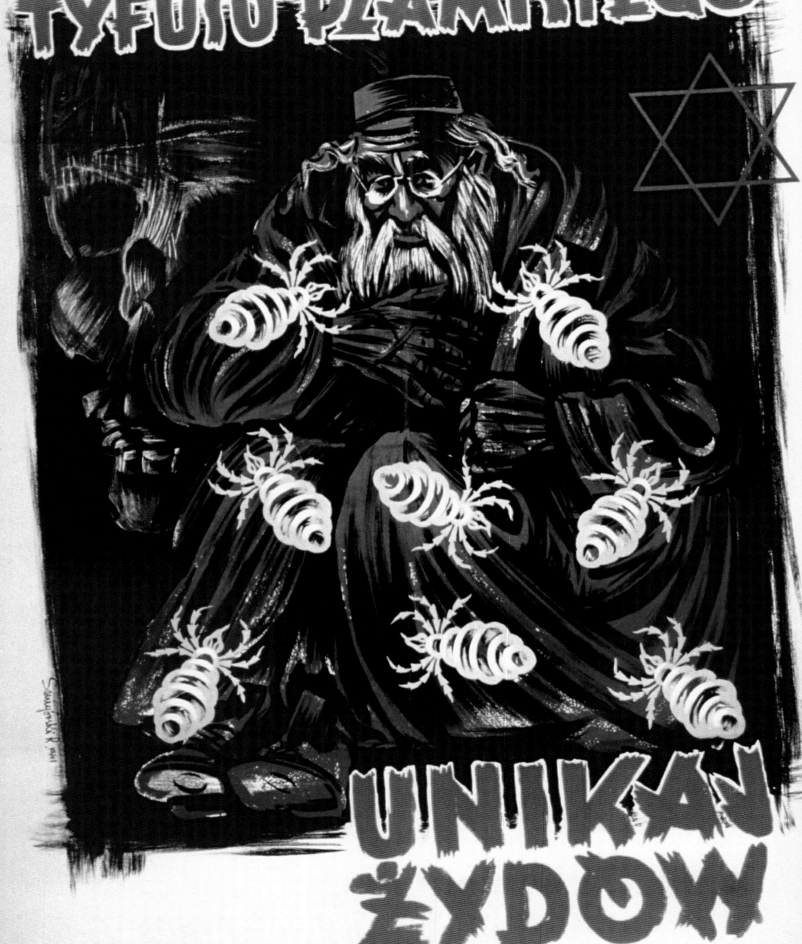

requiring quarantine. German educational films depicted "the Jew" as a carrier of lice and typhus. In Warsaw and elsewhere, German officials used hateful images of Jews to justify their forced relocation into ghettos, which soon became overcrowded and the very breeding grounds for the contagious diseases the Germans sought to combat. The governor of the Warsaw district, Ludwig Fischer, reported the distribution of "3,000 large posters, 7,000 smaller posters, and 500,000 pamphlets" to inform the Polish population of the health threat posed by the ghettoized Jews. German-controlled newspapers, radio, and schools in Poland also "warned of the danger."[36] Such fearmongering no doubt hindered public aid to Jews in the ghettos.

PROPAGANDA IN THE SERVICE OF MASS MURDER

Following the German invasion of the Soviet Union on June 22, 1941, Nazi Germany embarked on the path of mass murder, with propaganda playing a crucial role in inciting hatred, justifying atrocities, and preparing the German population to accept or support ever harsher measures against Jews and others in occupied territories and in Germany. The Nazi leadership saw the high-stakes, do-or-die war against the Soviet Union as a "war of extermination." As they planned the invasion, code-named Operation Barbarossa, Hitler and his generals perceived the war to be unlike warfare in the West. "More than a clash of arms; it also entails a struggle between two ideologies," Hitler informed General Alfred Jodl, the Wehrmacht's chief of operations.[37] All real or potential resistance to German occupation was to be crushed ruthlessly, the territory and its peoples exploited for the benefit of the occupiers, and the entire Soviet system demolished. German state officials calculated that Soviet civilian casualties would number in the many millions. In planning for the conquering Wehrmacht to feed and supply itself from the land it conquered, the Ministry for Food Supply calculated that as many as thirty million Soviet civilians would starve to death as a consequence.[38] On May 13, 1941, General Wilhelm Keitel, on behalf of Hitler, issued a decree that ordered the troops to "mercilessly eliminate guerillas in battle" or "trying to escape." The order removed the investigation and prosecution of any hostile actions by a Soviet civilian from the jurisdiction of military courts and authorized individual German military officers to determine—on the spot—punishment for such hostile actions up to and including the death sentence. The decree also authorized military courts to refrain from prosecuting German soldiers for criminal offenses against the local population and admonished military judges to consider, as a mitigating factor in making the decision whether to prosecute, anger at the "damage" inflicted upon Germany since 1918 due to the influence of Communism. The "Commissar Order" given by Hitler on June 6, 1941, called for the immediate killing of political officers assigned to the Soviet troops: "In the struggle against Bolshevism, we *must not* reckon with enemy behavior that is consistent with the principles of humanity or international law. In particular, we must expect a hateful, cruel, and inhuman treatment of our own soldiers taken prisoner from *political commissars of all kinds*, as the real proponents of resistance."[39]

In addition to preparing the German civilian population for the upcoming struggle, propagandists produced materials aimed at indoctrinating Waffen-SS troops (combat arm of the SS), Order Police, and Wehrmacht units with hatred against officials of

Antisemitic poster aimed at indoctrinating a Polish audience reads "Beware of Typhus—Avoid Jews," 1940–44. *Muzeum Okręgowe w Rzeszowie*

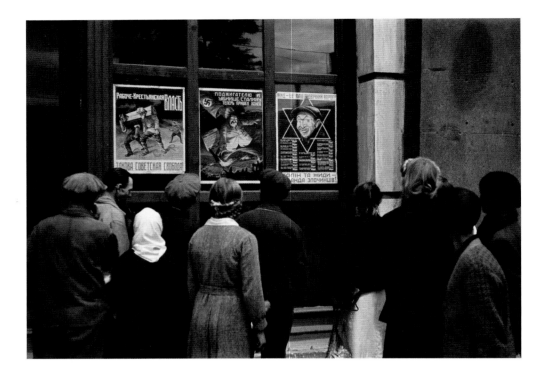

German-made anti-Communist and antisemitic posters aimed at Ukrainian residents of Kharkov, October 1941. The posters read (*left to right*): "Repression of the Proletariat Is Soviet Freedom!"; "Arsonist and Killer, Stalin, Your Reign Is Over!"; "The Jew Is Your Eternal Enemy! Stalin and the Jews Are One!" *BPK*

OPPOSITE: Russian-language German poster captioned "Vinnitsa," portraying a crude caricature of a Jew as the executioner in a massacre of more than 9,000 Soviet citizens during 1937 and 1938 in the Ukrainian city of that name by the Soviet Secret Police (NKVD), ca. 1943. German forces used the discovery of the graves in May 1943 to foment anti-Soviet and antisemitic fervor. *LC, PPD*

the Soviet Communist Party and the Soviet state apparatus, in particular against the "Jewish Bolshevik commissar." This propaganda reinforced the Nazi linkage between European Jews and international Communism and ratcheted up the image of the Jews as "the enemy" bent on the destruction of Germany. In new materials formulated by the propaganda section of the German armed forces for distribution to the troops ahead of the attack, the text portrayed "Bolshevism" as the "mortal enemy" of the German people. Ruthless action was necessary against "Bolshevik agitators, guerillas, saboteurs, [and] Jews." The directives portrayed the conflict as a war of liberation to free the nations of the Soviet Union from the tyranny of "Jewish–Bolshevik" commissars. Propaganda companies were to be attached to army groups, and war reporters were urged to focus on Red Army "atrocities and infringements of international law." The Wehrmacht propaganda materials included vile stereotypes of the commissars: "It would be an insult to animals if one were to call the features of these largely Jewish tormentors of people bestial. They are the embodiment of the infernal, and have become the personification of insane hatred of everything that is noble humanity."[40]

Within hours of the Wehrmacht's surprise attack on the Soviet Union in the predawn hours of June 22, 1941, Goebbels read Hitler's proclamation to German radio listeners, justifying the military campaign as a defensive measure. Hitler aimed to thwart the conspiracy between the Jewish Anglo–Saxon "warmongers" and the Jewish "power holders" in "Bolshevik" Moscow. He accused Britain, once more, of pursuing a policy of encirclement against Germany, this time by secretly negotiating with the Soviet Union to create a second front. For its part, the Soviet Union had incited rebellion in the Balkans and encroached on German territory. The military campaign of Germany and its allies, Hitler maintained, was no longer the defense of individual countries, but a matter of the "security of Europe" and the "rescue" of all.[41] The German press immediately fell in step with the new propaganda line.[42] *Der Stürmer*

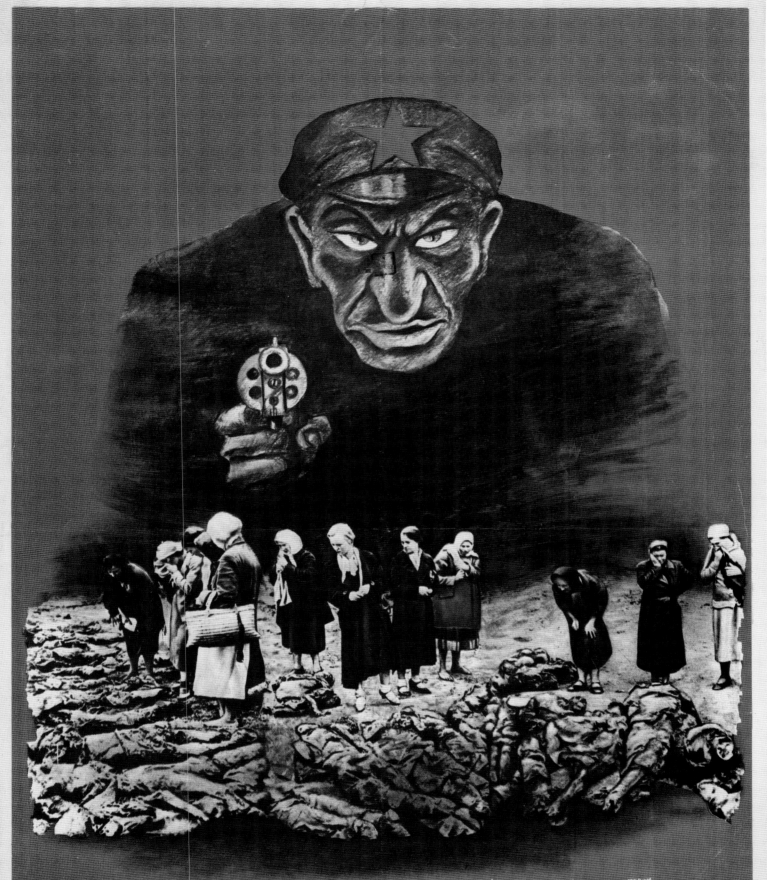

ВИННЦА

P. 132 / Winniza, jüdischer Kommissar / Russisch

ABOVE: German soldiers with a Wehrmacht propaganda unit filming a pogrom in Lvov, occupied Poland, June 30–July 3, 1941, carried out by local residents whom the Germans had convinced that Jews had been the perpetrators of prisoner killings by Soviet Secret Police. *Yad Vashem Photo Archives*

RIGHT: German soldiers walk in the courtyard of a prison in Lvov among the bodies of individuals killed by the Soviet Secret Police prior to the Soviet withdrawal from eastern Poland in the face of the German advance. A Wehrmacht film crew (visible in the background) captured the scene for later use as anti-Soviet propaganda, June 30–July 1, 1941. *Dokumentationsarchiv des österreichischen Widerstandes*

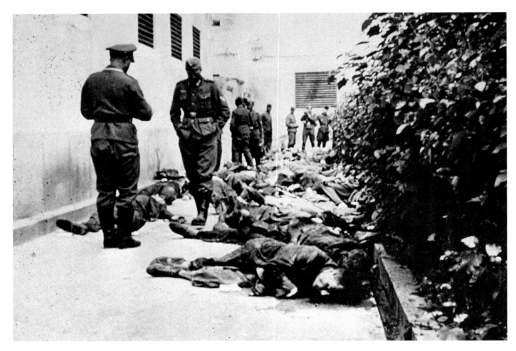

proclaimed Hitler's decision to invade as the "parried stab in the back," reminding its readers of "Marxist treachery" in the past but emphasizing how the Führer's quick action saved the nation. Nazi propagandists again deployed "atrocity stories," this time exploiting and manipulating the discovery of Soviet crimes in Lvov in Soviet-occupied Poland, in Riga in Latvia, and in Soviet-occupied Bessarabia (part of Romania before the war). Propaganda companies photographed and filmed the bereft, weeping families of the victims of the Soviet secret police standing next to the corpses, and intentionally misidentified the perpetrators as Jews and Communists. The incidents served as catalysts for local, often murderous pogroms against Jews and Communists. In Germany and Hungary, newsreel coverage of the "atrocities" in summer 1941 led crowds to demand harsher measures against the Jews. The newsreels presented the story as a three-act morality play: a crime had been committed, the perpetrators discovered, and justice rendered.

By the end of 1941, the German army had advanced to the outskirts of Moscow. In the first six months of the war in the Soviet Union, SS and police units, German military units, and locally recruited auxiliaries had murdered some nine hundred thousand Jews in their communities in the Baltic States, in eastern Poland, in Belorussia, and in Ukraine. In late summer 1941, the SS and police shifted strategy from killing Jewish men of arms-bearing age to annihilating entire families and communities, regardless of sex or age. The largest single massacre was in Kiev, Ukraine, at the Babi Yar ravine, where SS and police units killed more than thirty-three thousand Jewish men, women, and children during September 29 and 30, 1941.

Beginning in autumn 1941, the SS and police began to kill Jews and others using carbon monoxide fumes pumped into sealed mobile vans. During the autumn and winter of 1941–42, the Germans also killed nearly two million Soviet prisoners of war, either by shooting them directly or through deliberate neglect, denying them sufficient food, shelter, and medicine to permit them to survive the winter. News of German

GERMAN PROPAGANDA COMPANY ABETS MASS MURDER

Following the invasion of the Soviet Union, the Nazi conquerors organized public acts of anti-Jewish violence to emphasize the alleged link between Jewry and Communism. One such episode in the Ukrainian city of Zhitomer involved a propaganda company. In August 1941, SS Einsatzgruppe C, operating in Ukraine, notified Berlin of the capture in Chernyakhov of a leading Soviet "People's Judge," Wolf Kieper, fifteen Soviet secret police employees, and eleven informers. Having determined that local Jews were aiding Soviet partisans to "terrorize" the local population, an SS unit rounded up all the male Jews in the town, including Kieper and the others whom they had subjected to lengthy interrogations. According to his captors, Kieper described with "Jewish cynicism" numerous atrocities for which he had been responsible over the previous thirty-six years and stated that he had been involved in the deaths of at least 1,350 persons. After these "confessions," members of

Einsatzkommando 4a publicly hanged Kieper and another Jewish official, Moshe Kogan, in nearby Zhitomir on August 7, 1941. To attract an audience, the 6th Army's propaganda company vehicle, mounted with loudspeakers, broadcast in German and Ukrainian a description of the atrocities allegedly committed by the two accused and announced the death sentence. Thousands of local inhabitants and many regular German soldiers crowded the local market to watch the event. Members of SS Einsatzkommando 4a rounded up 402 Jewish men from Zhitomir and forced them to sit and watch. During the event, the SS asked the assembled crowd if they had any scores to settle with the Jews sitting in the square. In response to the crowd's affirmation, the Jews were subjected to beatings and abuse. The "guilt" of Kieper and Kogan thus transferred to the 402 Jews, the SS and their auxiliaries led those Jews out of the city to previously excavated pits and shot them.[43]

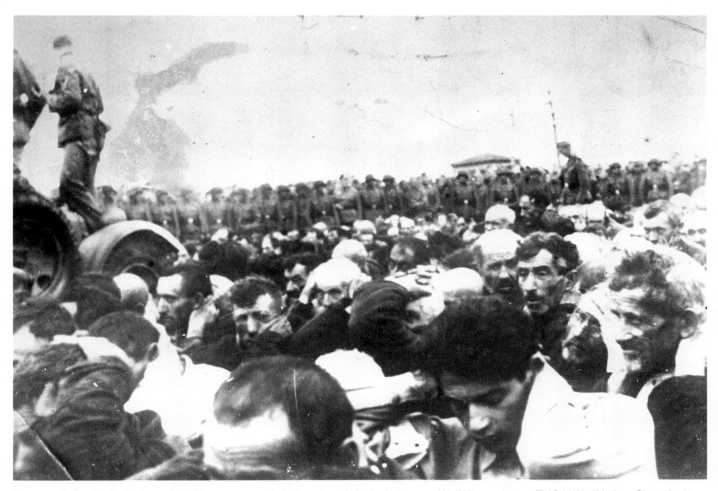

Jews rounded up by the Wehrmacht in Zhitomir to watch the hanging of Moshe Kogan and Wolf Kieper, August 7, 1941. *Yad Vashem Photo Archives*

Jewish children being marched to a site on a beach near Liepaja, Latvia, where they were killed by Latvian and German police under SS command, December 15–17, 1941. *Yad Vashem Photo Archives*

crimes in the Soviet Union quickly spread throughout the world. On January 6, 1942, Soviet foreign minister Vyacheslav Molotov issued a statement to diplomatic representatives outlining massive Nazi atrocities, including the destruction of thousands of villages, widespread rape, and the mass murder of Jews and others in Kiev and elsewhere.[44]

News of Nazi crimes helped stiffen Soviet resistance on the battlefield.[45] At the same time, German propagandists realized the failures of their campaigns in the East. In April 1942, for instance, the Reich Propaganda Directorate of the Nazi Party learned that posters prepared for the local population lacked appeal, had too much text, and as two–sided leaflets, demanded too much of the reader. After testing them on Soviet prisoners of war, German propagandists calculated that the texts were written at too high a level for the audience. The Nazi Propaganda Directorate concluded that Germany's propagandists in the East needed to learn from the "Reds" and create propaganda with "striking caricatures," with which they were familiar.[46] Snowfall and difficult road conditions also complicated the February and March 1942 "propaganda offensives": vehicles bearing loudspeakers could not reach their destinations; leaflets for reconnaissance teams to take with them on their missions did not arrive in time; and the Germans lacked shells to bombard Soviet lines with leaflets or even balloons to drop them.[47]

In fall 1941, reflecting the shift in their anti–Jewish policy to genocide, the Nazis stepped up the persecution of Jews within the Reich. Goebbels took advantage of an unforeseen opportunity, the publication in the United States of a book titled *Germany Must Perish*, to expand anti–Jewish propaganda. Self–published by Theodore Kaufman,

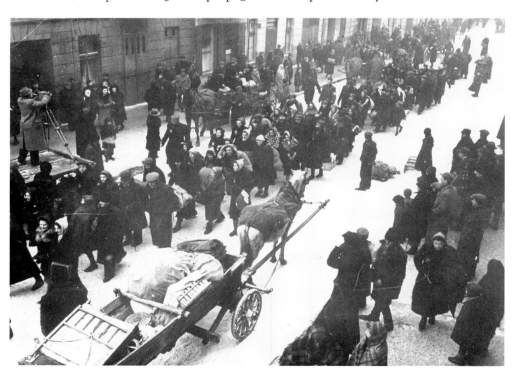

Arrival of German and Austrian Jews in Lodz, ca. October 1941. The march, under German guard through the streets to the site of the ghetto, was captured on film by the person standing on the platform (*upper left*), for potential later use as propaganda. *Bayerische Staatsbibliothek*

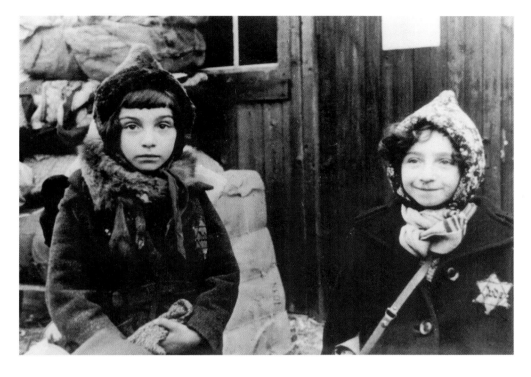

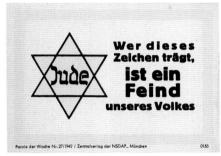

an obscure Jewish salesman of theater tickets who lived in New Jersey, the book advocated the forced sterilization of the entire German population. The Propaganda Ministry used this little-read tract to unleash a campaign focusing on the Jews as the originator of genocide against the German people. The vicious antisemitic campaign vilified the Jews and justified such measures as requiring Jews in Germany to wear Stars of David and deporting them to the East.

In 1942, Nazi Germany implemented genocide on a continental scale with the deportation of Jews from all over Europe to Auschwitz–Birkenau, Treblinka, and other killing centers in German-occupied Poland. The decision to annihilate the European Jews was announced at the Wannsee Conference on January 20, 1942, to key high-level party, SS, and state officials, whose agencies would contribute to implementing a Europe-wide "Final Solution to the Jewish Question."

Joseph Goebbels was not present at the Wannsee Conference, but he was briefed.[48] His diary entries indicate that he was aware of the mass murder under way in Soviet territories in late summer 1941 and the "huge shootings" of Jews in Ukraine that fall.[49] Two years earlier, after a tour of the Lodz ghetto, located in western Polish territory incorporated into the Reich, Goebbels recorded his hatred of the Jews: "Drive through the ghetto. We get out and inspect everything thoroughly. It is indescribable. These are no longer human beings; they are animals. For this reason, our task is no longer humanitarian but surgical. We must cut here, and quite invasively; otherwise Europe will perish from the Jewish disease."[50]

THE PROPAGANDA OF DECEPTION

The Nazis aimed to deceive the German population, the victims, and the outside world regarding their genocidal policy toward Jews. What did ordinary Germans know about the persecution and mass murder of Jews? Despite the public broadcasting

ABOVE, LEFT: Girls who were photographed in an assembly camp prior to their deportation from Munich, November 1941. After their three-day train trip and arrival in Kaunas in German-occupied Lithuania, the 1,000 German Jews in this action were marched more than three miles to the Ninth Fort, where two days later they were shot by members of Einsatzgruppe A. *Stadtarchiv München*

ABOVE: Nazi propaganda poster reading "Whoever Wears This Symbol Is an Enemy of Our People," Munich, 1942. *USHMM, gift of Leonard Lauder*

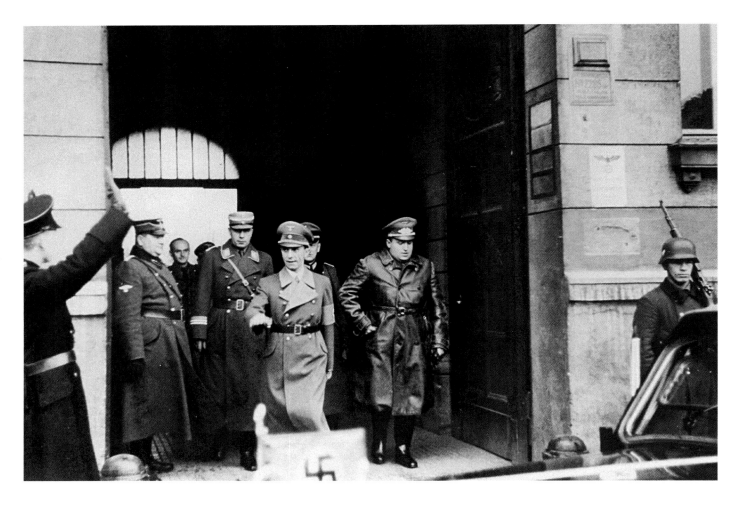

Reich Propaganda Minister Joseph Goebbels in Warsaw during an official visit to German-occupied Poland, November 1, 1939. *BPK*

and printing of statements about the general goal of eliminating "the Jews," the propaganda of deception meant hiding any specific details about the "Final Solution," and press controls prevented Germans from reading the public statements by Roosevelt, Churchill, and Molotov condemning Nazi crimes.[51] At the same time, positive stories were fabricated as part of the planned deception. One booklet printed in 1941 glowingly reported that in occupied Poland, German authorities had put Jews to work, built clean hospitals, set up soup kitchens for Jews, and provided them with newspapers and vocational training. Posters and articles continually reminded the German population not to forget the lies that the Allies spread about Germans cutting off Belgian children's hands during World War I and other atrocity stories used as propaganda against Germany.

Many victims were also deceived about the murderous intentions of the perpetrators. Prior to the deportations of Jews from their homes to ghettos or transit camps, and from the ghettos and camps to the gas chambers at Auschwitz and other killing centers, the Germans made abundant use of deceptive euphemisms. German officials stamped "evacuated," a word with positive connotations, on the passports of Jews deported from the Reich to the "model" ghetto at Theresienstadt, near Prague, or to ghettos in the East. Deportations from the ghettos were characterized as "resettlements," though "resettlement" usually ended in death.

As with efforts to deceive the German population and the wider world, the Nazi regime benefited from the average human being's inability to grasp the dimensions

of the crimes. Leaders of Jewish resistance organizations, for example, tried to warn ghetto residents of the German intentions, but hearing about something was not the same as believing it. "Common sense could not understand that it was possible to exterminate tens and hundreds of thousands of Jews," Yitzhak Zuckerman, a leader of the Jewish resistance in Warsaw, observed. "They decided that the Jews were being transported for agricultural work in the part of Russia occupied by the Germans."[52] One Jewish survivor recalled after the war that, upon arriving at Treblinka, his first impression was that it was a farm.[53]

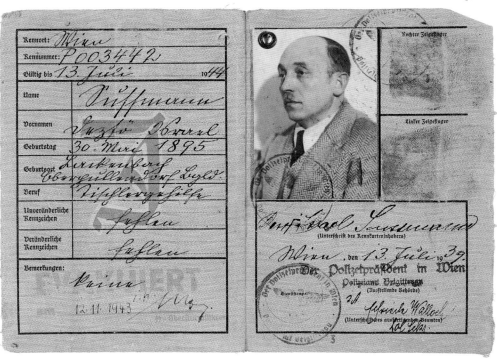

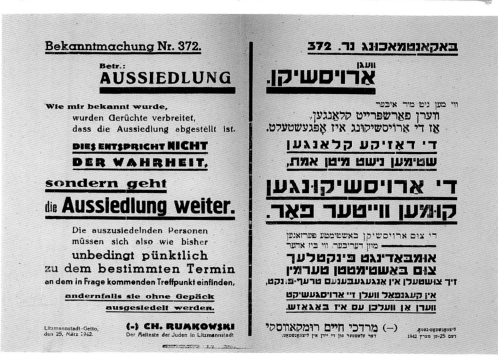

ABOVE: Nazi officials frequently stamped identity cards for Jews deported to Nazi concentration camps with the deceptive term "evacuated" (*evakuiert*), suggesting that they had been removed from a dangerous situation to safety. *USHMM, gift of Henry Sussman*

LEFT: German announcement of the "resettlement" (*Aussiedlung*) of Jews interned in the Lodz (Litzmannstadt) ghetto conceals the victims' actual fate—deportation to their deaths in a Nazi camp equipped with gassing facilities. *USHMM, gift of Malwina Gerson Allen*

THERESIENSTADT: A PROPAGANDA HOAX

One of the most notorious of Nazi efforts at deception was the establishment in November 1941 of a ghetto for Jews in Terezín, in the Czech province of Bohemia. Known by its German name, Theresienstadt, this facility functioned both as a ghetto for elderly and prominent Jews from Germany and Austria and as a transit camp for the Czech Jews residing in German-controlled Bohemia and Moravia. Because the notion that elderly Jews or disabled war veterans could be used for forced labor—the publicly stated purpose for the "evacuation" of the Jews from Germany "to the East"—seemed implausible, the Nazi regime cynically publicized the existence of Theresienstadt as a "spa town," where elderly or disabled German Jews could "retire" and live out their lives in peace and safety. This fiction was invented for domestic consumption within the Greater German Reich. In reality, the ghetto served as a collection center for deportations to ghettos and killing centers in German-occupied Poland and to killing sites in the German-occupied Baltic States. In 1944, succumbing to pressure from the International Red Cross and the Danish Red Cross following the deportation of Danish Jews to Theresienstadt, SS officials permitted Red Cross representatives to visit Theresienstadt. By this time, news of the mass murder of Jews had reached the world press, and Germany was losing the war. As an elaborate hoax, the SS authorities accelerated deportations from the ghetto shortly before the visit and ordered the remaining prisoners to "beautify" the ghetto—gardens were planted, houses painted, and barracks renovated. The SS authorities staged social and cultural events for the visiting dignitaries. After the Red Cross officials left, the SS resumed deportations from Theresienstadt, which did not end until October 1944. In the ghetto itself, more than thirty thousand prisoners died, mostly from disease or starvation.[54]

Dutch Jewish artist Josef Spier, an inmate of the Thersienstadt ghetto, drew this sketch of the city center, beautified for the Red Cross visit in June 1944. *Comité international de la Croix-Rouge*

Crew filming Theresienstadt for the Nazi propaganda film *The Führer Gives the Jews a City.* Czech Jew Ivan Fric (*center with his hand on the rail*), a trained photographer, was one of two ghetto inmates forced to serve as cameramen. *USHMM, courtesy of Ivan Vojtech Fric*

Looking deceptively happy, Jewish children interned in Theresienstadt were photographed by the International Red Cross during their controlled inspection of the ghetto, June 23, 1944. Most of the children were later taken to Auschwitz and murdered. *Comité international de la Croix-Rouge*

Still photo of a soccer match at Theresienstadt from the Nazi propaganda film *The Führer Gives the Jews a City*, 1944. *Beit Lohamei Haghetaot*

The Red Cross visit and depictions of ghetto prisoners going to concerts, playing soccer, working in family gardens, and relaxing in the barracks and outside in the sunshine were filmed and photographed for later use. The Nazis forced the inmates to serve as writers, actors, set designers, editors, and composers. Many children were willing participants in the film because it gave them the opportunity to eat foods, including milk and sweets, they normally were not given. The edited documentary was intended for international audiences only; it might have backfired with German audiences because it would have appeared that ghetto residents lived a better, more luxurious life than many Germans.

PROPAGANDA TO THE BITTER END

The Soviet victory in defense of Moscow on December 6, 1941, and the German declaration of war against the United States on December 11 ensured a protracted conflict. After the catastrophic German defeat at Stalingrad in February 1943, the challenge of maintaining popular support for the war became even more daunting for Nazi propagandists. Germans increasingly could not reconcile news stories with reality, and many turned to foreign radio broadcasts for information. With moviegoers beginning to reject the newsreels as blatant propaganda, Goebbels even ordered theaters to lock their doors before the weekly episode was projected, forcing viewers to watch it if they wanted to see the feature film.[55]

Between July 1943 and May 1944, battlefield deaths averaged seventy thousand a month—figures that propagandists never reported.[56] In the face of such catastrophic losses, German propaganda experts worked to strengthen popular resolve by ratcheting up fear of the consequences of a lost war and intensifying anti–Jewish sentiment. As Goebbels evoked memories of successful Nazi propaganda during the Nazi Party's "period of struggle" of the 1920s, the press, radio, and other media all strove to

Goebbels in a major speech popularizing the concept of "Total War," requiring all the strength of the German people, Berlin, Feburary 18, 1943. *BAK, Bild 183-J05235, Fotograf: Schwahn*

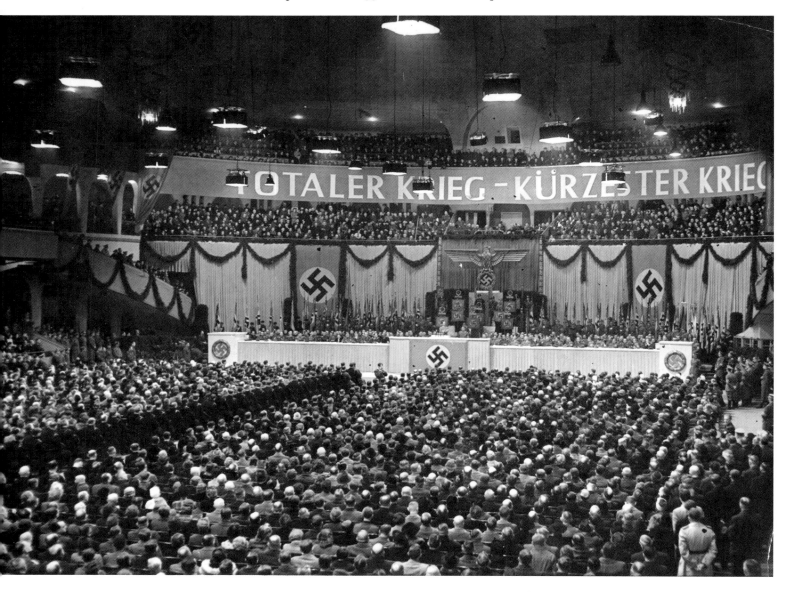

STATE OF DECEPTION: THE POWER OF NAZI PROPAGANDA

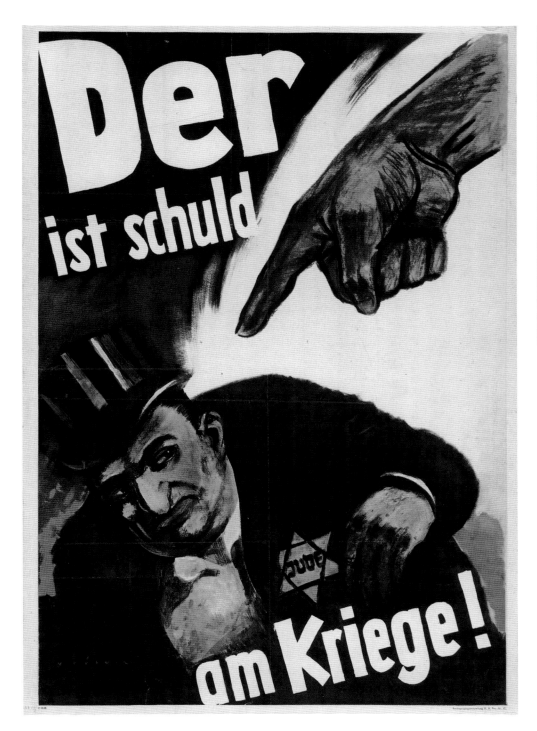

revitalize the specter of "Jewish–Bolsheviks," eager to murder or enslave the German and European populations. "Not since the Hun and Mongol storms has Europe experienced such a danger," one "news" story read. Another reported that the "Jewish plutocrats" in Britain and the United States were planning to deliver the European continent to "Bolshevism," which meant that "millions of German men, women, and children would be slaughtered or transported to the tundra for forced labor." The only defense against the "Jewish–Bolshevik exterminatory designs" was the German Wehrmacht and its allies, "which will defend the life and culture of the European continent with their lives."[57]

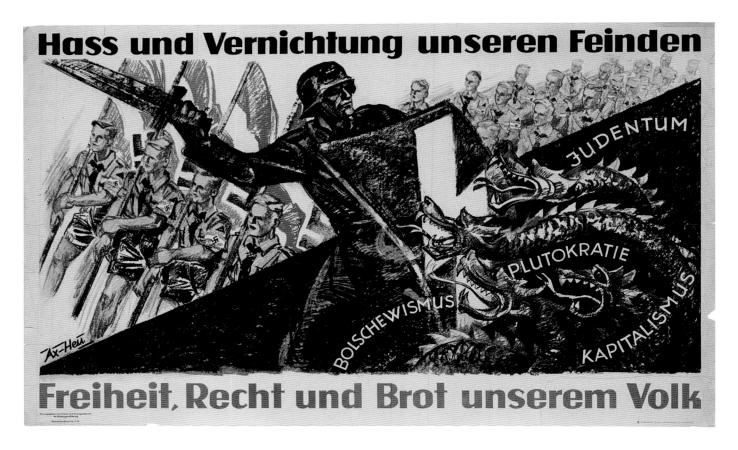

"Hate and Destruction for Our Enemies. Freedom, Justice, and Bread for Our Nation," poster by artists Werner and Maria von Axster-Heudtlass, 1939–1944. *Museum für Kunst und Gewerbe*

OPPOSITE: War propaganda poster "Victory or Bolshevism," by artist Hans Schweitzer ("Mjölnir"), February 1943. *BAK, Plak 003-029-043*

Writing in May 1943 during the height of this new German propaganda offensive, Victor Klemperer, scholar and diarist in Dresden, Germany, categorized by the Nazis as a Jew though he had long before converted to Christianity, observed in his diary: "Uninterrupted Jew-baiting on the radio. . . . again and again in every report, every talk, every context, the word Jewish. Jewish Bolshevism, Jewish plutocracy . . . Jewish influence in the White House."[58] In his own diary, Joseph Goebbels recorded that Hitler was "immensely pleased with our sharpening up the antisemitic propaganda in the press and radio [including] our foreign broadcasts." The propaganda minister also described how the new campaign built on existing Jew-hatred: "The antisemitic bacilli naturally exist in all Europe; we must merely make them virulent."[59] Broadcasts in English to the United States and to American and British troops in Europe included programs by British fascist and committed antisemite William Joyce, nicknamed by the Allies "Lord Haw-Haw," which were transmitted by German-controlled radio stations in Hamburg, Bremen, Luxembourg, Hilversum (the Netherlands), Calais (France), Oslo, and Zeesen (Germany), the site of one of the most powerful shortwave transmitters in the world.

Until the very end of the war, Nazi propagandists kept public attention focused on what would happen to Germany in the event of defeat. The Propaganda Ministry particularly exploited the leak of a postwar plan for Germany's economy developed in 1944 by Henry Morgenthau, Jr., secretary of the treasury in the Roosevelt administration. Morgenthau envisioned stripping Germany of its heavy industry and returning the country to an agrarian economy. "The Wall Street Journal, the organ of Jewish high finance, reports that the United States government has firmly decided to hold to Finance Secretary Morgenthau's elaborate extermination plan for Germany,"

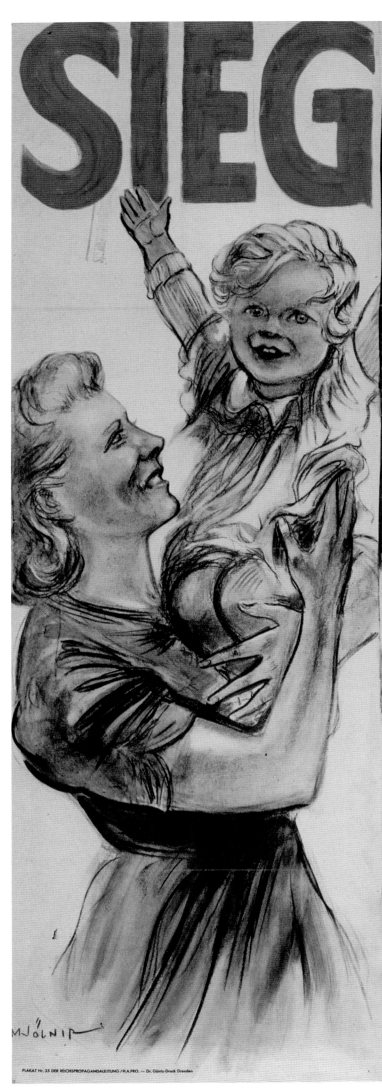
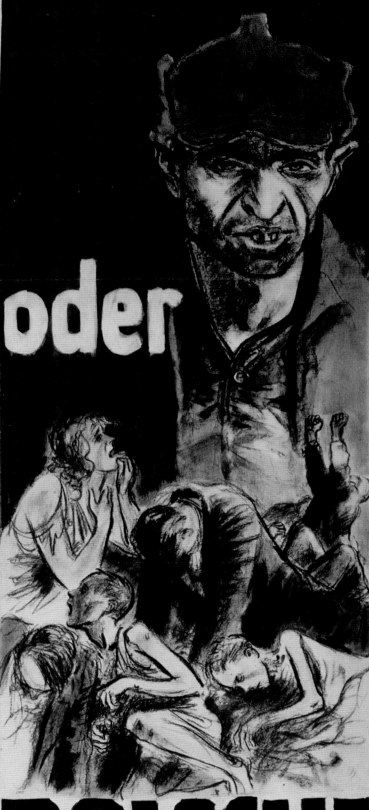

SIEG oder BOLSCHE WISMUS

PLAKAT Nr. 35 DER REICHSPROPAGANDALEITUNG / H.A.PRO. — Dr. Güntz-Druck Dresden

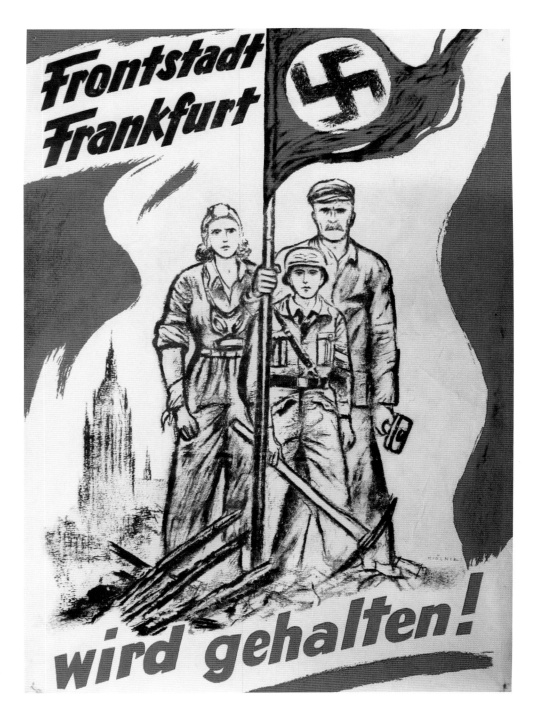

"Frontline City Frankfurt Will
Be Held!" poster by artist Hans
Schweitzer ("Mjölnir"), 1944–45.
*Institut für Stadtgeschichte, Frankfurt
am Main*

reported the German News Office on April 2, 1945. Such stories, which achieved some
success in stiffening resistance as Allied troops moved into Germany, were aimed
at intensifying fear of capitulation, encouraging fanaticism, and urging continued
destruction of the enemy.[60] Goebbels also exploited German hopes for "wonder
weapons"—the V1 and V2 rockets being developed that first appeared in German
newsreels in early July 1944. The promise of the "wonder weapons" only briefly raised
morale, however, as it became apparent they would not change the course of the war.[61]

In his last political testament, composed in his Berlin bunker prior to his suicide
on April 30, 1945, Hitler returned to old propaganda themes. He recalled his "modest
contribution" as a soldier in World War I and his version of how that war had been

"forced upon the Reich." He wrote that he had not wanted war in 1939 and that "international Jewry" had instigated the war. Hitler then again blamed the Jews and promised that "centuries may pass, but out of the ruins of our cities and monuments, the hatred against that people which is ultimately responsible, whom we have to thank for all this—international Jewry and its helpers—will renew itself."[62] In this way, the Nazi Party's first propagandist ended as he had begun. Also in his final testament, Hitler appointed Joseph Goebbels to succeed him as chancellor. Loyal to the end, Goebbels committed suicide in Hitler's Berlin bunker on May 1, 1945. The war in Europe ended on May 8, 1945.

The fact that Germany remained in the war for some two years after the massive military defeats on the Eastern Front in the winter and spring of 1943, the loss of North Africa that same spring, and the ongoing, heavy Allied bombing raids on German cities, as well as the refusal of German leaders to capitulate until Berlin was completely occupied and the country overrun by foreign armies, speaks to the power of Nazi ideology and its expression as propaganda. In the end, Hitler delivered on his promise that Germany would not reexperience November 1918. The Wehrmacht did finally surrender, but this time not until Germany experienced devastating destruction and complete occupation by British, U.S., and Soviet troops.[63] Hitler and the Nazis fulfilled this pledge—but at an enormous cost. Millions of innocent civilians, including nearly six million Jews, were killed. Many of Europe's cities, towns, and villages were ravaged or destroyed, and their populations decimated and left starving. Tens of millions of military combatants lost their lives.

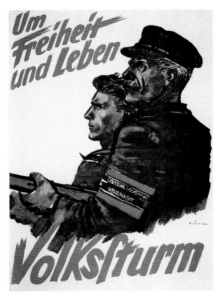

ABOVE: "For Freedom and Life," 1944–45. Recruitment poster by artist Hans Schweitzer ("Mjölnir") for the Volkssturm, troops assembled near the end of the war to defend the "home soil." *BPK*

BELOW: Note the Volkssturm poster on the kiosk in Nuremberg, 1945. *Ullstein Bild, Berlin*

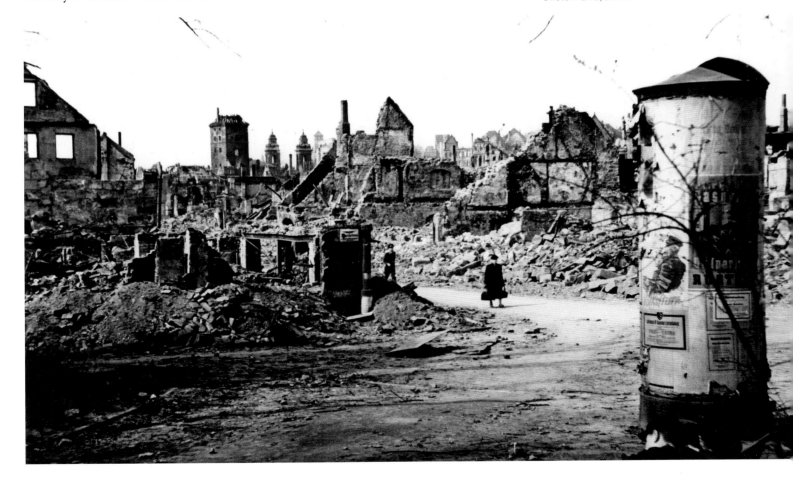

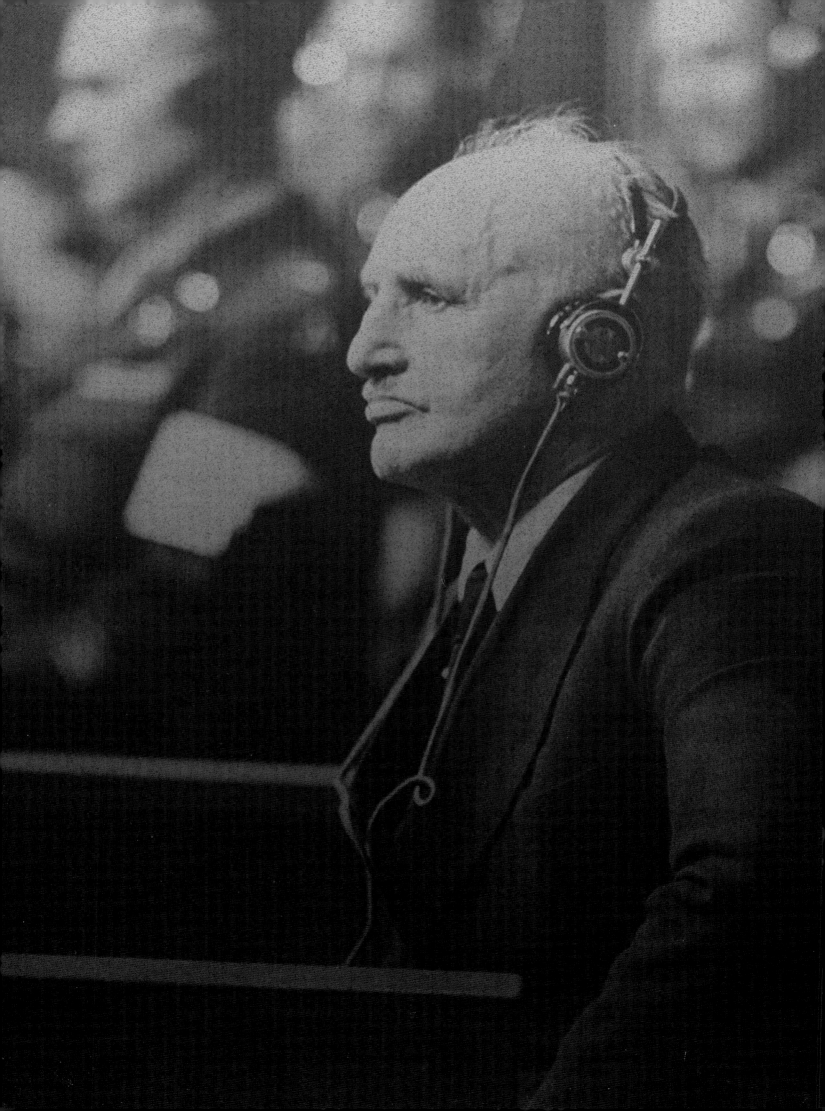

PROPAGANDA ON TRIAL

When the war in Europe ended in May 1945, the Allies faced the major task of reforming German society and reeducating its population after twelve years of Nazi rule. "Nazism," as Victor Klemperer wrote in 1946, had "permeated the flesh and blood of the people through single words, idioms, and sentence structures which were imposed on them in a million repetitions and taken on board mechanically and unconsciously."[1] The Allies forced Germans to confront their recent past by exposing the criminality of the Nazi regime through prosecution of the nation's leaders and by eradicating the vestiges of the Führer cult and Joseph Goebbels's propaganda. For the first time in history, war crimes courts tried propagandists—individuals whose spoken words, images, and writings had contributed to Nazi aggression, persecution, and mass murder.

CONFRONTING NAZI ATROCITIES

Though the Nazi regime attempted to keep the "Final Solution to the Jewish Question" secret, information about the murder of the European Jews, especially of mass shootings in occupied Soviet territories, trickled out to Germans through the indiscreet conversations of Wehrmacht soldiers, SS men, police officials, and civilians operating in eastern Europe. Foreign radio broadcasts and Allied leaflets detailing the extent of Nazi crimes also reached Germans. How many people heard or read the reports and to what extent the reports were believed and their meaning grasped, or whether they were simply viewed as propagandistic "atrocity stories," is impossible to ascertain. Émigré German novelist Thomas Mann broadcast several reports for the British Broadcasting Corporation (BBC), including descriptions in 1942 of the horrific conditions of Jews in the ghettos of occupied Poland and the mass deportations of Jews from France and from the Warsaw ghetto to Nazi killing centers. On January 14, 1945, Mann informed his audiences about the Majdanek and Auschwitz–Birkenau camps and reported that 1,715,000 Jews had been murdered in these two German killing centers between April 1942 and April 1944.[2] The U.S. Army Air Forces bombarded Germany in April 1944 with leaflets titled "Warning to the German People." They contained President Roosevelt's March 24, 1944, statement in which he spoke of "one of the blackest crimes of all history . . . the wholesale systematic murder of the Jews of Europe [which] goes

Poster by Jürgen Freese reading "Nuremberg. Guilty!" 1946. *USHMM, The Abraham and Ruth Goldfarb Family Acquisition Fund*

OPPOSITE: Nazi propagandist Julius Streicher, a defendant at Nuremberg, 1945–1946. *NARA*

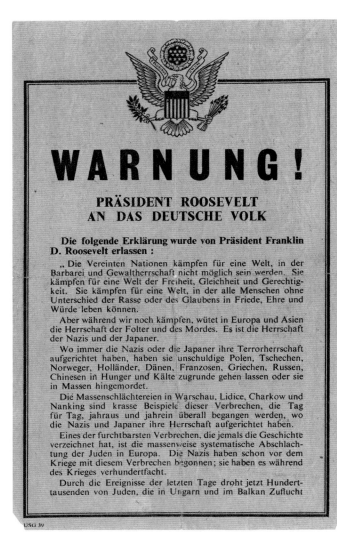

U.S. leaflet dropped on Germany: "Warning! President Roosevelt to the German People," 1944. *USHMM, gift of Kevin Mahoney*

on unabated every hour." Referring to the German invasion of Hungary a few days earlier, Roosevelt feared that "hundreds of thousands of Jews . . . are now threatened with annihilation."[3] The leaflet did nothing to keep Adolf Eichmann and other SS officers from deporting more than four hundred thousand Jews from Hungary, primarily to Auschwitz–Birkenau, though repeated warnings of future punishment may have influenced the Hungarian regent Admiral Miklós Horthy to call an end to the deportations on July 7, 1944.[4]

When the war in Europe ended in May 1945, the Allied armies found powerful means to educate Germans in a more systematic way about the crimes of the Nazi regime. In April 1945, as British and U.S. forces advanced into the Reich, they encountered evidence of Nazi barbarities in the concentration camps. On April 4, U.S. Army units entered the Ohrdruf camp, a subcamp of Buchenwald concentration camp, and found stacks of corpses, prisoners who had recently died or been killed. A week later, on April 12, Supreme Commander of the Allied Forces General Dwight D. Eisenhower visited the camp. "The things I saw beggar description," Eisenhower cabled Army Chief of Staff George C. Marshall. "The visual evidence and the verbal testimony of starvation, cruelty, and bestiality were so overpowering as to leave me a bit sick. . . . I made the visit deliberately, in order to be in a position to give *first-hand* evidence of these things if ever, in the future, there develops a tendency to charge these allegations merely to 'propaganda.' " Soon after, Eisenhower asked Marshall to arrange for "a dozen leaders of Congress and a dozen prominent editors" to tour the camp.[5] On April 15, 1945, respected American radio journalist Edward R. Murrow broadcast a report to the United States from Buchenwald, which had been liberated just a few days before. Murrow contrasted the relative comfort of the Germans living nearby with the wretched conditions for the inmates in the camp.[6] Within days of Murrow's visit, more U.S. soldiers, journalists, and congressional representatives entered Buchenwald to see this firsthand evidence for themselves. The U.S. Army documented in photographs and films the horrific conditions at these sites for exhibition to Allied home audiences. By publicizing the crimes perpetrated in Nazi concentration camps, the Allies promoted the justness of their cause and the evil nature of the enemy.

Eisenhower's admonition to document and publicize information about the concentration camps to dispel possible future allegations of falsehood was carried out rigorously in Germany. Townspeople from nearby Weimar were forced to visit Buchenwald to see what had transpired in their own backyards, while villagers were ordered to attend memorial services for murdered prisoners and then ceremoniously bury them in local cemeteries or mass graves. The Allies required German civilians who did not live near the camps to watch graphic footage taken by the U.S. Army Signal Corps. Posters displaying the dead bodies of prisoners and emaciated camp survivors lined walls, kiosks, and store windows. In keeping with Allied propaganda

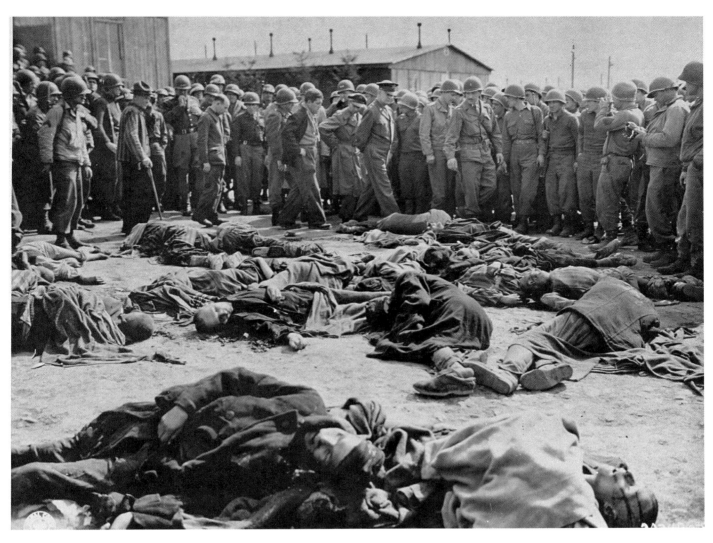

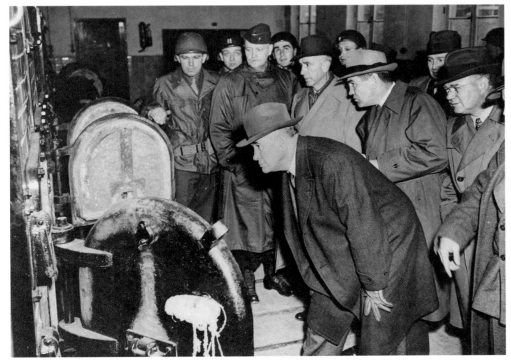

ABOVE: General Dwight Eisenhower and other high-ranking U.S. Army officers viewing the bodies of prisoners while on a tour of the newly liberated Ohrdruf concentration camp, a subcamp of Buchenwald, April 12, 1945. *NARA*

LEFT: U.S. congressmen inspecting the crematoria at Buchenwald, April 24, 1945. *NARA*

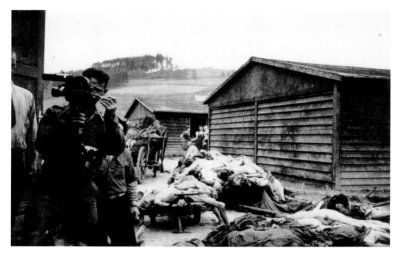

U.S. Army Signal Corps photographer filming the clearing of corpses in the Mauthausen concentration camp, ca. May 1945. *USHMM, courtesy of Lois Mullins*

policy in occupied Germany, these broadsides were to be accurate, factual, and stark. Most important, they had to reinforce the notion of collective guilt or responsibility—that Germans had supported a criminal regime.[7] A twenty-minute newsreel released on June 15, 1945, focused exclusively on the concentration camps. To dispel the notion that these were fabricated scenes, the filmmakers were instructed to show nearby roads and railroad stations as well as German residents at the sites testifying to what they saw there.[8]

German reactions to the Allied press campaign about the concentration camps ranged from acknowledgment of the crimes to astonishment and disbelief. On June 25, 1945, German diarist Ursula von Kardorff recounted the arrival in her southern village of a busload of priests who were former prisoners of Dachau: "They showed us ghastly photos of corpses piled up in the concentration camps. But the people here who saw them said that they were really pictures of the bombing of Dresden. This is the result of Goebbels's propaganda. These people no longer believe anything and mistrust everything and everybody."[9] One of diarist Victor Klemperer's friends, a German physician, expressed guarded disbelief at claims of SS

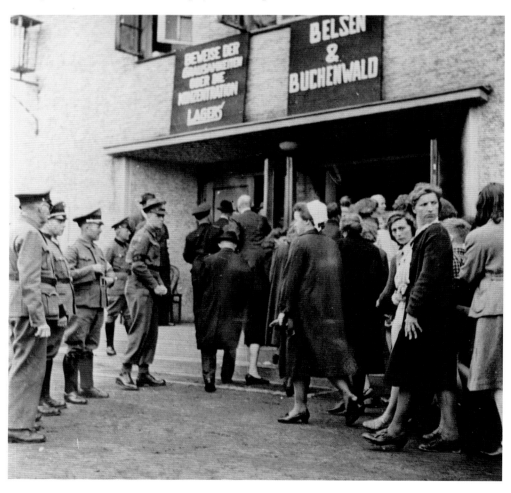

German civilians forced to view a film depicting Nazi crimes. The signs read "Evidence of the Atrocities in the Concentration Camps" and "Belsen & Buchenwald." *Imperial War Museum*

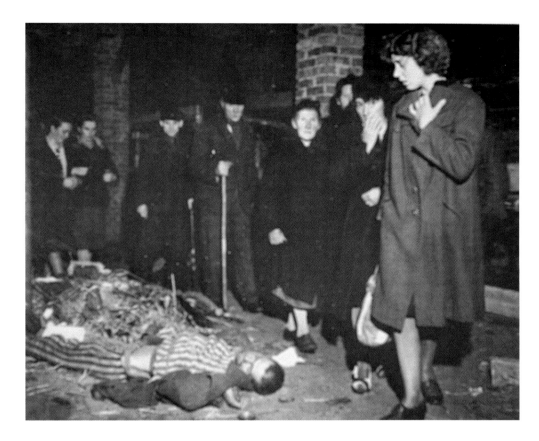

Germans forced to view the bodies of prisoners at Wöbbelin concentration camp, May 6, 1945. *NARA*

crimes, asking Klemperer if he really believed that they had committed "*such* acts of cruelty, and why should they have committed so many atrocities?"[10] In the United States and Canada, hundreds of thousands of German prisoners of war were ordered to view the Signal Corps film footage or read about the camps in illustrated booklets made by the Office of War Information.[11] This compulsory viewing of images of Nazi atrocities provoked heated debates in prison camp newspapers, with some headlines claiming "It's All Propaganda!" Others defended the reports as accurate, speaking either from personal experience as former concentration camp prisoners or as witnesses to German crimes in the East.[12]

POSTWAR PLANS FOR GERMANY AND DENAZIFICATION

Meetings of the major Allied leaders in 1945 laid the groundwork for the military occupation of Germany. At the Yalta Conference in February 1945, Roosevelt, Stalin, and Churchill agreed that Germany and its capital Berlin would be divided into four zones of occupation apportioned to the United States, the Soviet Union, Great Britain, and France, and that common decisions were to be made by an Allied Control Council representing all four nations. At the Potsdam Conference of July–August 1945, U.S. president Harry S. Truman, Soviet premier Joseph Stalin, and newly elected British prime minister Clement Attlee agreed that Allied policy in occupied Germany was to be directed toward the "complete disarmament and demilitarization of Germany," including the abolition of the Wehrmacht, the Gestapo, the SS, the SA, and all other organizations, schools, and clubs serving "to keep alive the military tradition in Germany." Second, the Allies agreed on the need "to convince the German people

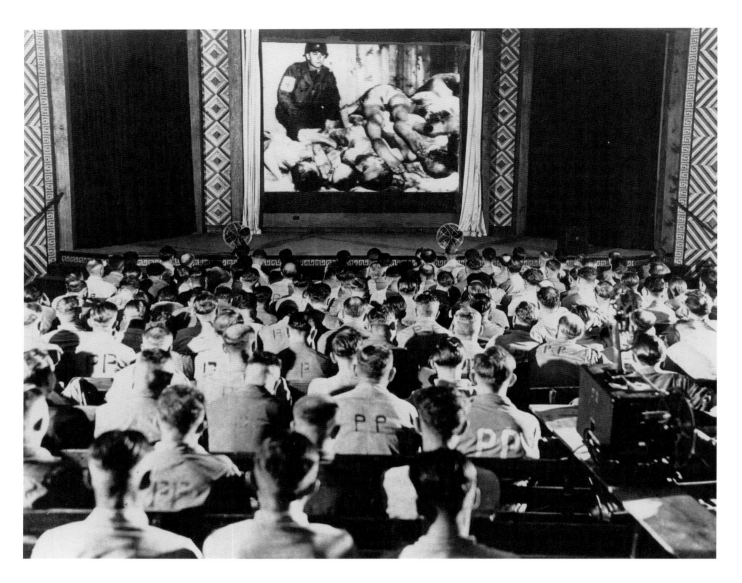

German POWs forced to watch U. S. Army films of Nazi atrocities, New York, June 27, 1945. *Corbis*

OPPOSITE: Catalogue for the "antifascist" exhibition *Niemals Vergessen!* (Never Forget!), Vienna, 1946. *USHMM*

that they have suffered a total military defeat and that they cannot escape responsibility for what they have brought upon themselves." Finally, the occupation authorities would work jointly to destroy the Nazi Party and "its affiliated and supervised organizations, to dissolve all Nazi institutions, to ensure that they are not revived in any form, and to prevent all Nazi and militaristic activity or propaganda."[13]

The removal of party members from positions of influence was a critical but difficult task, given the estimated ten million to thirteen million Germans who had been in some way affiliated with the party.[14] By early July, military authorities in the U.S. Zone had arrested some seventy-five thousand Germans.[15] On January 12, 1946, the Allied Control Council issued Directive No. 24, which stipulated that all members of the Nazi Party who had been "more than nominal participants in its activities, and all other persons hostile to Allied purposes" were to be excluded from holding public and semipublic offices. The directive also required the removal of some former Nazi Party members from sensitive positions, including those involved in the press, publishing, and "other agencies disseminating news and propaganda." Likewise, Nazi Party activists who had been teachers in public, private, or parochial schools, or on the administrative staffs, were subject to immediate dismissal.[16]

In March 1946, the Office of Military Government in the U.S. Zone established the Law for Liberation from National Socialism and Militarism. This law provided for the establishment of special German denazification courts in the American sector to determine the culpability of individuals according to five categories of Nazi Party membership, from major offenders (Class 1) to followers (Class 4) and nonoffenders (Class 5).[17] As of late June 1948, some 12,753,000 Germans had registered under this law. The vast majority, almost 75 percent, were placed in Class 5 and exonerated. Only 836,000 individuals were prosecuted, and of these, 309,320 were exonerated. Of those convicted, 503,360 merely received fines, while the serious offenders—fewer than

Poster from the Supreme Commander banning the use of any seals bearing a swastika or other insignia of the Nazi Party on documents, March 1945. *NARA*

MILITARY GOVERNMENT— GERMANY

SUPREME COMMANDER'S AREA OF CONTROL

LAW NO. 7

REMOVAL FROM OFFICIAL SEALS OF NATIONAL SOCIALIST EMBLEMS

1. No notary, no official and no military, naval, air force, or governmental officer, department, agency or body within the occupied territory shall hereafter use to authenticate any document or for any other official purpose a seal bearing the swastika or other insignia, emblem or legend of the NSDAP, SS, or other National Socialist organization, ████████████████████████████

2. There are hereby deprived of effect hereafter within the occupied territory all requirements or provisions under German law to the effect that any such seal shall bear any such insignia or emblem.

3. When under German law any document requires for its validity or effectiveness authentication or impressment thereon of any such seal or provides that such impressment confers upon such a document a legal status which it would not otherwise have, a seal conforming with all applicable provisions under German law not inconsistent with paragraphs 1 and 2 hereof shall be operative for such purposes.

4. Any person violating the provisions of this Law shall, upon conviction by a Military Government Court, be liable to any lawful punishment, other than death, as the Court may determine.

5. This Law shall become effective upon the date of its first promulgation.

BY ORDER OF MILITARY GOVERNMENT.

A.93499. W.L44764/SA. 293. 15m. 12/44. M. & H. Gp.S.　　　　　CA/G 43

MILITAERREGIERUNG—DEUTSCHLAND

KONTROLLGEBIET DES OBERSTEN BEFEHLSHABERS

GESETZ NR. 7

ENTFERNUNG NATIONALSOZIALISTISCHER ABZEICHEN VON AMTSSIEGELN

1. Im besetzten Gebiet dürfen Notare, Beamte, Offiziere, der Land-, See- und Luftstreitkräfte, Behörden, Dienststellen oder Körperschaften in Zukunft Siegel mit dem Hakenkreuz oder anderen Sinnbildern, Emblemen, oder Aufschriften der NSDAP, SS oder einer anderen nationalsozialistischen Organisation nicht zur Beglaubigung von Schriftstücken oder zu irgend einem sonstigen Amtsgebrauch verwenden. ████████ ████████████████████████████████████

2. Allen Erfordernissen oder Vorschriften des deutschen Rechts, welche derartige Sinnbilder oder Embleme für den Siegel vorschreiben, wird hiermit im besetzten Gebiete jede Rechtswirkung entzogen.

3. Falls nach deutschem Recht ein Schriftstück zu seiner Gültigkeit oder Wirksamkeit der Beglaubigung oder des Aufdrucks mittels eines solchen Siegels bedarf oder durch einen solchen Aufdruck eine rechtliche Eigenschaft erlangt, die es sonst nicht hätte, so genügt für alle Zwecke die Beglaubigung oder der Aufdruck mittels eines Siegels, der allen anwendbaren Vorschriften des deutschen Rechts entspricht, die mit vorstehenden Paragraphen 1 und 2 nicht im Widerspruch stehen.

4. Jeder Verstoss gegen die Bestimmungen dieses Gesetzes wird im Falle der Schuldigsprechung des Täters durch ein Gericht der Militärregierung, nach dessen Ermessen mit jeder gesetzlich zulässigen Strafe, jedoch nicht mit der Todesstrafe, geahndet.

5. Dieses Gesetz tritt am Tage der ersten Verkündung in Kraft.

IM AUFTRAGE DER MILITAERREGIERUNG.

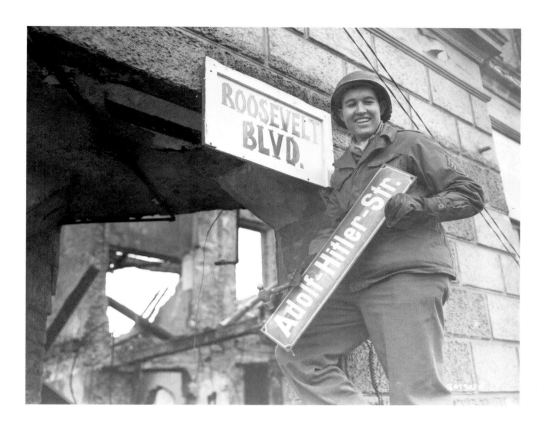

U.S. soldier in Krefeld, Germany, March 9, 1945. *NARA*

25,000 in all—received sentences in labor camps from one to five years.[18] The relative failure of this program reflected the growth of antagonism between the Western Allies and the Soviet Union and a shift in political priorities from denazification to fighting the Cold War. Proponents of economic reconstruction, a strong priority on both sides of the Iron Curtain that divided the Western democracies from Communist Eastern Europe, also played a role, arguing for more leniency in permitting former Nazis to return to their positions.

Denazification also entailed renaming streets, parks, and buildings that had Nazi or militaristic associations; removing monuments, statues, signs, and emblems linked with Nazism or militarism; confiscating Nazi Party property; eliminating Nazi propaganda from education, the media, and the many religious institutions that had pro-Nazi leaders and clergymen; and prohibiting Nazi or military parades, anthems, or the public display of Nazi symbols. Allied soldiers, former concentration camp prisoners, and anti-Hitler Germans took out their vengeance on Nazi symbols by burning or destroying swastika-emblazoned flags, banners, and posters. In a moment captured on film, U.S. soldiers blew up the huge swastika at the Nuremberg Zeppelin Field reviewing stand, the site of former Nazi Party rallies. To those who witnessed it, whether in person or in newsreels shown at movie theaters, the explosion symbolized the end of Nazism and the beginning of a new era.[19] The Führer cult had to be discredited, and the former German leader was shown to have been a maniacal mass murderer whose policies had brought misery to millions of Europeans and had led to the destruction of Germany. Film crews documented workers as they took sledgehammers to a massive metal bust of Hitler and melted down the lead printing plates for his autobiography, *Mein Kampf*, to produce type for a democratic newspaper for the new Germany.[20]

The Allies' denazification program also involved the presentation of information to the German populace in an objective, commanding, and factual way. U.S.-disseminated information was not to appear like propaganda because twelve years of Nazi propaganda had made German audiences overly conscious of any Allied propaganda. According to Directive No. 1 for Propaganda of Overt Allied Information Services, "The last vestiges of 'propaganda' will be removed from its presentation. The propaganda will consist entirely in skilled selection and factual writing. . . . Obvious propaganda clichés, and particularly obvious propaganda headlines will be eliminated. . . . It must be emphasized that this first stage of reeducation, which is a critical stage, will have the opposite effect to that intended, if it is permitted even to look like a propaganda campaign."[21] As a first step, the Allies closed down all of Germany's newspapers, radio stations, cinemas, and schools. The occupying armies immediately began publishing new newspapers for the German population. The U.S. Office of War Information developed glossy magazines, such as *Heute* (Today), which featured stories about the United States, the Nuremberg trials, and international events. By 1947, *Heute* had a circulation of some five hundred thousand.[22]

As part of their reeducation, Germans were exposed to cultural offerings and ideas denied them under the Nazis. Art that had been declared degenerate now was on display in German galleries and museums, and jazz became a staple on radio in the U.S. Zone.

Discrediting the Führer cult, Germany, April 1946. *Landesarchiv Berlin*

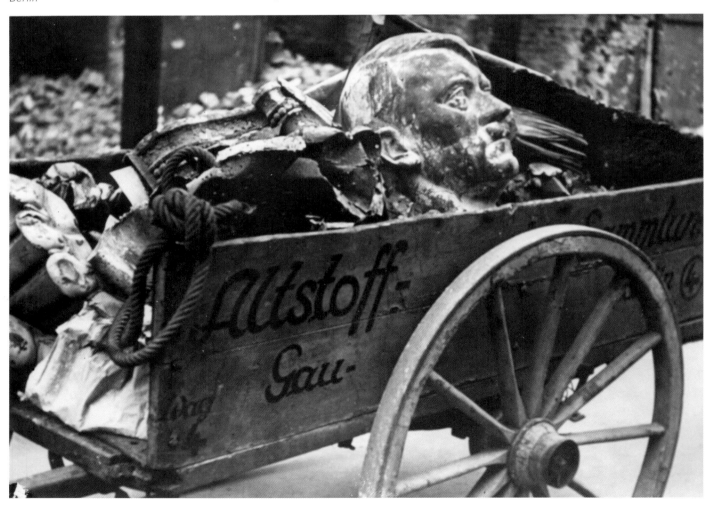

STATE OF DECEPTION: THE POWER OF NAZI PROPAGANDA

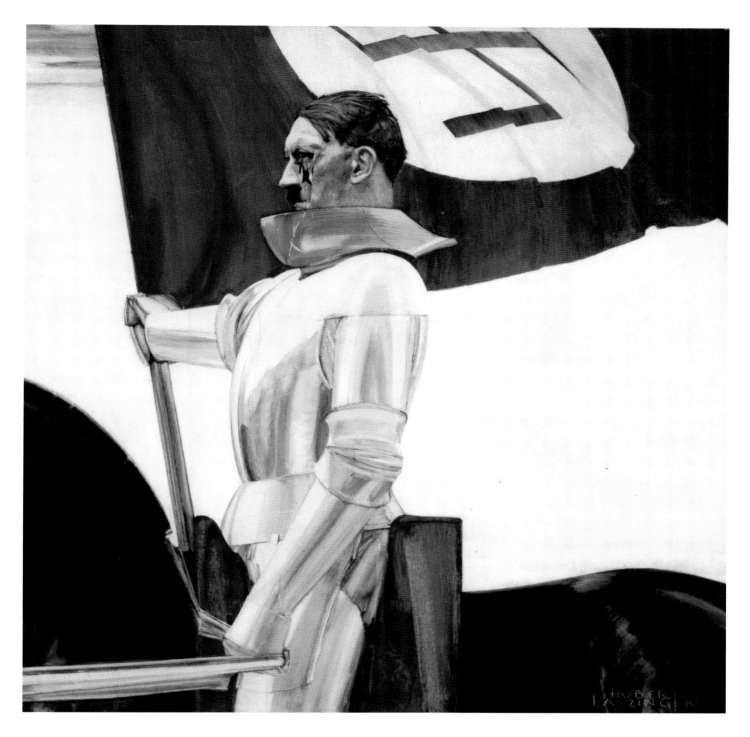

The Information Control Division of the Office of Military Government developed ambitious programming. Its Music and Theater Branch introduced American classical composers such as Samuel Barber, Aaron Copland, and Leonard Bernstein to German audiences. In 1945, the Berlin Philharmonic, under African American conductor Rudolph Dunbar, gave the European premiere of William Grant Still's *Afro-American Symphony*.[23] Despite the destruction from the war, radio and film could still reach large audiences in Germany. In the U.S. Zone alone, an estimated two million radio sets could receive broadcasts not only from local stations but also from the Voice of America in New York.[24] Hollywood mogul Jack Warner hoped that Germany's defeat would

The Standard Bearer, oil painting by Hubert Lanzinger with Hitler's face slashed by a U.S. soldier. *U.S. Army Center of Military History*

Ruins of the Reich Ministry for Public Enlightenment and Propaganda, Berlin, 1945. Rebuilding Germany's infrastructure became critical to the Allies' postwar plans. *Ullstein Bild, Berlin*

eliminate an unwanted filmmaking competitor in Europe and that American films could inundate the conquered land, fulfilling the reeducation policy and enriching U.S. studios' coffers.[25] The newsreel also found a welcome place in Allied policy, and within weeks of the war's end, filmmakers were producing the Anglo–American newsreel series *Die Welt in Film* (The World in Film) for the German public.[26] Film audiences were presented segments on Nazi atrocities, war crimes trials, and curfew-breaking scofflaws, as well as stories highlighting the success of democratization and American goodwill.

When the Allied armies took control of Germany, occupation authorities worried especially about the indoctrination of German youth, who had been educated exclusively under Nazi rule.[27] The defeat of the Wehrmacht on the battlefield and the virtual destruction of Germany's major cities, however, had greatly weakened the mass appeal of Nazism. Yet Allied occupation forces understood that they had to remove the causes of popular discontent to prevent a future resurgence of Nazism. The daily struggle for existence, finding food and shelter, and locating family members dominated the lives of the average German. Winning over German public opinion to democracy, in the Western zones of occupation, was predicated upon "restoring the economy, creating a better standard of living, and successful reeducation."[28] To win

over young people, the Allies had to supply new textbooks, restore school buildings, and install "proper" teachers.

The occupation authorities began purging schools, public libraries, and bookstores of Nazi–generated literature. Allied Control Council Order No. 4, issued on May 13, 1946, mandated that "all owners of circulating libraries, bookshops, bookstores, and publishing houses" turn over any books or other printed material, films, or slides that included Nazi propaganda, including Nazi racial theories and any military training manuals. The order also required public libraries and educational institutions to remove all Nazi and military literature and turn it over to occupation authorities.[29] Authorities sent copies of the selected material to the Library of Congress in Washington, D.C., and destroyed the remaining copies in Germany. To some Americans, such a sweeping policy of confiscation and destruction conjured up images of Nazi book burning and totalitarianism. General Lucius Clay, the commander in chief of the U.S. occupation forces in Germany and the military governor of the U.S. Zone, defended the order, noting that Germans under occupation did not have full civil rights. Clay made clear that no public book burnings would take place in the U.S. Zone, nor would the sanctity of private homes be violated by searches for Nazi literature.[30]

PROSECUTING PROPAGANDISTS

During the war, the Allies repeatedly warned Germany and the other Axis powers of their determination to punish those government, military, or Nazi Party officials responsible for criminal actions. The International Military Tribunal opened in Nuremberg on November 20, 1945. By publicizing the trial of the top Nazi leaders to

German youth reading a poster with images of crimes committed in concentration camps, distributed by the U.S. Army, titled "You Should Know about It!" June 18, 1945.
Imperial War Museum

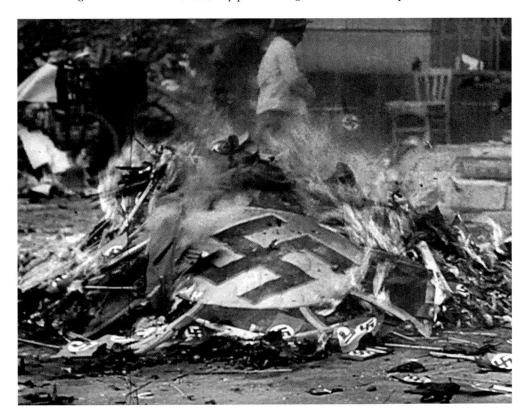

American soldiers in Cologne burning Nazi insignia as part of the denazification program, 1945.
NARA

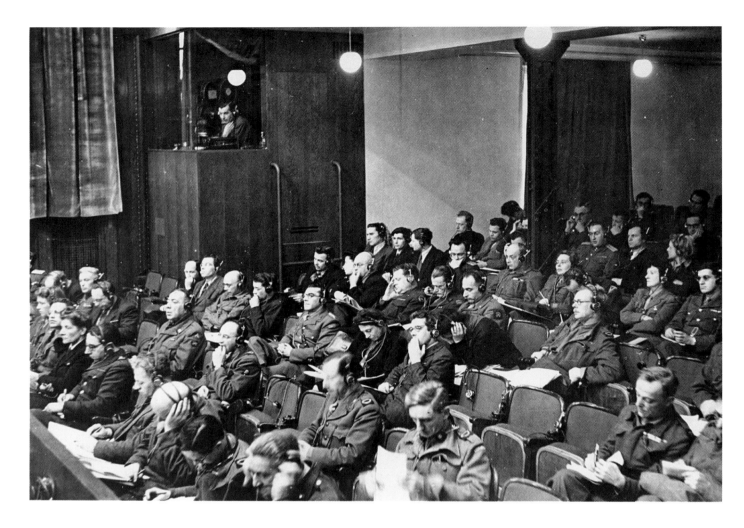

ABOVE: Press section of the courtroom at the International Military Tribunal trial of war criminals at Nuremberg, October 18, 1945–October 1, 1946. *Imperial War Museum*

BELOW: Photographer for *World in Film*, the U.S. Army weekly newsreel, reloading film in camera under a cloth during the verdict phase of the International Military Tribunal of war criminals at Nuremberg, September 30, 1946. *BPK*

the German populace, the Allies hoped to discredit the Hitler regime and expose the scope of its aggression and mass murder. Two hundred fifty journalists from across the globe attended the proceedings at the Palace of Justice, using a special pressroom created to provide them with telephones, typewriters, and piles of trial documents.[31] To make sure that the local population received news of the trials, the occupation authorities increased the newsprint allotment for the German press, and for the duration of the trial, radio stations broadcast reports with commentary several times daily.[32] Beginning on December 7, 1945, newsreels carried regular reports about the trial.[33] U.S. Army Signal Corps photographers filmed most of the proceedings.

In many respects, the proceedings at Nuremberg were unprecedented. Never had so many national leaders been tried by a court composed of their military conquerors. Twenty-four individuals, representing all sectors of political life under Nazi rule, were indicted on four counts: common plan or conspiracy to commit crimes against peace; crimes against peace; war crimes; crimes against humanity. Among the defendants were several individuals linked to the creation or dissemination of Nazi propaganda. The cases against the editor of *Der Stürmer*, Julius Streicher, and Ministry of Public Enlightenment and Propaganda official Hans Fritzsche rested entirely upon their actions as propagandists. The indictment included the statement that propaganda was "one of the strongest weapons of the conspirators [who] from the outset . . . appreciated the urgency of the task of inculcating the German masses with the National

Socialist principles and ideology," and who used propaganda "to prepare the ground psychologically for political action and military aggression."[34]

The key challenge that the prosecution faced in its case against Streicher and Fritzsche was to prove a direct, causal link between the activities of the Nazi propagandists and the implementation of a policy of aggression or mass murder. The Streicher case proved the stronger of the two: the twenty-two-year run of *Der Stürmer* provided ample evidence of Streicher's fanatical hatred for Jews and calls for action against them. One article appearing in May 1939 stated: "A punitive expedition must come against the Jews in Russia. A punitive expedition which will provide the same fate for them that every murderer and criminal must expect. Death sentence and execution. The Jews in Russia must be killed. They must be exterminated root and branch."[35] Documenting Streicher's knowledge of and responsibility for the implementation of the "Final Solution" was more difficult. An article written for *Der Stürmer* on November 4, 1943, suggested knowledge: "It is actually true that the Jews have so to speak disappeared from Europe and that the Jewish 'Reservoir of the East,' from which the Jewish pestilence has for centuries beset the peoples of Europe, has ceased to exist. But the Führer of the German people at the beginning of the war prophesied what has now come to pass."[36] Testifying in his own defense, Streicher insisted that he learned

The International Military Tribunal trial of war criminals at Nuremberg, November 1945. The defendants, under guard, sit in the last two rows. *NARA*

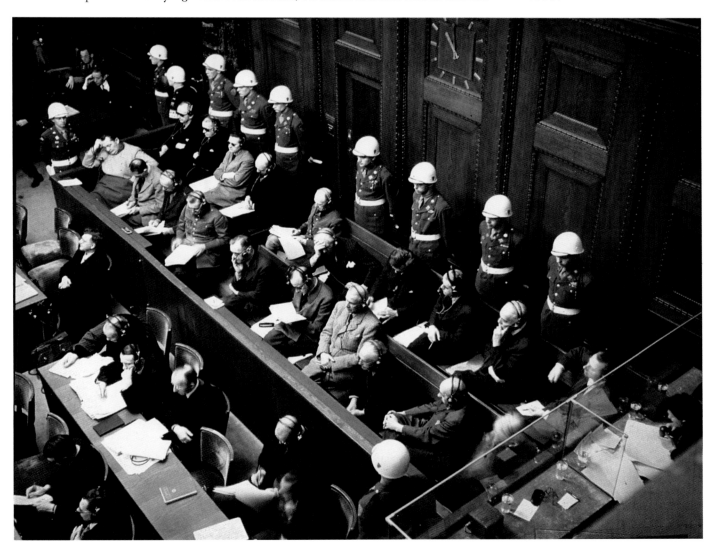

of the mass killings only when he was imprisoned by the Allies. He also claimed that his speeches and articles did not aim to incite the Germans but only "to inform" and "enlighten" them "on a question which appeared to me one of the most important questions." Streicher, whom psychiatrists had evaluated as sane but obsessed with hatred for "the Jews," came off as insincere and untrustworthy.[37]

In closing arguments, the prosecution compellingly detailed the accused's guilt: "The defendant Streicher is an accessory to the persecution of the Jews within Germany and in occupied territories which culminated in mass murder of an estimated six million men, women, and children. The propaganda in *Der Stürmer* and other Streicher publications, for which he had admitted responsibility, was of a character calculated to stir up fanatic fear and hatred of the Jewish people and to incite to murder. It was disseminated, moreover, in a country in which there was no free market of ideas; in which, in fact, as defendant Streicher well knew and approved,

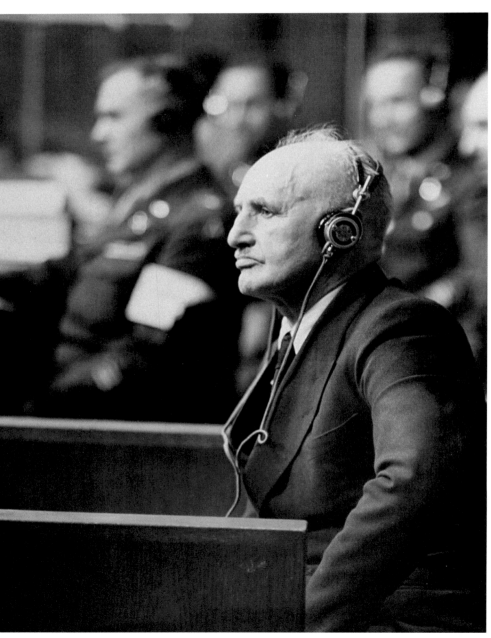

Defendant Julius Streicher (*right*), the editor of *Der Stürmer*, wore this headset during the Nuremberg trial to listen to simultaneous translations of the proceedings. The tag bears his name. The multinational tribunal required English, French, Russian, and German. *NARA; USHMM, gift of IBM Corporation*

STATE OF DECEPTION: THE POWER OF NAZI PROPAGANDA

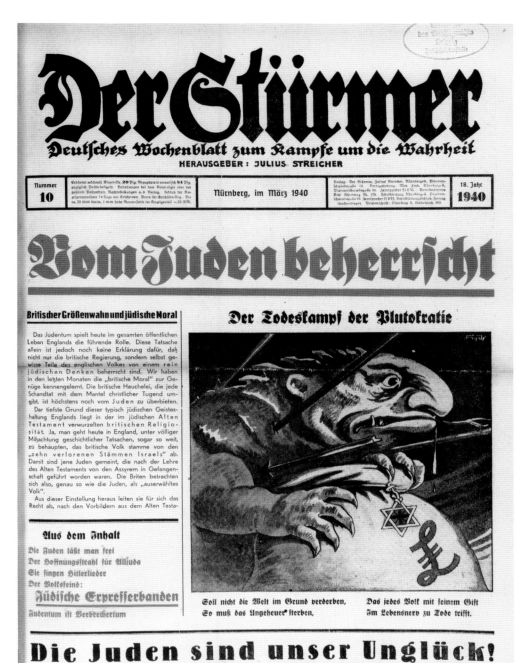

no countervailing argument could find public expression; and in which, therefore, the impact of such propaganda was of a clearly foreseeable and peculiarly sweeping force. Through propaganda designed to incite hatred and fear, defendant Streicher devoted himself, over a period of twenty–five years, to creating the psychological basis essential to carrying through a program of mass murder. This alone would suffice to establish his guilt as an accessory to the criminal program of extermination."[38] Unable to prove that Streicher had a causal connection to the actual implementation of mass murder, the prosecution settled for the argument that Streicher actively "recommended and promoted the program of extermination" while mass murder was being committed.[39]

The tribunal found Streicher guilty on the charge of crimes against humanity, concluding that twenty-three articles published in *Der Stürmer* between 1938 and 1941 had called for the extermination of the Jews. The main evidence used to establish Streicher's knowledge of the "Final Solution" was his subscription to a Swiss Jewish newspaper, *Israelitische Wochenblatt* (Israelite Weekly), which published reports of Nazi killings.[40] The court ruled that "Streicher's incitement to murder and extermination at the time when Jews in the East were being killed under the most horrible conditions clearly constitutes persecution on political and racial grounds in connection with War Crimes, as defined by the Charter, and constitutes a Crime against Humanity."[41] The tribunal sentenced him to death by hanging. At 2:12 a.m. on October 16, 1946, Streicher was led to the gallows and hanged.

Hans Fritzsche of the Propaganda Ministry was the lowest-ranking German official tried by the International Military Tribunal.[42] Fritzsche probably ended up as a defendant along with the more senior German officials because Goebbels's death had left the Allies without a senior representative of the Ministry of Public Enlightenment and Propaganda, and the Western Allies were eager to appease the Soviets by selecting Fritzsche, one of only two Nuremberg defendants in Soviet custody in 1945. He had served as director of the Propaganda Ministry's Broadcasting Division and hosted his own radio program, *Hier Spricht Hans Fritzsche!* (Hans Fritzsche Speaks!). The prosecutor in Fritzsche's case tried to prove the defendant's guilt by drawing on the blatantly antisemitic statements from his many broadcasts, which the BBC had intercepted and translated into English. "Fritzsche is not in the dock as a free journalist," the prosecuting attorney argued, "but as an efficient, controlled Nazi propagandist . . . who helped substantially to tighten the Nazi stronghold over the German people [and] who made the excesses of these conspirators more palatable to the consciences of the German people themselves."[43] The court did not find the evidence convincing and found Fritzsche not guilty on all three counts against him. "It appears that Fritzsche sometimes made strong statements of a propagandist nature in his broadcasts," the court concluded. "But the Tribunal is not prepared to hold that they were intended to incite the German people to commit atrocities on conquered peoples, and he cannot be held to have been a participant in the crimes charged. His aim was rather to arouse popular sentiment in support of Hitler and the German war effort."[44]

The court's findings in the Fritzsche case established an important distinction by distinguishing between hate speech or hate propaganda and incitement. Although he made antisemitic broadcasts and statements during his tenure in office, Fritzsche did not specifically call for the mass murder of Europe's Jews. This fact clearly separated his propaganda from Streicher's. (Only the Soviet judge, Major General I. T. Nikitchenko, dissented: "The dissemination of provocative lies and the systematic deception of public opinion were as necessary to the Hitlerites for the realization of their plans as were the production of armaments and the drafting of military plans."[45]) Fritzsche was later deemed to be a category-one "major offender" by the Nuremberg denazification court and sentenced to nine years' imprisonment in a labor camp. Though banned from writing for life, he penned his memoirs during his incarceration and published them under a pseudonym. After his sentence was reduced and he was released in 1950, Fritzsche worked in advertising and public relations until 1953, when he died of cancer at the age of 53.[46]

THE LATER TRIALS

In separate cases in Nuremberg, tried under the auspices of the International Military Tribunal but presided over by American judges, U.S. prosecutors charged leading German officials with war crimes, crimes against peace, and crimes against humanity in key fields: medicine, industry, the armed forces, law, and government. Former Nazi press chief Otto Dietrich ended up on the docket in the Ministries Trial, charged with crimes against humanity. He refused to testify on his own behalf. After weighing the evidence and hearing testimony from his former colleagues in the Reich Press Office, the tribunal convicted Dietrich and sentenced him to seven years' imprisonment. In its verdict, the court ruled: "A well thought-out, oft-repeated persistent campaign to arouse the hatred of the German people against Jews was fostered and directed by the press department and its press chief, Dietrich. . . . [The press and periodical directives aimed] to enrage Germans against the Jews to justify the measures taken and to be taken against them, and to subdue any doubts which might arise as to the justice of measures of racial persecution to which Jews were to be subjected. . . . Dietrich consciously implemented and, by furnishing the excuses and justifications, participated in the crimes against humanity regarding Jews."[47] Because of time already served, Dietrich was released from prison in 1952. He died shortly thereafter.

Mug shot of Otto Dietrich for the International Military Tribunal, 1945. *NARA*

German denazification courts charged other Germans as propagandists. A court in Munich found Hitler's personal photographer, Heinrich Hoffmann, guilty of having a leadership position in the government, supporting the Nazi regime through his propaganda, and contributing to Hitler's assumption of power. Hoffmann failed to convince the court that he was an "apolitical" photojournalist who objectively reported the events as they happened. He was sentenced to ten years in a labor camp, but while imprisoned, he appealed the court's decision and won a considerably reduced sentence in November 1950.[48] Filmmaker Leni Riefenstahl, known for her films *Triumph of the Will* and *Olympia*, was arrested by U.S. troops shortly after the war ended. Riefenstahl portrayed herself to U.S. interrogators as a consummate artist who refused to bow to the whims of Nazi Party bosses. Like many of her fellow propagandists, Riefenstahl pleaded relative ignorance of the concentration camps and expressed her shock at what she learned after the war: "Today, when I hear all these dreadful things which happened in Germany, I could cry. And I cannot grasp how any of the people who shared Hitler's political ideas have the courage to continue living. I would have committed suicide, had I felt that I shared the responsibility for these crimes." To reinforce this impression, she disclosed that she had maintained friendships with Jewish artists and even helped them financially during the Third Reich.[49] After U.S. authorities released her, Riefenstahl went through four denazification trials between 1948 and 1952. In all but one of these, courts completely exonerated her; she was once declared a "follower" (Class 4), but she obtained a pardon in a subsequent proceeding. Despite German press reports that she witnessed a massacre of Jews in Konskie, Poland, on September 12, 1939, and used Gypsy (Roma and Sinti) prisoners from Nazi internment camps in her 1954 film *Tiefland*, the denazification courts cleared her.[50] Only in August 2002, as the result of a civil suit brought by one of the Gypsies who had appeared as an extra in *Tiefland*, was Riefenstahl compelled to take some responsibility for the forced laborers used in her film, and she

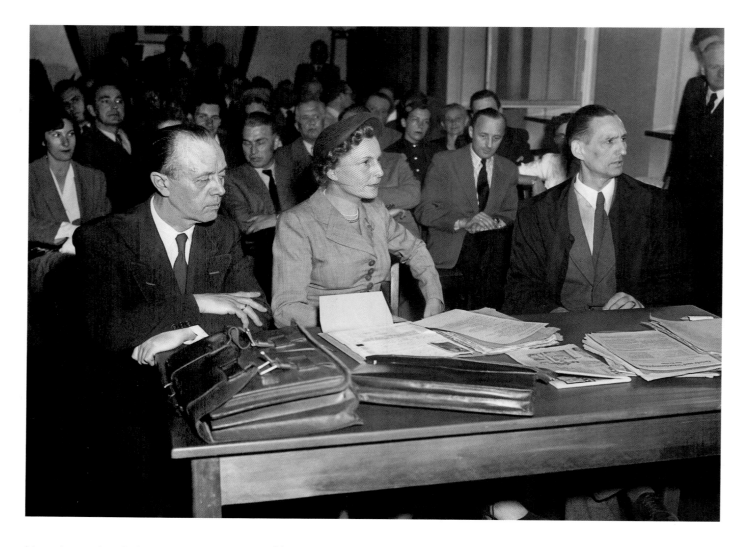

Movie director Leni Riefenstahl (*center*) with her lawyer Dr. Alfred von Seefeld (*right*) at the West Berlin court for denazification, April 21, 1952. *AP Images*

Film director Fritz Hippler, 1941. *Ullstein Bild / The Granger Collection, New York*

retracted her statement that all of the *Tiefland* extras survived the war.[51] Riefenstahl died in 2003 at the age of 101.

Several individuals connected to the 1940 antisemitic film *The Jew Süss* were indicted. They included the director, Veit Harlan, who was tried and acquitted three times and subsequently returned to work as a film director; the actor Ferdinand Marian, who was banned from his profession and died in an automobile accident in 1945; and the actor Heinrich George, who was arrested by Soviet authorities and died in 1946 while imprisoned in the former Nazi camp, Sachsenhausen.[52] Fritz Hippler, the director of the notorious *The Eternal Jew*, served two years' imprisonment but later found employment working in German documentary films, sometimes under an alias. After retiring from filmmaking, he opened a travel agency.[53]

German courts tried artists who had created Nazi antisemitic propaganda as well as Nazi press moguls. Philipp Rupprecht ("Fips"), the German cartoonist whose antisemitic images appeared in *Der Stürmer*, was in U.S. custody as a prisoner of war when Germany surrendered. In 1947 German authorities tried and convicted him, sentencing him to ten years in a work camp. Following an appeal, the court reduced his sentence. In 1950, he was released and spent the rest of his life as a painter and decorator in Bavaria.[54] Nazi poster artist Hans Schweitzer ("Mjölnir") was tried by a German court but only fined five hundred marks, which was then remitted because of

time spent in internment. Even this fine was later reduced on appeal, and his record was cleared in 1955.[55] Max Amann, who had built up an enormous Nazi newspaper empire, including the SS newspaper *Das Schwarze Korps*, was tried by a denazification court and sentenced as a major offender in 1948 to ten years in a labor camp. Released in 1953, the onetime Nazi press magnate died in poverty four years later.[56] After the war, U.S. war crimes prosecutors interrogated but never tried Paul Karl Schmidt, the former director of the press department for the German Foreign Office who disseminated Nazi propaganda abroad. In the Federal Republic of Germany, Schmidt entered the field of journalism under the assumed name Paul Carell and quickly became a best-selling author of popular World War II history books.[57]

Artist Philipp Rupprecht ("Fips"), ca. 1926. *Stadtarchiv Nürnberg, C21/VII Passkarteien Nr. 132*

A number of individuals were charged with treason for aiding Germany and the other Axis powers through foreign broadcasts. Arrested by the British in northern Germany, William Joyce ("Lord Haw-Haw"), though born in the United States, was tried by a British court on the technicality that he could be tried for treason against the Crown. He was found guilty and executed in January 1946.[58] Noted British writer P. G. Wodehouse was investigated for treason but found only to have been naive and not a traitor.[59] Ezra Pound, the eccentric American poet, was indicted for treason in 1943. Captured by U.S. troops in Italy, he was held in custody there and then returned to the United States. In December 1945, psychiatric examinations determined that Pound was insane and mentally unfit for trial. He was committed to St. Elizabeth's Hospital in Washington, D.C. In 1958, the federal district court dropped the indictment against him after receiving appeals on his behalf by noted men of letters such as Robert Frost and Ernest Hemingway.[60] A court in Norway indicted Nobel Prize–winning Norwegian novelist Knut Hamsun for treason after the war but ultimately found him mentally incompetent to stand trial.[61] Finally, the Arab nationalist and Muslim religious leader, the Grand Mufti of Jerusalem, Hajj Amin al-Husayni, who had broadcast pro-Axis propaganda on the radio from Berlin to the Arab world, was arrested in 1945 in the French occupation zone of Germany. After authorities moved al-Husayni to France, he managed to flee to Egypt, where he continued to produce and disseminate anti-Zionist, anti-Jewish, and anti-Israel propaganda.[62] He died in 1974.

Hajj Amin al-Husayni, the Grand Mufti of Jerusalem, June 21, 1946. *Corbis*

CONCLUSION

After the war, the Allied powers endeavored to have ordinary Germans accept responsibility for crimes committed against other peoples under Nazi rule. This daunting task met with only limited success. Many Germans, having lost relatives in the conflict or personally suffered harm, deprivation, and displacement, created a collective vision of themselves as victims of Nazi rule and the war.[63] Ordinary Germans following postwar trials of propagandists saw how media figures like Streicher, to avoid the hangman's noose, or Riefenstahl, to save her career and reputation, refused to take responsibility for their involvement in Nazi crimes and demonstrated little remorse. Hans Fritzsche's statement as a defendant at Nuremberg was the exception: "After the totalitarian form of government has brought about the catastrophe of the murder of five millions, I consider this form of government wrong even in times of emergency. I believe any kind of democratic control, even a restricted democratic control, would have made such a catastrophe impossible." The former radio broadcaster concluded,

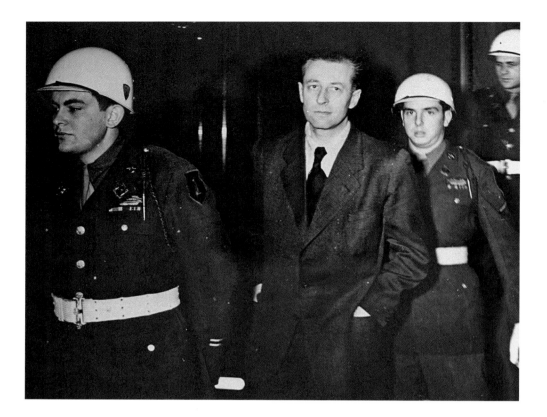

Hans Fritzsche, former head of the radio division of the German Propaganda Ministry, being escorted into the courtroom by American Military Police at the International Military Tribunal trial of war criminals at Nuremberg, November 20, 1945–October 1, 1946. *USHMM, Robert M. W. Kempner Papers*

"He who, after Auschwitz, still clings to racial politics has rendered himself guilty."[64] It would take new generations of Germans, including scholars born after the war and active in the last three decades of the twentieth century, to raise questions about the behavior of their parents and grandparents during the Nazi years.

In other areas, however, the Allied occupying powers achieved considerable success. They not only dismantled the military, the SS, and other instruments of Nazi terror. They also destroyed the apparatus of propaganda that had served the regime until its end in 1945 as a vital tool in building support for or acquiescence in the implementation of anti-Jewish policies—from persecution to genocide—and in creating support for a prolonged war at untold cost to the nation and the world. Nazi control of information ended with the collapse of the regime, with the deaths of Adolf Hitler and his propaganda minister Joseph Goebbels, and with military defeat. Information specialists for the Allied occupying powers used some of the same tactics that Hitler and Goebbels adroitly deployed from the early Nazi Party's "time of struggle" through the twelve-year Reich, but they did so toward quite different ends. The aims of Allied officials were to enlighten Germans and peoples abroad about what had transpired to thoroughly discredit the regime that had perpetrated unimaginable crimes, in the hope that such crimes would never occur again. Serving similar aims were the postwar trials, including the major case conducted by the International Military Tribunal at Nuremberg and the trials conducted in the various occupation zones and by denazification courts. Postwar trials highlighted the important role that propaganda played in maintaining popular support for the Nazi regime and in fomenting and justifying the persecution of Jews and other victims of the Holocaust era. The prosecution of propagandists for "crimes against humanity" established an important precedent invoked by international bodies and courts to the present day.

AFTERWORD

The history of the Nazi regime provides a striking example of the use of propaganda for malevolent purposes by political leaders backed by a repressive police apparatus and a party-controlled court system. Certainly, Nazism's uniqueness and particular goals notwithstanding, propaganda exists in all modern societies. Politicians and other advocates of various causes today deploy words, myths, symbols, photographs, films, and music to shape public opinion to serve their purposes. "Every day we are bombarded with one persuasive communication after another," observe American experts on propaganda Anthony Pratkanis and Elliot Aronson. "These appeals persuade not through the give-and-take of argument and debate, but through the manipulation of symbols and of our most basic human emotion. . . . For better or worse, ours is an age of propaganda."[1] These authors and others aim to enlighten readers on the specific tactics used in contemporary propaganda, such as name-calling and the use of distracting generalities and euphemisms, all of which were well-known to Adolf Hitler, Joseph Goebbels, and other Nazi propagandists.[2]

Although the use of propaganda in contemporary societies is widespread, its effectiveness depends not only on propagandists' ability to tap into existing sentiments but also on wider contexts, especially the absence of freedom of speech and other civil rights. The history of the Third Reich demonstrates that propaganda in the hands of a nondemocratic state that controls most means of communication can be a potent weapon. In the absence of publicly voiced dissent, political leaders may more effectively use propaganda to build support for their policies—or reluctance to oppose them—including such extremes as waging wars of aggression or committing genocide.

From the immediate postwar years to the present, recognition of these basic truths about propaganda as well as the legal precedents established by the trials of *Der Stürmer* editor Julius Streicher and other Nazi propagandists have informed discussions in various countries, international organizations, and international tribunals about the use of propaganda for evil ends. Political leaders, diplomats, jurists, journalists, and leaders of human rights organizations have considered the harm or potential for harm arising from particular forms of propaganda associated with racism, antisemitism, and ethnic conflicts. Throughout the postwar era, the United Nations has discussed the issue of propaganda and the ways in which member nations could curb, restrict, or combat warlike, extreme nationalistic, and racist propaganda.[3] In the discussions leading up to the UN's adoption in 1948 of the Convention on the Prevention and Punishment of the Crime of Genocide, international representatives sought to make the

use of hate propaganda a punishable offense under international law. In the first draft of the Genocide Convention, the framers pushed for the inclusion of the following clause: "All forms of public propaganda tending by their systematic and hateful character to promote genocide, or tending to make it appear as a necessary, legitimate, or excusable act shall be punished."[4] This article was ultimately dropped from the final version. Instead, Article III (c) of the convention made the "direct and public incitement to genocide" a punishable offense under international law. As a consequence, the scope of the clause became much more narrow. The debate over the provision had pitted at one extreme the Soviet Union—in its wish for a broader definition that would include virulently racist propaganda—against the United States on the other, with its strong commitment to free speech and freedom of the press. Both countries proposed amendments reflecting their respective positions, and both were defeated.[5]

Most recently, this clause of the Genocide Convention and the trials of the Nazi propagandists at Nuremberg gained new significance in the wake of genocide in the Central African nation of Rwanda. Between April and July 1994, members of the Hutu majority, wielding machetes, firearms, and other weapons, killed at least a half million people (of a total population of 7.9 million). The vast majority of the victims were members of the Tutsi minority.[6] In 1997, the United Nations International Criminal Tribunal for Rwanda (ICTR) indicted three Rwandans for "incitement to genocide." The first was Hassan Ngeze, who founded, published, and edited *Kangura* (Wake It Up!), a Hutu-owned tabloid that in the months preceding the genocide published vitriolic articles dehumanizing the Tutsi as *inyenzi* (cockroaches), though it never called directly for killing them. The other two were Ferdinand Nahimana and Jean-Bosco Barayagwiza, founders of a talk-radio station called Radio Mille Collines (Thousand Hills Radio) that explicitly called for murder, even providing the names and license plate numbers of people to be killed. In a country where few people own televisions or have access to print media, radio is the major medium for communication. In the days leading to and during the massacres, Radio Mille Collines received help from Radio Rwanda, the government-owned station, and programs were relayed to villages and towns throughout the country by a network of transmitters operated by Radio Rwanda.[7] At the heart of the Rwanda "Media Trial" that opened October 23, 2000, was the issue of free speech rights. "A key question is what kind of speech is protected and where the limits lie," said American lawyer Stephen J. Rapp, the senior prosecutor for the tribunal. "It is important to draw that line. We hope the judgment will give the world some guidance."[8]

The ICTR handed down its verdict in December 2003. The three judges (a South African, a Sri Lankan, and a Norwegian) convicted Ngeze, Nahimana, and Barayagwiza for "direct and public incitement to genocide." The judges declared: "Without a firearm, machete or any physical weapon, you caused the deaths of thousands of innocent civilians."[9] In framing their verdict, the judges noted: "This case raises important principles concerning the role of the media, which have not been addressed at the level of international criminal justice since Nuremberg. The power of the media to create and destroy fundamental human values comes with great responsibility. Those who control the media are accountable for its consequences." The Julius Streicher case served as the key historical precedent.[10] As in the Streicher case, prosecutors for the ICTR had to persuade the judges that the defendants

shared the intent of the perpetrators of the genocide. They also had to prove that the speech was likely to provoke violence—that the propagandists commanded sufficient authority to influence listeners or readers. This argument involved the interpretation of euphemisms, such as the phrase "go to work," that came to signify "kill the Tutsi and the Hutus who opposed the Rwandan regime." That a person killed someone as an immediate, direct response to the radio broadcasts or newspaper articles was not required to prove the "incitement to genocide" charge.[11]

Reactions to the ICTR's decision were mixed. Floyd Abrams, a leading American legal expert on the U.S. Constitution's First Amendment, supported the verdicts. Abrams said that "while the United States protected free speech more fiercely than any other country, it did not shield statements intended to provoke violence and likely to do so."[12] (Despite general agreement, however, Abrams later drew up the amicus brief submitted to the appeals court, criticizing the decision on legal grounds and holding it up as a bad precedent that could be used to suppress freedom of speech.) Political scientist Scott Straus analyzed the timing of the radio broadcasts and the killings, the content of available radio transcripts, and interviews conducted with imprisoned perpetrators of the genocide. He concluded that radio propaganda did have an impact during the Rwanda genocide—in catalyzing a minority of perpetrators who led others to kill, in reinforcing messages about the Tutsi "enemy," and in "framing public choice." But Straus criticized some popular analyses of the genocide for oversimplifying the direct and primary role of Radio Mille Collines. He argued that the perpetrators had been motivated to act for a variety of reasons, based on their fears and experiences within the wider context of a civil war and a long history of ethnic tensions.[13] A third group of commentators disagreed with aspects of the ICTR's decision because they feared it might "provide cover for the suppression of legitimate dissent through overly broad restrictions on speech and incitement."[14]

The lawyers for the defendants in the Rwanda "Media Trial" in January 2007 appealed the tribunal's decisions on numerous grounds. On November 28, 2007, the tribunal issued a decision reaffirming the charge of "direct and public incitement to commit genocide" against Ngeze and Nahimana. The judges reversed the finding of guilt on this charge against Barayagwiza, however. They ruled that only broadcasts on Radio Mille Collines made after April 6, 1994—the commencement of the killings and thus under tribunal jurisdiction—constituted "direct and public incitement to commit genocide," and that Barayagwiza had no longer exercised control over the employees of the radio station at that time. The tribunal did affirm findings of guilt against Barayagwiza on different grounds, for instigating the perpetration of acts of genocide and crimes against humanity. Because of the reversal of some charges against the three defendants, the judges reduced the defendants' sentences: for Nahimana from life to thirty years, for Ngeze from life to thirty-five years, and for Barayagwiza from thirty-five to thirty-two years.[15]

Some human rights activists had hoped that the ICTR's ruling would provide the world a legal weapon to help prevent genocide before it could occur. Commenting on the Rwanda "Media Trial" in 2004, Susan Benesch, a lawyer for Amnesty International, wrote: "Each modern case of genocide has been preceded by a propaganda campaign transmitted via mass media and directed by a handful of political leaders. If such campaigns could be stopped—or their masterminds deterred—genocide might be

averted." Benesch also argued that any despotic ruler who wanted to suppress dissent could do so without referencing the Rwanda Tribunal's decision.[16] On the issue of whether it provided useful legal precedent, the constraints on the Rwanda Tribunal to limit its decision to the time frame directly surrounding the genocide meant that it did not consider the impact of the larger propaganda campaign in the months prior to April 6, 1994, that helped shape the wider climate for the killings.

The Genocide Convention's Article III (c) regarding propaganda has most recently been invoked in the spirit of genocide prevention. Iranian President Mahmoud Ahmadinejad at the "World without Zionism" conference in Tehran, on October 26, 2005, called for Israel to be "wiped off the map."[17] In 2006, Israeli diplomats proposed to charge Ahmadinejad with direct and public incitement to genocide before the International Court of Justice in The Hague. In June 2007, the U.S. House of Representatives passed a resolution calling upon the UN Security Council to charge Ahmadinejad with violating the Genocide Convention by his repeated calls for Israel to be annihilated.[18] Government officials in the United Kingdom, Canada, and Australia have adopted similar statements. The proposals were largely symbolic in value; few have advanced.

Because of their specific histories and legal traditions, countries today take different approaches to hate propaganda. As a result of Germany's experience under the Nazi regime, constitutional rights of free speech, press, and assembly are qualified in Germany. Articles 86 and 86a of the German Penal Code prohibit the dissemination of propaganda by "unconstitutional and National Socialist organizations" and criminalize the display of Nazi "flags, badges, uniform parts, passwords, and salutes."[19] The dissemination of Nazi propaganda and antisemitic tracts, such as the *Protocols of the Elders of Zion*, are punishable offenses under German law. Hitler's autobiography, *Mein Kampf*, which circulated in millions of copies in the 1930s and 1940s, is available only for research purposes and cannot be legally printed or sold. The swastika cannot be shown on objects for purchase, even in catalogs selling World War II collectibles.[20]

In the way it currently protects expression characterized as "hate speech," the United States differs not only from Germany but also from Canada and most other Western societies. It is a crime in eleven European countries to say that the Holocaust did not happen—but not in the United States. The right of American Nazi Party members to demonstrate publicly in Skokie, Illinois, in 1977 was upheld by the U.S. Court of Appeals for the Seventh Circuit, which ruled that Skokie town ordinances to stop the demonstration were unconstitutional. The Nazis called off their march after the city of Chicago relented on its earlier denial of a permit to the group and allowed it to march in Marquette Park.[21] Generally, U.S. courts have been reluctant to restrict First Amendment freedoms except in "perilous times" of war.[22]

Where should the line be drawn between hurtful propaganda and free speech rights? How would knowledge of a nation's history, a propagandist's power to influence people toward harmful ends, and a specific political context—a system of government, the existence of ethnic tensions, and the presence of military conflict—inform the answer? Whatever one's point of view, free speech and a free and responsible press, together with an engaged and informed citizenry, remain the best safeguards against pernicious propaganda.

NOTES

INTRODUCTION

1. This quotation comes from Orwell's diary entry for March 14, 1942, when he was working as a "propagandist" for the British Broadcasting Corporation Eastern services. Cited in C. Fleay and M. L. Sanders, "Looking into the Abyss: George Orwell at the BBC," *Journal of Contemporary History* 24 (1989): 503–18, 512.

2. On the etymology of the term, see Erwin W. Fellows, " 'Propaganda': History of a Word," *American Speech* 34 (1959): 182–89. See also David Welch, David Culbert, and Nicholas Cull, eds., *Propaganda and Mass Persuasion: A Historical Encyclopedia 1500 to the Present* (Santa Barbara, CA: ABC–CLIO, 2003).

3. Aristotle A. Kallis, *Nazi Propaganda and the Second World War* (Basingstoke, U.K.: Palgrave Macmillan, 2005), 1.

4. Sigmund Freud, "Thoughts for the Times on War and Death," in Ernest Jones, ed., *Sigmund Freud, M.D., LL.D., Collected Papers*, vol. 4, trans. Joan Riviere (London: Hogarth Press and Institute of Psycho-Analysis, 1949), 288–317.

5. Kenneth Cmiel, "On Cynicism, Evil, and the Discovery of Communication in the 1940s," *Journal of Communication* 46 (1996): 3.

6. Will Irwin, "An Age of Lies. How the Propagandist Attacks the Foundations of Public Opinion," *Sunset* 43 (December 1919): 23–25, 54–56.

7. Everett Dean Martin, "Our Invisible Masters," *The Forum*, series, "Are We Victims of Propaganda? A Debate," 81 (1929): 142–45.

8. Bruce Bliven, "Let's Have More Propaganda!" *The World Tomorrow* 9 (1926): 254–55.

9. Edward L. Bernays, "Manipulating Public Opinion: The Why and the How," *American Journal of Sociology* 33 (1928): 958–71.

10. *America's Town Meeting of the Air. Propaganda—Asset or Liability in Democracy?* Broadcast from the Town Hall, New York, over NBC Blue Network (New York: American Book Company, April 15, 1937), 12–13.

11. Sir Campbell Stuart, *Secrets of Crewe House: The Story of a Famous Campaign* (London, New York, and Toronto: Hodder and Stoughton, 1920); George Creel, *How We Advertised America: The First Telling of the Amazing Story of the Committee on Public Information That Carried the Gospel of Americanism to Every Corner of the Globe* (New York: Harper and Brothers, 1920); Arthur Ponsonby, *Falsehood in Wartime: Propaganda Lies of the First World War* (London: George Allen and Unwin, 1919).

12. Walter Millis, *The Road to War* (Boston: Houghton Mifflin, 1935).

13. Geoffrey Stone and Zechariah Chaffee, Jr., *Free Speech in the United States* (Cambridge, MA: Harvard University Press, 1967).

14. Cmiel, "On Cynicism, Evil, and the Discovery of Communication in the 1940s," 2.

15. I. Keith Tyler, "What Can We Do about the Radio?" *The English Journal* 27 (1938): 556–66; H. V. Kaltenborn, "An American View of European Broadcasting," *Annals of the American Academy of Political and Social Science* 177 (1935): 73–80; John B. Whitton, "War by Radio," *Foreign Affairs* 19 (1941): 584–96.

16. John Houseman, *Unfinished Business: Memoirs: 1902–1988* (New York: Applause Theatre Books, 1989), chap. 8; Raymond Moley, "Perspective: Radio Dangers," *Newsweek*, November 14, 1938, 43.

17. Stuart Ewen, *PR! A Social History of Spin* (New York: Basic Books, 1996); Larry Tye, *The Father of Spin: Edward Bernays and the Birth of Public Relations* (New York: Henry Holt, 2002); Edward Bernays, *Propaganda* (1928; repr. Brooklyn, NY: Ig Publishing, 2005).

18. Gustave Le Bon, *The Crowd: A Study of the Popular Mind* (Atlanta: Cherokee Publishing, 1982).

19. I. W. Howerth, "The Great War and the Instinct of the Herd," *International Journal of Ethics* 29 (1919): 174–87; Sigmund Freud, *Group Psychology and the Analysis of the Ego*, trans. James Strachey (New York: Bantam Books, 1965).

20. Ernest Bramsted, *Goebbels and National Socialist Propaganda, 1925–1945* (East Lansing: Michigan State University Press, 1965); Erwin Leiser, *Nazi Cinema*, trans. Gertrud Mander and David Wilson (New York: Macmillan, 1975); Robert E. Herzstein, *The War That Hitler Won: Goebbels and the Nazi Media Campaign* (New York: Paragon House, 1987); Jay Baird, *The Mythical World of Nazi War Propaganda, 1939–1945* (Minneapolis: University of Minnesota Press, 1974); David Welch, *The Third Reich: Politics and Propaganda* (New York: Routledge, 1993), and *Propaganda and the German Cinema, 1933–1945* (London and New York: I. B. Tauris); Peter Paret, *German Encounters with Modernism, 1840–1945* (Cambridge: Cambridge University Press, 2001); Peter Paret, Beth Irwin Lewis, and Paul Paret, *Persuasive Images: Posters of War and Revolution from the Hoover Institution Archives* (Princeton, NJ: Princeton University Press, 1992); Peter Longerich, "Davon Haben Wir Nichts Gewusst": *Die Deutschen und die Judenverfolgung, 1933–1945* (Munich: Siedler, 2006), and Peter Longerich, *Propagandisten im Krieg: Die Presseabteilung des Auswärtigen Amtes unter Ribbentrop* (Munich: R. Oldenbourg, 1987); Jeffrey Herf, *The Jewish Enemy: Nazi Propaganda during World War II and the Holocaust* (Cambridge, MA: Harvard University Press, 2006); Lutz Hachmeister and Michael Kloft, eds., *Das Goebbels-Experiment: Propaganda und Politik* (Munich: Deutsche Verlags-Anstalt, 2005); Kallis, *Nazi Propaganda and the Second World War*. Catalogues of exhibitions touching on Nazi propaganda include Hans-Jörg Czech und Nikola Doll, eds., *Kunst und Propaganda im Streit der Nationen 1930–1945* (Dresden: Sandstein Verlag, 2007); James Aulich, *War Posters: Weapons of Mass Communication* (New York: Thames and Hudson, 2007); Stiftung der Haus der Geschichte, *Bilder und Macht im 20. Jahrhundert* (Bielefeld: Kerber Verlag, 2004); Haus der Geschichte der Bundesrepublik Deutschland, ed., *Bilder, die lügen* (Bonn: Bouvier Verlag, 2003); Marianne Lamonaca and Sarah Schleuning, *Weapons of Mass Dissemination: The Propaganda of War* (Miami Beach, FL: The Wolfsonian—Florida International University, 2004); Kenneth W. Rendell, *With Weapons and Wits: Propaganda and Psychological Warfare in World War II* (Wellesley, MA: Overlord Press, 1991).

21. Rudolf Herz, *Hoffmann & Hitler: Fotografie als Medium des Führer-Mythos* (Munich: Münchner Stadtmuseum, 1994). The Haus der Geschichte in Bonn opened an exhibition on Leni Riefenstahl in December 2002.

PROPAGANDA FOR VOTES AND POWER

1. August Kubizek, *Adolf Hitler Mein Jugendfreund*, unabridged special edition (Graz: Leopold Stocker Verlag, 2002), 83. On Wagner's influence on Hitler, see Frederic Spotts, *Hitler and the Power of Aesthetics* (Woodstock, NY: Overlook, 2003); Brigitte Hamann, *Winifred*

Wagner: A Life at the Heart of Hitler's Bayreuth, trans. Alan Bance (New York: Harcourt, 2006).

2. Ian Kershaw, *Hitler 1889–1936: Hubris* (New York: W. W. Norton, 1998), 34–35; Brigitte Hamann, *Hitler's Vienna: A Dictator's Apprenticeship*, trans. Thomas Thornton (New York: Oxford University Press, 1999).

3. John Weiss, *Ideology of Death: Why the Holocaust Happened in Germany* (Chicago: Elephant Paperbacks, 1997), 168, 187.

4. Adolf Hitler, *Mein Kampf*, trans. Ralph Mannheim (Boston: Houghton Mifflin, 1971), 176.

5. Lothar Gruchmann and Reinhard Weber, eds., *Der Hitler-Prozess 1924: Wortlaut der Hauptverhandlung vor dem Volksgericht München I* (Munich: K. G. Saur, 1997), 22–24.

6. Hitler, *Mein Kampf*, 181.

7. Ibid., 181–83. See also Erwin Schockel, *Das politische Plakat: Eine psychologische Betrachtung* (Munich: Zentralverlag der NSDAP, Franz Eher Verlag Nachfolger, 1938).

8. "Americans Saw No Cruel Acts," *New York Times*, September 7, 1914, 1; "Ran Down 'Atrocity' Tales," *New York Times*, September 27, 1914, 3; "Atrocity Yarn Disproved," *New York Times*, September 27, 1914, 3. See also John Horne and Alan Kramer, *German Atrocities, 1914: A History of Denial* (New Haven, CT: Yale University Press, 2001).

9. Observation by Joseph Goebbels, future Nazi propaganda minister, cited in Gerhard Paul, *Aufstand der Bilder: Die NS-Propaganda vor 1933* (Bonn: Verlag J. H. W. Dietz Nachf., 1992), 49.

10. Wolfgang Schivelbusch, *The Culture of Defeat: On National Trauma, Mourning, and Recovery* (New York: Metropolitan Books, 2003), 214.

11. Niall Ferguson, *The Pity of War* (New York: Basic Books, 1999), 212.

12. Edwin Emery and Michael Emery, *The Press and America: An Interpretive History of the Mass Media* (Englewood Cliffs, NJ: Prentice-Hall, 1984), 336–43.

13. Paul Starr, *The Creation of the Media: Political Origins of Modern Communications* (New York: Basic Books, 2004), 222–23.

14. Peter Buitenhuis, *The Great War of Words: Literature as Propaganda 1914–18 and After* (London: B. T. Batsford, 1989).

15. George Creel, *How We Advertised America*; J. A. Thompson, "American Progressive Publicists and the First World War, 1914–1917," *Journal of American History* 58 (1971): 364–83.

16. Stéphane Audoin-Rouzeau and Annette Becker, *14–18: Understanding the Great War*, trans. Catherine Temerson (New York: Hill and Wang, 2002), 109–10.

17. Sir Philip Gibbs, *Now It Can Be Told* (Garden City, NY: Garden City Publishing, 1920), 69.

18. Ibid., 68.

19. Ferdinand Avenarius, *Die Mache im Weltwahn: Schriften für Echten Frieden* (Berlin: W. Büxenstein Druckereigesellschaft, 1922), 80–81; George L. Mosse, *Fallen Soldiers: Reshaping the Memory of the World Wars* (New York: Oxford University Press, 1991), 173.

20. Hitler, *Mein Kampf*, 202–6.

21. Saul Friedlander, *Nazi Germany and the Jews. Volume 1: The Years of Persecution, 1933–1939* (New York: HarperCollins, 1998), 75; Werner T. Angress, "The German Army's 'Judenzählung' of 1916: Genesis-Consequences-Significance," *Leo Baeck Institute Yearbook* 23 (1978): 117–37.

22. John Keegan, *The First World War* (New York: Vintage Books, 2000), 6.

23. Dora Apel, "Cultural Battlegrounds: Weimar Photographic Narratives of War," *New German Critique* 76 (1999): 49–84.

24. Dennis Crockett, "The Most Famous Painting of the 'Golden Twenties'? Otto Dix and the Trench Affair," *Art Journal* 51, no. 1 (1992): 72–80.

25. Modris Eksteins, "War, Memory, and Politics: The Fate of the Film *All Quiet on the Western Front*," *Central European History* 13 (1980): 60–82.

26. Hitler, *Mein Kampf*, 187.

27. Erich Ludendorff, *Meine Kriegserinnerungen 1914–1918* (Berlin: Ernst Siegfried Mittler und Sohn, 1919), 285.

28. Edgar Stern-Rubarth, quoted in Schivelbusch, *Culture of Defeat*, 215–16. A leading scholar of Nazi propaganda, David Welch [*The Third Reich: Politics and Propaganda* (London and New York: Routledge, 1993), 11], asserts that "the evidence does not support [Hitler's claim]; in many respects German propaganda during the First World War was more advanced than the British." Hitler's account became the "official truth" and was repeated by other Nazis and "right-wing politicians in general."

29. Alan Bullock, *Hitler: A Study in Tyranny* (New York: Harper and Row, 1962), 34.

30. Ibid., 65–66.

31. Kershaw, *Hitler: Hubris*, 145–49.

32. Benjamin Sax and Dieter Kuntz, *Inside Hitler's Germany* (Lexington, MA: D. C. Heath, 1992), 70.

33. Detlef Mühlberger, *Hitler's Voice: The Völkischer Beobachter, 1920–1933*, vol. 1 (Oxford: Peter Lang, 2004), 20–22.

34. Welch, *The Third Reich*, 12.

35. David Clay Large, *Where Ghosts Walked: Munich's Road to the Third Reich* (New York: W. W. Norton), 78.

36. Hitler, *Mein Kampf*, 496–97.

37. Ibid., 106.

38. Kershaw, *Hitler: Hubris*, 133.

39. Ernst Hanfstaengl, *The Unknown Hitler* (London: Gibson Square, 2005), 72–73.

40. Hitler, *Mein Kampf*, 180.

41. Ibid., 182.

42. Ibid., 184–85; Sterling Fishman, "The Rise of Hitler as Beer Hall Orator," *Review of Politics* 26 (1964): 244–56.

43. Hanfstaengl, *The Unknown Hitler*, 75.

44. Albert Speer, *Inside the Third Reich*, trans. Richard and Clare Winston (New York: Avon Books, 1971), 44.

45. *Hitler's Table Talk 1941–1944: His Private Conversations*, trans. Norman Cameron and R. H. Stevens (New York: Enigma Books, 2000), 413–14.

46. David Jablonsky, *The Nazi Party in Dissolution: Hitler and the* Verbotzeit *1923–1925* (London: Frank Cass, 1989), 47.

47. Ibid., 171–72; Martin Broszat, *Hitler and the Collapse of the Weimar Republic*, trans. V. R. Berghahn (New York: Berg, 1987), 61.

48. Paul, *Aufstand der Bilder*, 64–68.

49. Johnpeter Horst Grill, "The Nazi Party's Rural Propaganda before 1928," *Central European History* 15 (1982), 149–85.

50. http://www.calvin.edu/academic/cas/gpa/wille.htm. See also USHMM Archives, RG 68.025M (Bundesarchiv NS 51) Selected Records from Kanzlei des Führers der NSDAP, 1934–1945, Reel 6, NS 51/211, for instructions by party representatives in Saxony to propagandists.

51. Thomas Childers, *The Nazi Voter: The Social Foundations of Fascism in Germany, 1919–1933* (Chapel Hill: University of North Carolina Press, 1983), 140; Ian Kershaw, *The 'Hitler Myth': Image and Reality in the Third Reich* (New York: Oxford University Press, 2001), 29.

52. Sax and Kuntz, *Inside Hitler's Germany*, 99.

53. *Das Freie Wort*, October 19, 1930.

54. Sarah Gordon, *Hitler, Germans and the "Jewish Question"* (Princeton, NJ: Princeton University Press, 1984), 69.

55. Horst Gies, "The NSDAP and Agrarian Organizations in the Final Phase of the Weimar Republic," in Henry A. Turner, Jr., ed., *Nazism and the Third Reich* (New York: Quadrangle Books, 1972), 45–88, 56.

56. Gordon, *Hitler, Germans and the "Jewish Question,"* 66; Christopher R. Browning, with a contribution by Jürgen Matthäus, *The Origins of the Final Solution: The Evolution of Nazi Jewish Policy, September 1939–March 1942* (London: William Heinemann, 2004), 8.

57. Detlev J. K. Peukert, *The Weimar Republic: The Crisis of Classical Modernity*, trans. Richard Deveson (New York: Hill and Wang, 1992), 237.

58. Browning, *Origins of the Final Solution*, 8.

59. Thomas Childers and Eugene Weiss, "Voters and Violence: Political Violence and the Limits of National Socialist Mass Mobilization," *German Studies Review* 13, no. 3 (1990): 481–98, 482; Russel Lemmons, *Goebbels and Der Angriff* (Lexington: University Press of Kentucky, 1994), 66.

60. Jürgen W. Falter, "The Two Hindenburg Elections of 1925 and 1932: A Total Reversal of Voter Coalitions," *Central European History* 23 (1990): 225–41, 227.

61. Kershaw, *Hitler: Hubris*, 363.

62. Richard J. Evans, *The Coming of the Third Reich* (New York: Penguin Books, 2003), 281–82.

63. Otto Dietrich, *Mit Hitler in die Macht. Persönliche Erlebnisse mit meinem Führer* (Munich: Verlag Franz Eher Nachfolger, 1934), 65.

64. William G. Chrystal, "Nazi Party Election Films, 1927–1938," *Cinema Journal* 15 (1975): 29–47.

65. Karl Dietrich Erdmann, *Die Weimarer Republik* (Munich: Deutscher Taschenbuch Verlag, 1985), 300.

POWER AND PERSUASION IN THE RACIAL STATE

1. *Völkischer Beobachter*, February 3, 1933, first insert.

2. Ingo Müller, *Hitler's Justice: The Courts of the Third Reich*, trans. Deborah Lucas Schneider (Cambridge, MA: Harvard University Press, 1991), 27.

3. Max Domarus, *Hitler: Reden und Proklamationen*, vol. 1 (Wiesbaden: Löwit, 1973), 217, 247.

4. Welch, *Third Reich*, 18.

5. Helmut Heiber, ed., *Goebbels-Reden*, vol. 1: 1932– (Düsseldorf: Droste Verlag, 1971), 108–12.

6. Welch, *Third Reich*, 45.

7. George L. Mosse, *Nazism: A Historical and Comparative Analysis of National Socialism* (New Brunswick, NJ: Transaction, 1978), 22–23; Robert M. W. Kempner, "Hitler und die Zerstörung des Hauses Ullstein: Dokumente und Vernehmungen," *Sonderdruck aus Hundert Jahre Ullstein* (Berlin: Ullstein, 1977), 267–92.

8. Welch, *Third Reich*, 37.

9. Lutz Hachmeister and Michael Kloft, eds., *Das Goebbels-Experiment*, 29; Elke Fröhlich, ed., *Auftrag des Instituts für Zeitgeschichte und mit Unterstützung des Staatlichen Archivdienstes Russlands*, Part I: *Aufzeichnungen 1923–1941*. Vol. 2/2: June 1931–September 1932 (Munich: K. G. Saur, 2004), 335–36, diary entry of August 9, 1932.

10. Hachmeister and Kloft, eds., *Das Goebbels-Experiment*.

11. Ibid., 39; Goebbels's diary entry, April 14, 1943, in Louis P. Lochner, ed., *The Goebbels Diaries, 1942–1943* (New York: Doubleday, 1948), 327.

12. Michael P. Hensle, " 'Rundfunkverbrechen' vor NS-Sondergerichten," *Rundfunk und Geschichte* 26 (2000): 111–26.

13. Inge Marssolek and Adelheid von Saldern, eds., *Zuhören und Gehörtwerden I: Radio im Nationalsozialismus. Zwischen Lenkung und Ablenkung* (Tübingen: Edition Discord, 1998), 50.

14. Ibid., 52–53.

15. Welch, *Third Reich*, 30–31.

16. Richard Grunberger, *The 12-Year Reich: A Social History of Nazi Germany 1933–1945* (New York: Holt, Rinehart and Winston, 1979), 401–2; Welch, *Third Reich*, 33.

17. Welch, *Third Reich*, 39–49.

18. See William Uricchio, "Television as History: Representations of German Television Broadcasting, 1935–1944," in Bruce A. Murray and Christopher J. Wickham, eds., *Framing the Past: The Historiography of German Cinema and Television* (Carbondale, IL: Southern Illinois University Press, 1992), 167–96.

19. Ibid., 172–73, 179–80.

20. Aryeh L. Unger, "The Public Opinion Reports of the Nazi Party," *Public Opinion Quarterly* 29, no. 4 (Winter 1965–1966): 567, 569, 578–82.

21. Ian Kershaw, *Popular Opinion and Political Dissent in the Third Reich: Bavaria 1933–1945* (Oxford: Clarendon Press, 1983), 7–8.

22. Bruno Bettelheim, *Surviving and Other Essays* (New York: Vintage Books, 1980), 318, 327–28.

23. Willy Schumann, *Being Present: Growing Up in Hitler's Germany* (Kent, OH: Kent State University Press, 1991), 14.

24. Kershaw, *Hitler: Hubris*, 507–8; Kershaw, *Popular Opinion*.

25. Robert Gellately and Nathan Stolzfus, eds., *Social Outsiders in Nazi Germany* (Princeton, NJ: Princeton University Press, 2001), 4; Mosse, *Nazism*, 42–44.

26. Richard Bessel, *Nazism and War* (New York: Modern Library, 2004), 30.

27. Melita Maschmann, *Account Rendered: A Dossier on My Former Self*, trans. Geoffrey Strachan (London: Abelard-Schuman, 1964), 10–11.

28. George L. Mosse, *Nazi Culture: Intellectual, Cultural, and Social Life in the Third Reich* (New York: Grosset and Dunlap, 1968), 263–318.

29. Welch, *Third Reich*, 62.

30. Kershaw, *Hitler: Hubris*, 526; David Culbert and Martin Loiperdinger, "Leni Riefenstahl's '*Tag der Freiheit*': The 1935 Nazi Party Rally Film," *Historical Journal of Film, Radio and Television* 12 (1992): 3–39.

31. David Welch, *Propaganda and the German Cinema, 1933–1945* (London and New York: I. B. Tauris), 134.

32. Saul Friedlander, *Nazi Germany and the Jews. Volume 1: The Years of Persecution, 1933–1939* (New York: HarperCollins, 1998), 1, 117, 180–81.

33. Gabriele Toepser-Ziegert, ed., *NS-Presseanweisungen der Vorkriegszeit*, vol. 4/II (1936) (Munich: K. G. Saur, 1993), 782, 831–32.

34. William Shirer, *Berlin Diary: The Journal of a Foreign Correspondent 1934–1941* (New York: Alfred A. Knopf, 1941), entry of August 16, 1936, 65.

35. Maschmann, *Account Rendered*, 211.

36. Friedlander, *Nazi Germany and the Jews*, 1:253.

37. Stephanie Barron, "*Degenerate Art*": *The Fate of the Avant-Garde in Nazi Germany* (New York: Harry N. Abrams, 1991), 36.

38. Friedlander, *Nazi Germany and the Jews*, 1:42.

39. Ibid., 1:122–23.

40. Ibid., 1:122–23, 141–43, 151, 184–85.

41. Ibid., 1:185.

42. Kershaw, *Hitler: Hubris*, 410.

43. Ibid., 573.

44. Freidlander, *Nazi Germany and the Jews*, 1:166; Victor Klemperer, *I Will Bear Witness: A Diary of the Nazi Years*, vol. 1, trans. Martin Chalmers (New York: Modern Library, 1999), 136.

45. Deborah E. Lipstadt, *Beyond Belief: The American Press and the Coming of the Holocaust, 1933–1945* (New York: Free Press, 1986), 99, 104–5, 112.

46. *Das Schwarze Korps*, November 24, 1938, 8; December 1, 1938, 8–10; December 8, 1938, 8; December 15, 1938, 8.

47. Gerhart L. Weinberg, *Germany, Hitler, and World War II* (New York: Cambridge University Press, 1995), 79.

48. Arnold J. Zurcher, "The Hitler Referenda," *American Political Science Review* 29, no. 1 (February 1935): 91–99.

PROPAGANDA FOR WAR AND MASS MURDER

1. Bessel, *Nazism and War*, 95.

2. Richard Overy, *Why the Allies Won* (New York: W. W. Norton, 1995), chapter 9.

3. Herf, *The Jewish Enemy*.

4. William L. Shirer, *"This Is Berlin": Radio Broadcasts from Nazi Germany* (Woodstock, NY: Overlook, 1999), 58–60; Gerhard L. Weinberg, *Germany, Hitler, and World War II: Essays in Modern German and World History* (New York: Cambridge University Press, 1995), 68–82.

5. Alexander G. Hardy, *Hitler's Secret Weapon: The "Managed" Press and Propaganda Machine of Nazi Germany* (New York: Vantage, 1967), 123–34.

6. Gerhard L. Weinberg, *A World at Arms: A Global History of World War II* (New York: Cambridge University Press, 1994), 33–49; Hoover Institution Archives, Wilfrid Bade Papers, 1927–1945, Box 9, Deutsches Nachrichtenbüro, 1939.

7. Helmut Sündermann, *Tagesparolen: Deutsche Presseweisungen 1939–1945. Hitlers Propaganda und Kriegsführung* (Leoni am Starnberger See: Druffel-Verlag, 1973), 40.

8. Martin Broszat, *Zweihundert Jahre deutsche Polenpolitik* (Frankfurt am Main: Suhrkamp, 1981), 281–83.

9. Shirer, *Berlin Diary*, entry of September 9, 1939, 206–7; Hans Schadewaldt, ed., *Polish Acts of Atrocity against the German Minority in Poland* (Berlin and New York: Volk und Reich Verlag and German Library of Information, 1940).

10. For full or partial transcripts of these broadcasts, see Records of the Princeton Listening Center (1939–1941), Seeley G. Mudd Manuscript Library, Princeton University, box 9.

11. Alexander B. Rossino, "Destructive Impulses: German Soldiers and the Invasion of Poland," *Holocaust and Genocide Studies* 11 (1997): 351–65.

12. Helmut Krausnick et al., *Die Truppe der Weltanschauungskrieges: Die Einsatzgruppen der Sicherheitspolizei und des SD, 1938–1942* (Stuttgart: Deutsche Verlags-Anstalt, 1981), 82.

13. *Völkischer Beobachter*, September 2, 1939, 4. On the official German monitoring of news from abroad, see Marie Vassiltchikov, *Berlin Diaries, 1940–1945* (New York: Alfred A. Knopf, 1987), 9.

14. Irving Settel, *A Pictorial History of Radio* (New York: Grosset and Dunlap, 1967), 30–31.

15. On *Heimkehr*, see Welch, *Propaganda and the German Cinema*, 110–16.

16. USHMM Archives, RG-68.076M NS 18 Selected Records of the Reichspropaganda-leitung, 1940–1944, BA NS [hereafter cited as Reichspropagandaleitung] 18/355, frames 0008–00012.

17. Eric A. Johnson, *Nazi Terror: The Gestapo, Jews, and Ordinary Germans* (New York: Basic Books, 1999), 325, 566; American postwar estimates based on interviews with Germans were much higher.

18. Michael P. Hensle, *Rundfunk verbrechen: das Hören von "Feindsendern" im Nationalsozialismus* (Berlin: Metropol, 2003), 123; Johnson, *Nazi Terror*, 325; see also Eric A. Johnson and Karl-Heinz Reuband, *What We Knew: Terror, Mass Murder, and Everyday Life in Nazi Germany; An Oral History* (New York: Basic Books, 2005).

19. Johnson, *Nazi Terror*, 327–28.

20. Kay Hoffmann, "Nationalsozialistischer Realismus und Film-Krieg. Am Beispiel der *Deutschen Wochenschau*," in Harro Segeberg, ed., *Mediale Mobilmachung: Das Dritte Reich und der Film* (Munich: Wilhelm Fink Verlag, 2004), 162, 151–78; see also *Historical Journal of Film, Radio and Television* 24, no. 1 (2004).

21. Kershaw, *"Hitler Myth,"* 151, 154–55.

22. Heinz Boberach, ed., *Meldungen aus dem Reich, 1938–1945: Die geheimen Lageberichte des Sicherheitsdienstes der SS* (Herrsching: Pawlak, 1984), vol. 4, June 27, 1940, 1307.

23. Müller, *Hitler's Justice*, 184; Nikolaus Wachsmann, *Hitler's Prisons: Legal Terror in Nazi Germany* (New Haven, CT: Yale University Press, 2004), 402–3.

24. Unterricht über Aufgaben und Pflichten der Wachposten in einem Konzenstrationslager, USHMM Archives, RG–11.001M.20 Concentration and POW Camps in Germany including KL Sachsenhausen, Reel 84, Fond 1367, Opis 1, Folder 2.

25. Max Domarus, *Hitler: Reden und Proklamationen, 1932–1945*, Part II *Untergang*. Vol. 3 (1939–1945) (Neustadt an der Aich: Verlagsdruckerei Schmidt, 1988), 1528–30.

26. See Shirer, *Berlin Diary*, 419–25, and Louis P. Lochner, *What about Germany?* (New York: Dodd, Mead, 1942), 135–37.

27. Domarus, *Hitler: Reden und Proklamationen*, Part II, vol. 3, 1530.

28. Welch, *Third Reich*, 80–81.

29. USHMM Archives, Reichspropagandaleitung, 18/348, Reel 4, frame 0004; Welch, *Third Reich*, 79.

30. Welch, *Propaganda and the German Cinema*, 226–27; Niall Ferguson, *The House of Rothschild* (New York: Penguin, 1998).

31. The usual association of Jews with Bolshevism was dropped from Hitler's speech on this occasion in deference to the temporary German–Soviet alliance. On *Der ewige Jude*, see David Culbert and Stif Hornshøj-Møller, *"Der ewige Jude* (1940): Joseph Goebbels' Unequaled Monument to Anti-Semitism," *Historical Journal of Film, Radio and Television* 12 (1992): 41–67.

32. Jens Eder, "Das populäre Kino im Krieg. NS-Film und Hollywoodkino—Massenunterhaltung und Mobilmachung," in Harro Segeberg, ed., *Mediengeschichte des Films*, vol. 4, *Mediale Mobilmachung: Das Dritte Reich und der Film* (Munich: Wilhelm Fink Verlag, 2004), 379–416, 382.

33. Ursula von Keitz, "Wie 'Deutsch Kamerun-Bananen' ins Klassenzimmer kommen. Pädagogik und Politik des Unterrichtsfilm," in Segeberg, *Mediengeschichte des Films*, 4:71–102, 91.

34. Welch, *Propaganda and the German Cinema*, 229–36.

35. USHMM Archives, Reichspropagandaleitung, 18/348, Reel 4, frame 0007; Michael Burleigh, *Selling Murder: The Killing Films of the Third Reich* (London: Domino Films, 1991), videorecording.

36. Israel Gutman, *Resistance: The Warsaw Ghetto Uprising* (Boston: Houghton Mifflin, 1994), 89.

37. Jürgen Förster, "Operation Barbarossa as a War of Conquest and Annihilation," in Militärgeschichtliches Forschungsamt, ed., *Germany and the Second World War*, vol. 4, *The Attack on the Soviet Union*, trans. Dean S. McMurry, Ewald Osers, and Louise Wilmot (Oxford: Clarendon Press, 1998), 481–521.

38. Christian Gerlach, *Krieg, Ernährung, Völkermord: Forschungen zur Deutschenvernichtungs–politik im Zweiten Weltkrieg* (Hamburg: Hamburger Edition, 1998).

39. Förster, "Operation Barbarossa," 501–3, 510.

40. Ibid., 516.

41. Cited in *Völkischer Beobachter*, June 23, 1941, 3.

42. Willi A. Boelcke, ed., *The Secret Conferences of Dr. Goebbels: The Nazi Propaganda War 1939–43* (New York: E. P. Dutton, 1970), 176.

43. See USHMM Archives, RG–14.016M Reichssicherheitshauptamt, R58, Folders 214–221, Ereignismeldung UdSSR Nr. 58 (August 20, 1941), and Hamburg Institute for Social Research, ed., *The German Army and Genocide: Crimes against War Prisoners, Jews, and Other Civilians in the East, 1939–1944* (New York: New Press, 1999), 84–87.

44. Cited in Franklin Watts, ed., *Voices of History, 1942–43* (New York: Gramercy, 1943), 16–33.

45. Ortwin Buchbender, *Das tönende Erz: Deutsche Propaganda gegen die Roten Armee im Zweiten Weltkrieg* (Stuttgart: Seewald Verlag, 1978).

46. USHMM Reichspropagandaleitung, 18/204, Reel 2, frames 0002–0007, memorandum dated April 7, 1942.

47. Ibid., Reel 2, frame 0003.

48. Louis P. Lochner, ed., *The Goebbels Diaries 1942–1943* (Garden City, NY: Doubleday, 1948), entries of March 7 and 27, 1942, 115–116, 147–148.

49. Herf, *Jewish Enemy*, 116; Elke Frohlich, ed., *Die Tagebücher von Joseph Goebbels*, Part 2 *Diktate 1941–1945*, vol. 1, July–September 1941 (Munich: K. G. Saur, 1996), entry of August 19, 1941, 255–272; and vol. 2 October–December 1941 (Munich: K. G. Saur, 1996), entry of October 19, 1941, 140–144.

50. Joseph Goebbels's diary 39 in Fröhlich, ed., *Tagebücher*, Part 1: *Aufzeichnungen, 1923–1941*, vol. 7 (Munich: K. G. Saur, 1998), entry of November 2, 1939, 177.

51. Livia Rothkirchen, *The Jews of Bohemia and Moravia: Facing the Holocaust* (Lincoln: University of Nebraska Press, 2005), 233–64; Raul Hilberg, *The Destruction of the European Jews* (New Haven, CT: Yale University Press, 2003), 447–57.

52. Yitzhak Arad, Yisrael Gutman, and Abraham Margaliot, eds., *Documents on the Holocaust: Selected Sources on the Destruction of the Jews of Germany and Austria, Poland, and the Soviet Union* (Jerusalem: Yad Vashem, 1981), 277.

53. Richard Glazer, *Trap with a Green Fence: Survival in Treblinka* (Evanston, IL: Northwestern University Press, 1995), 6.

54. Herf, *Jewish Enemy*, 126–27, 149, 174–77, 234.

55. Welch, *Propaganda and the German Cinema*, 170.

56. Herf, *Jewish Enemy*, 232.

57. USHMM, Reichspropagandaleitung, 18/164, *Deutscher Wochendienst*, 5. Februar 1943, Nummer 8312–37 and *Zeitschriften-Dienst*, 5 Februar, Nummer 8312–51.

58. Victor Klemperer, *I Will Bear Witness: A Diary of the Nazi Years, 1942–1945*, vol. 2, trans. Martin Chalmers (New York: Modern Library, 2001), entry of May 6, 1943, 226.

59. Lochner, ed., *Goebbels Diaries*, entry of May 10, 1943, 366; Fröhlich, ed., *Tagebücher*, Part 2, vol. 8, 261.

60. Michael R. Beschloss, *The Conquerors: Roosevelt, Truman and the Destruction of Hitler's Germany, 1941–1945* (New York: Simon and Schuster, 2002), 172–73.

61. Welch, *The Third Reich*, 117.

62. Hitler's Political Testament, April 29, 1945, in Domarus, *Hitler: Reden und Proklamationen*, Part II, 4:2236–37.

63. Bessel, *Nazism and War*, 180.

PROPAGANDA ON TRIAL

1. Victor Klemperer, *The Language of the Third Reich: LTI–Lingua Tertii Imperii: A Philologist's Notebook*, trans. Martin Brady (London: Athlone, 2000), 15.

2. See Thomas Mann, *Deutsche Hörer! Radiosendungen nach Deutschland aus den Jahren 1940–1945* (Frankfurt am Main: Fischer Taschenbuch, 1995), 133. Current scholarship puts the number of Jews killed at Auschwitz and Majdanek between April 1942 and April 1944 at closer to 725,000.

3. Michael J. Neufeld and Michael Berenbaum, eds., *The Bombing of Auschwitz: Should the Allies*

Have Attempted It? (Lawrence: University Press of Kansas, 2003), 139; David S. Wyman, *The Abandonment of the Jews: America and the Holocaust* (New York: Pantheon Books, 1984), 237.

4. Randolph L. Braham, *The Politics of Genocide: The Holocaust in Hungary*, vol. 2 (New York: Columbia University Press, 1994), 870–82.

5. Alfred D. Chandler, Jr., and Stephen E. Ambrose, eds., *The Papers of Dwight D. Eisenhower: The War Years*, vol. 4 (Baltimore: Johns Hopkins University Press, 1970), 2615–16.

6. Mark Bernstein and Alex Lubertozzi, *World War II on the Air: Edward R. Murrow and the Broadcasts That Riveted a Nation* (Naperville, IL: Sourcebooks, Inc., 2003), 202.

7. On the publicity campaign in Germany, see Cornelia Brink, " 'Ungläubig stehen oft Leute vor den Bildern von Leichenhaufen abgemagerter Skelette . . .' KZ-Fotografien auf Plakaten—Deutschland 1945," in *Auschwitz. Geschichte, Rezeption und Wirkung*, ed. Fritz Bauer Institut (Frankfurt am Main: Campus Verlag, 1996), 189–219; Cornelia Brink, *Ikonen der Vernichtung: öffentlicher Gebrauch von Fotografien aus nationalsozialistischen Konzentrationslager nach 1945* (Berlin: Akademie, 1998); Habbo Knoch, *Die Tat als Bild: Fotografien des Holocaust in der deutschen Erinnerungskultur* (Hamburg: Hamburger Edition, 2001).

8. Stephan Dolezel, "*Welt im Film* 1945 and the Re-education of Occupied Germany," in R. M. Short and Stephan Dolezel, eds., *Hitler's Fall: The Newsreel Witness* (London: Croom Helm, 1988), 152.

9. Ursula von Kardorff, *Diary of a Nightmare: Berlin 1942–1945*, trans. Ewan Butler (New York: John Day Company, 1966), 198–99.

10. Victor Klemperer, *The Lesser Evil: The Diaries of Victor Klemperer 1945–1959*, ed. Martin Chalmers (London: Weidenfield and Nicholson, 2003), 15.

11. Sybil Milton, "Confronting Atrocities," in Susan D. Bachrach, ed., *Liberation 1945* (Washington, DC: United States Holocaust Memorial Museum, 1995), 63–64.

12. National Archives and Records Administration, RG 208, NC-148, Entry 407, Boxes 2191–94, and Entry 269, Box 1485; Gunter Grass, *Peeling the Onion*, trans. Michael Henry Heim (Orlando, FL: Harcourt, 2007), 195–97.

13. See the protocol of the conference in Charle L. Mee, Jr., *Meeting at Potsdam* (New York: M. Evans, 1975), 316–35.

14. Elmer Plischke, "Denazifying the Reich," *Review of Politics* 9 (1947): 153–72, 156, 117.

15. General Lucius Clay, military governor of the U.S. Zone, provided the figure of seventy-five thousand by early July; see Jean Edward Smith, ed., *The Papers of General Lucius D. Clay: Germany 1945–1949* (Bloomington: Indiana University Press, 1974), 1:46. Plischke ("Denazifying the Reich," 157) calculates that U.S. military personnel were arresting some four hundred to six hundred Germans per day in the initial months after Germany's defeat.

16. See Control Council Directive No. 24 in Allied Control Authority Germany, *Enactments and Approved Papers*, vol. 2 (January–February 1946) (Berlin: Legal Division, April 1946), 16–44.

17. Elmer Plischke, "Denazification Law and Procedure," *American Journal of International Law* 41 (1947): 807–27, 824–25.

18. John H. Herz, "The Fiasco of Denazification in Germany," *Political Science Quarterly* 63 (1948): 578; Plischke ("Denazification Law and Procedure," 826) provides figures through 1947.

19. Nuremberg Municipal Museums, *Faszination und Gewalt: Das Reichsparteitagsgelände in Nürnberg* (Nuremberg: W. Tümmels, 1996), 36.

20. Dolezel, *Welt im Film* 1945, 154. For the formal order prohibiting such symbols and monuments, see "Directive No. 30: Liquidation of German Military and Nazi Memorials and Museums (May 13, 1946)," http://www.loc.gov/rr/frd/Military_Law/Enactments/law-index.pdf, 134–37.

21. Lawrence R. Hartenian, "The Role of Media in Democratizing Germany: United States Occupation Policy 1945," *Central European History* 20 (1987): 145–190.

22. Raymond J. Spahn and Leslie I. Poste, "The Germans Hail America: Some Aspects of Communication Media in Occupied Germany," *Modern Language Journal* 33 (1949): 417–26, 418.

23. Amy C. Beal, "The Army, the Airwaves, and the Avant-Garde: American Classical Music in Postwar West Germany," *American Music* 21 (2003): 474–513, 481.

24. Spahn and Poste, "Germans Hail America," 418.

25. Wolfgang Schivelbusch, *In a Cold Crater: Cultural and Intellectual Life in Berlin, 1945–1948*, trans. Kelly Barry (Berkeley: University of California Press, 1998), 137–38.

26. On *Die Welt in Film*, see Heinrich Bodensieck, "*Welt im Film*: Origins and Message," and Dolezel, "*Welt im Film* 1945," in Short and Dolezel, eds., *Hitler's Fall*, 119–47, 148–57.

27. Saul K. Padover, *Experiment in Germany: The Story of an American Intelligence Officer* (New York: Duell, Sloan and Pearce, 1946), 176; Richard L. Merritt, *Democracy Imposed: U.S. Occupation Policy and the German Public, 1945–1949* (New Haven, CT: Yale University Press, 1995), 271–78.

28. Sir Bernard L. Montgomery, *The Memoirs of Field-Marshal the Viscount Montgomery of Alamein, K.G.* (Cleveland: World, 1958), 367.

29. See the relevant Allied Control Council documents scanned by the Library of Congress, http://www.loc.gov/rr/frd/Military_Law/Enactments/law-index.pdf, "Control Council Order No. 4: Confiscation of Literature and Material of a Nazi and Militarist Nature (May 13, 1946)," 130–31.

30. Smith, ed., *Papers of General Lucius D. Clay, 1945–1949*, 1:224–26.

31. Robert E. Conot, *Justice at Nuremberg* (New York: Carroll and Graf, 1984), 103.

32. Max Bonacker, *Goebbels' Mann beim Radio: Der NS-Propagandist Hans Fritzsche (1900–1953)* (Munich: R. Oldenbourg Verlag, 2007), 218.

33. Dolezel, "*Welt im Film* 1945," 154.

34. *Trial of the Major War Criminals before the International Military Tribunal, Nuremberg 14 November 1945–30 November 1945*, vol. 2 (Buffalo, NY: William S. Hein, 1995), 209.

35. From the International Military Tribunal (IMT), quoted in William A. Schabas, *Genocide in International Law: The Crimes of Crimes* (New York: Cambridge University Press, 2000), 279.

36. *Trial of the Major War Criminals*, vol. 5, 109.

37. Ibid., 322, 316, 154; Douglas M. Kelley, *22 Cells in Nuremberg: A Psychiatrist Examines the Nazi Criminals* (New York: Greenberg Publishers, 1947), 142.

38. Closing Brief against Julius Streicher, July 31, 1946, USHMM Collection, Robert M. W. Kempner Papers, Buffalo Box, 125, folders 4–5.12.

39. Ibid., folders 4–5.13.

40. Ibid., folders 4–5.

41. *Trial of the Major War Criminals*, vol. 1, 302–4; see also Bradley F. Smith, *Reaching Judgment at Nuremberg* (New York: New American Library, 1977), 200–3; Nina Andrews, "Julius Streicher at Nuremberg: A Case of Justice Denied?" *British Journal of Holocaust Education* 3 (1994): 32–55.

42. On Fritzsche, see Max Bonacker, *Goebbels' Mann beim Radio*; Philipp Gassert, " 'This Is Hans Fritzsche': A Nazi Broadcaster and His Audience," *Journal of Radio Studies* 8 (2001): 81–103; *Hans Fritzche, The Sword in the Scales*, trans. Diana Pyke and Heinrich Fraenkel (London: L. A. Wingate, 1953).

43. Drexel Sprecher, *Looking Backward—Thinking Forward: A Nuremberg Prosecutor's Memoir with Numerous Commentaries on Subjects of Contemporary Interest* (Lanham, MD: Hamilton Books, 2005), 77–80.

44. Telford Taylor, *The Anatomy of the Nuremberg Trials* (New York: Alfred A. Knopf, 1992), 597.

45. The Soviet opinion is contained in the first volume of the printed volumes of the IMT and is available online at http://www.yale.edu/lawweb/avalon/imt/proc/judfritz.htm.

46. Bonacker, *Goebbels' Mann beim Radio*, 248, 252–57.

47. Verdict, proceedings in Case XI, "The Ministries Case," *Trials of War Criminals before the Nuernberg Military Tribunals under Control Council Law No. 10*, vol. 14 (Buffalo, NY: William S. Hein, 1997), 575–76; USHMM, Robert M. W. Kempner Papers, Boxes 150 and 250; Otto Dietrich, *Hitler*, trans. Richard and Clara Winston (Chicago: Henry Regnery, 1955).

48. Rudolf Herz, *Hoffmann & Hitler: Fotografie als Medium des Führer-Mythos* (Munich: Münchner Stadtmuseum, 1994), 64–69; Heinrich Hoffmann, *Hitler Was My Friend*, trans. Lt. Col. R. H. Stevens (London: Burke, 1955), 231–49.

49. See Report of Riefenstahl's interrogation of May 30, 1945, in National Archives and Records Administration, RG 226, E16, Box 1543, Folder 134034.

50. Jürgen Trimborn, *Leni Riefenstahl: A Life*, trans. Edna McCown (New York: Faber and Faber, 2007), 233–37.

51. Susan Tegel, "Leni Riefenstahl's Failure of Memory: The Gypsy Extras in *Tiefland*," in Donald Kenrick, ed., *The Gypsies during the Second World War*, vol. 3, *The Final Chapter* (Hertfordshire, U.K.: University of Hertfordshire Press, 2006), 197–213, note on p. 211.

52. See ibid.; Friedrich Knilli, *Ich War Jud Süss. Die Geschichte des Filmstars Ferdinand Marian* (Berlin: Henschel, 2000); Christoph Funke, "Heinrich George—Ein Komödiant im Dritten Reich. Versuch einer Deutung," in Gunter Agde, *Sachsenhausen bei Berlin: Speziallager Nr. 7 1945–1950, Kassiber, Dokumente und Studien* (Berlin: Aufbau Taschenbuch Verlag, 1994), 216–29.

53. Roel Vande Winkel, "Nazi Germany's Fritz Hippler, 1909–2002," *Historical Journal of Film, Radio and Television* 23, no. 2 (2003): 91–99.

54. Gerhard Jochem, "Rupprecht, Philipp," in *Neue Deutsche Biographie*, vol. 22 (Berlin: Duncker & Humblot, 2005), 282–83.

55. See Peter Paret, *German Encounters with Modernism, 1840–1945* (Cambridge: Cambridge University Press, 2001), 202–28, 227; Hoover Institution Archives, Peter Paret Collection, Box 1, Folder "Hans Schweitzer."

56. Oron J. Hale, *The Captive Press in the Third Reich* (Princeton, NJ: Princeton University Press, 1973); Robert M. W. Kempner, *SS im Kreuzverhör: Die Elite, die Europa in Scherben schlug* (Schriften der Hamburger Stiftung für Sozialgeschichte des 20. Jahrhunderts) (Aachen: Volksblatt Verlag, 1991), 340–43.

57. See Schmidt (Carell)'s interrogations in Kempner, *SS im Kreuzverhör* and Paul Carell, *Hitler Moves East, 1941–1943*, trans. Ewald Osers (New York: Bantam, 1966).

58. Though a U.S. citizen, Joyce illegally obtained a British passport during the 1930s. The passport expired in 1940, one year after "Lord Haw-Haw" began his broadcasts. Consequently, the British court established jurisdiction for Joyce's prosecution on charges of giving aid and comfort to the enemy in time of war, based on his broadcasts during that year, because, as the bearer of a British passport—even if illegally obtained—he could count on protections as a British subject and therefore owed his loyalty to the British Crown. See Peter Martland, *Lord Haw-Haw: The English Voice of Nazi Germany* (Richmond, Surrey, U.K.: National Archives, 2003), 1; Mary Kenny, *Germany Calling: A Biography of William Joyce Lord Haw-Haw* (Dublin: New Island, 2003).

59. On Wodehouse, see Nigel Farndale, *The Tragedy of William and Margaret Joyce* (London: Macmillan, 2005), 338–39; Horst J. P. Bergmeier and Rainer E. Lotz, *Hitler's Airwaves: The Inside Story of Nazi Radio Broadcasting and Propaganda Swing* (New Haven, CT: Yale University Press, 1997), 112–14.

60. William Van O'Connor and Edward Stone, eds., *A Casebook on Ezra Pound* (New York: Thomas Y. Crowell, 1959).

61. Martin Moll, "Zwischen Weimarer Klassik und nordischem Mythos: NS-Kulturpropaganda in Norwegen (1940–1945)," in Wolfgang Benz et al., eds., *Kultur—Propaganda—Öffentlichkeit: Intentionen deutscher Besatzungspolitik und Reacktionen auf die Okkupation*, vol. 5 (Berlin: Metropol, 1998), 189–223, 206–7.

62. Klaus Gensicke, *Der Mufti von Jerusalem, Amin el-Husseini, und die Nationalsozialisten* (Frankfurt am Main: Peter Lang, 1988), chapter 6; Zvi Elpeleg, *The Grand Mufti: Haj Amin al-Hussaini, Founder of the Palestinian National Movement* (London: Frank Cass, 1993); Philip Mattar, *The Mufti of Jerusalem: Al-Haj Amin al-Husayni and the Palestinian National Movement* (New York: Columbia University Press, 1988).

63. Bessel, *Nazism and War*, 193.

64. Conot, *Justice at Nuremberg*, xii.

AFTERWORD

1. Anthony Pratkanis and Eliot Aronson, *Age of Propaganda: The Everyday Use and Abuse of Persuasion* (New York: Henry Holt, 2002), 7.

2. See, for example, http://www.propagandacritic.com.

3. See, for instance, the discussion in John B. Whitton, "Radio Propaganda—a Modest Proposal," *American Journal of International Law* 52 (1958): 739–45; Universal Declaration of Human Rights (1948), G.A. res. 217A (III), U.N. Doc A/810 at 71 (1948), adopted on December 10, 1948, by the General Assembly of the United Nations (without dissent).

4. See Secretariat Draft, First Draft of the Genocide Convention, Prepared by the UN Secretariat, [May] 1947 [UN Doc E/447]; Raphael Lemkin, "Genocide as a Crime under International Law," *American Journal of International Law* 41 (1947): 145–51; Binoy Kampmark, "Shaping the Holocaust: The Final Solution in U.S. Political Discourses on the Genocide Convention, 1948–1956," *Journal of Genocide Research* 7 (2005): 85–100.

5. William A. Schabas, *Genocide in International Law: The Crimes of Crimes* (Cambridge: Cambridge University Press, 2000), 266–71; Colette Braekman, "Incitement to Genocide," *Crimes of War: What the Public Should Know*, ed. Roy Gutman and David Rieff (New York: W. W. Norton, 1999), 192–94.

6. http://www.ushmm.org/conscience/alert/rwanda/contents/01-overview; Helen M. Hintjens, "Explaining the 1994 Genocide in Rwanda," *Journal of Modern African Studies* 37 (1999): 241–86; Jamie Frederic Metzl, "Rwandan Genocide and the International Law of Radio Jamming," *American Journal of International Law* 94 (1997): 628–51.

7. Radio Netherlands Media Network, February 4, 2004. See http://www.radionetherlands.nl/features/media/dossiers/rwanda-h.html; Catharine A. MacKinnon, "*Prosecutor v. Nahimana, Barayagwiza & Ngeze*. Case No. ICTR 99-52-T," *American Journal of International Law* 98 (2004): 325–20.

8. Marlise Simons, "Trial Centers on Role of Press during Rwanda Massacre," *New York Times*, March 3, 2002.

9. Susan Benesch, "Inciting Genocide, Pleading Free Speech," *World Policy Journal* 21, no. 2 (Summer 2004): 62.

10. See the verdict online at UN ICTR, "Judgement and Sentence" and "Summary," *The Prosecutor v. Nahimana et al.*, Case No. ICTR-99-52-T, December 3, 2003, Arusha, Tanzania, http://69.94.11.53/default.htm.

11. Benesch, "Inciting Genocide," 66–67; Stephen J. Rapp, "Achieving Accountability for the Greatest Crimes: The Legacy of the International Tribunals," *Drake Law Review* 55 (2007): 259–309.

12. Sharon Lafraniere, "Court Convicts 3 in 1994 Genocide across Rwanda," *New York Times*, December 4, 2003; Open Society Institute, Justice Initiative, "*Amicus Curiae* brief on *Ferdinand Nahimana, Jean-Bosco Barayagwiza and Hassan Ngeze v. The Prosecutor* (ICTR Case No., ICTR-99-52-A)," http://www.justiceinitiative.org.

13. Scott Straus, "What Is the Relationship between Hate Radio and Violence? Rethinking Rwanda's 'Radio Machete,' " *Politics and Society* 35 (2007): 609–37.

14. See "*The Prosecutor v. Ferdinand Nahimana, Jean-Bosco Barayagwiza, Hassan Ngeze*," Open Society Justice Initiative, January 22, 2007, http://www.justiceinitiative.org/db/resource2?res_id=103601.

15. UN ICTR, "Summary of Judgement," *Nahimana et al. v. The Prosecutor*, Case No. ICTR-99-52-A, November 28, 2007, Arusha, Tanzania, http://69.94.11.53/default.htm.

16. Benesch, "Inciting Genocide," 63, 66.

17. "Text of Mahmoud Ahmadinejad's Speech," Week in Review, *New York Times*, October 30, 2005.

18. H. Con. Res. 21, passed in the House on June 20, 2007; *Congressional Record—House*, June 18, 2007; Joshua Rozenberg, "Four Ways to Act against Ahmadinejad," February 16, 2007, http://www/telegraph.co.uk/core/Content, 1–3.

19. Winfried Brugger, "The Treatment of Hate Speech in German Constitutional Law (Part I)," *German Law Journal* 12 (December 1, 2002), http://www.germanlawjournal.com/article.php?id=212.

20. Ibid.; Julia Pascal, "Unbanning Hitler," *New Statesman* 25, June 25, 2001, http://www.newstatesman.com; Matthias Küntzel, "The Booksellers of Teheran," *Wall Street Journal Online*, October 28, 2005, http://online.wsj.com.

21. Anthony Lewis, *Freedom for the Thought That We Hate: A Biography of the First Amendment* (New York: Basic Books, 2008), 157–60.

22. Geoffrey R. Stone, *Perilous Times: Free Speech in Wartime from the Sedition Act of 1798 to the War on Terrorism* (New York: W. W. Norton, 2004), 262–66.

FURTHER READING

Aulich, James. *War Posters: Weapons of Mass Communication*. New York: Thames and Hudson, 2007.

Baird, Jay. *The Mythical World of Nazi War Propaganda, 1939–1945*. Minneapolis: University of Minnesota Press, 1974.

Balfour, Michael. *Propaganda in War, 1939–1945: Organisations, Policies, and Publics, in Britain and Germany*. London: Routledge, 1979.

Benesch, Susan. "Inciting Genocide, Pleading Free Speech." *World Policy Journal*. 21, no. 2 (Summer 2004).

Bergmeier, Horst J. P., and Rainer E. Lotz. *Hitler's Airwaves: The Inside Story of Nazi Radio Broadcasting and Propaganda Swing*. New Haven, CT: Yale University Press, 1997.

Bernays, Edward L. *Propaganda*. 1928. Reprint, Brooklyn, NY: Ig Publishing, 2005.

Bessel, Richard. *Nazism and War*. New York: Modern Library, 2004.

Bramsted, Ernest. *Goebbels and National Socialist Propaganda, 1925–1945*. East Lansing: Michigan State University Press, 1965.

Buitenhuis, Peter. *The Great War of Words: Literature as Propaganda 1914–18 and After*. London: B. T. Batsford, 1989.

Bytwerk, Randall L. *Bending Spines: The Propagandas of Nazi Germany and the German Democratic Republic*. East Lansing: Michigan State University Press, 2004.

Cole, Robert, ed. *The Encyclopedia of Propaganda*. New York: Sharpe Reference, 1998.

Culbert, David. "The Impact of Anti-Semitic Film Propaganda on German Audiences: *Jew Süss* and *The Wandering Jew* (1940)." In *Art, Culture, and Media under the Third Reich*, edited by Richard A. Etlin, 139–57. Chicago: University of Chicago Press, 2002.

Cull, Nicholas J., David Culbert, and David Welch, eds. *Propaganda and Mass Persuasion: A Historical Encyclopedia, 1500 to the Present*. Santa Barbara, CA: ABC–CLIO, 2003.

Emery, Edwin, and Michael Emery. *The Press and America: An Interpretive History of the Mass Media*. Englewood Cliffs, NJ: Prentice-Hall, 1984.

Ewen, Stuart. *PR! A Social History of Spin*. New York: Basic Books, 1996.

Friedlander, Saul. *Nazi Germany and the Jews*. Vol. 1, *The Years of Persecution, 1933–1939*. New York: HarperPerennial, 1998.

Hale, Oron J. *The Captive Press in the Third Reich*. Princeton, NJ: Princeton University Press, 1973.

Hancock, Eleanor. *The National Socialist Leadership and Total War*. New York: St. Martin's, 1991.

Hardy, Alexander G. *Hitler's Secret Weapon: The "Managed" Press and Propaganda Machine of Nazi Germany*. New York: Vantage, 1967.

Herb, Guntram Henrik. *Under the Map of Germany: Nationalism and Propaganda 1918–1945*. New York: Routledge, 1997.

Herf, Jeffrey. *The Jewish Enemy: Nazi Propaganda during World War II and the Holocaust*. Cambridge, MA: Harvard University Press, 2006.

Herzstein, Robert E. *The War That Hitler Won: Goebbels and the Nazi Media Campaign*. New York: Paragon House, 1987.

Johnson, Eric A. *Nazi Terror: The Gestapo, Jews, and Ordinary Germans*. New York: Basic Books, 1999.

Johnson, Eric A., and Karl-Heinz Reuband. *What We Knew: Terror, Mass Murder, and Everyday Life in Nazi Germany; An Oral History*. New York: Basic Books, 2005.

Kallis, Aristotle A. *Nazi Propaganda and the Second World War*. Basingstoke, U.K.: Palgrave Macmillan, 2005.

Keen, Sam. *Faces of the Enemy: Reflections of the Hostile Imagination; The Psychology of Enmity*. New York: Harper and Row, 1986.

Kershaw, Ian. "The Persecution of the Jews and German Popular Opinion in the Third Reich." *Leo Baeck Institute Year Book* 26 (1981): 261–89.

———. *Hitler 1889–1936: Hubris*. New York: W. W. Norton, 1998.

———. *The "Hitler Myth": Image and Reality in the Third Reich*. New York: Oxford University Press, 2001.

Koonz, Claudia. *The Nazi Conscience*. Cambridge, MA: Harvard University Press, 2003.

Lamonaca, Marianne, and Sarah Schleunig. *Weapons of Mass Dissemination: The Propaganda of War*. Miami Beach, FL: The Wolfsonian—Florida International University, 2004.

Leiser, Erwin. *Nazi Cinema*. Translated by Gertrud Mander and David Wilson. New York: Macmillan, 1975.

Lemmons, Russel. *Goebbels and Der Angriff*. Lexington: University Press of Kentucky, 1994.

Lewis, Anthony. *Freedom for the Thought That We Hate: A Biography of the First Amendment*. New York: Basic Books, 2008.

Moeller, Felix. *The Film Minister: Goebbels and the Cinema of the Third Reich*. Translated by Michael Robinson. Stuttgart: Edition Axel Menger, 2000.

Mosse, George L. *Nazi Culture: Intellectual, Cultural, and Social Life in the Third Reich*. New York: Grosset and Dunlap, 1968.

Paret, Peter. *German Encounters with Modernism, 1840–1945*. Cambridge: Cambridge University Press, 2001.

Paret, Peter, Beth Irwin Lewis, and Paul Paret. *Persuasive Images: Posters of War and Revolution from the Hoover Institution Archives*. Princeton, NJ: Princeton University Press, 1992.

Peukert, Detlev. *Inside Nazi Germany: Conformity, Opposition, and Racism in Everyday Life*. New Haven, CT: Yale University Press, 1987.

Pratkanis, Anthony, and Eliot Aronson. *Age of Propaganda: The Everyday Use and Abuse of Persuasion*. New York: Henry Holt, 2002.

Rendell, Kenneth W. *With Weapons and Wits: Propaganda and Psychological Warfare in World War II*. Wellesley, MA: Overlord, 1991.

Rhodes, Anthony. *Propaganda: The Art of Persuasion, World War II*. New York: Chelsea House, 1983.

Roshwald, Aviel, and Richard Stites. *European Culture in the Great War: The Arts, Entertainment, and Propaganda, 1914–1918*. Cambridge: Cambridge University Press, 1999.

Rutherford, Ward. *Hitler's Propaganda Machine*. London: Bison Books, 1978.

Schabas, William A. *Genocide in International Law: The Crimes of Crimes*. Cambridge: Cambridge University Press, 2000.

Sington, Derrick, and Arthur Weidenfeld. *The Goebbels Experiment: A Study of the Nazi Propaganda Machine*. New Haven, CT: Yale University Press, 1943.

Starr, Paul. *The Creation of the Media: Political Origins of Modern Communications*. New York: Basic Books, 2004.

Stone, Geoffrey R. *Perilous Times: Free Speech in Wartime from the Sedition Act of 1798 to the War on Terrorism*. New York: W. W. Norton, 2004.

Straus, Scott. "What Is the Relationship between Hate Radio and Violence? Rethinking Rwanda's 'Radio Machete.' " *Politics and Society* 35 (2007): 609–37.

Tegel, Susan."Veit Harlan and the Origins of *Jud Süss*, 1938–1939: Opportunism in the Creation of Nazi Anti-Semitic Film Propaganda." *Historical Journal of Film, Radio and Television* 14 (1996): 515–32.

Tye, Larry. *The Father of Spin: Edward Bernays and the Birth of Public Relations*. New York: Henry Holt, 2002.

Welch, David. *The Third Reich: Politics and Propaganda*. New York: Routledge, 1993.

——— . *Propaganda and the German Cinema, 1933–1945*. London: I. B. Tauris, 2001.

Zeman, Z. A. B. *Nazi Propaganda*. New York: Oxford University Press, 1964.

VIDEOGRAPHY

Der Sieg des Glaubens. Directed by Leni Riefenstahl. (Original release 1933.) Bement, IL: World War 2 Books and Video, 2003.

Deutschland, erwache! Directed by Erwin Leiser. Chicago: International Historic Films, 1968.

The Goebbels Experiment. Directed by Lutz Hachmeister. New York: First Run Features, 2004.

Selling Murder: The Killing Films of the Third Reich. Directed by Joanna Mack. Written by Michael Burleigh. London: Domino Films, 1991.

Triumph des Willens. Directed by Leni Riefenstahl. (Original release 1935.) Bloomington, IL: Synapse Films, 2001.

The Wonderful, Horrible Life of Leni Reifenstahl. Directed by Ray Müller. New York: Kino Video, 1993.

World War II—the Propaganda Battle. In the series *A Walk through the 20th Century with Bill Moyers*. Produced and directed by David Grubin. New York: David Grubin Productions. 1984.

INDEX